Walter Pater's Renaissance

Almost every people, as we know, has had its legend of a "golden age" and of its return—legends which will hardly be forgotten, however prosaic the world may become, while man himself remains the aspiring, never quite contented being he is. And yet in truth, since we are no longer children, we might well question the advantage of the return to us of a condition of life in which, by the nature of the case, the values of things would, so to speak, lie wholly on their surfaces, unless we could regain also the childish consciousness or rather unconsciousness, in ourselves, to take all that adroitly and with the appropriate lightness of heart.

—*Walter Pater,* "Denys L'Auxerrois," Imaginary Portraits

Walter Pater's Renaissance

Paul Barolsky

THE PENNSYLVANIA STATE UNIVERSITY PRESS
University Park and London

Also by Paul Barolsky
Daniele da Volterra: A Catalogue Raisonné
Infinite Jest: Wit and Humor in Italian Renaissance Art

Excerpt from "A Dutch Courtyard," by Richard Wilbur,
from *The Beautiful Changes,* copyright 1947, 1975, by Richard Wilbur.
Reprinted by permission of Harcourt Brace Jovanovich, Inc.

Library of Congress Cataloging-in-Publication Data

Barolsky, Paul, 1941–
Walter Pater's Renaissance.

Bibliography: p.
Includes index.
1. Arts, Renaissance. 2. Pater, Walter, 1839–1894.
Renaissance. 3. Pater, Walter, 1839–1894—Criticism
and interpretation. I. Title.
NX450.5.B37 1986 700'.94 85–43561
ISBN 0-271-00436-3

For my father, my sister, and Ida,
and in memory of my mother

Contents

List of Illustrations

Preface

T his book is an essay, a fact that I wish to stress most emphatically at the outset, since many readers, especially academic readers, expect a book of this sort to be an argument, presenting explicit theses, copiously documented with massive footnotes that explain its subject utterly. Although I cannot pretend to be a Paterian writer, since after all Pater is a great writer, this essay is a sympathetic response to the very suggestiveness of Pater's prose, itself

suggestive of Pater's place in modern cultural life. It is intended to evoke a broad network of cultural relations and values, not to clinch arguments or prove anything in particular.

Because this is an essay, written in the spirit of Pater's, footnotes are relatively few. At the beginning the notes locate my own investigations in relation to the work of literary scholars; other notes make reference to art-historical interpretations to which I connect Pater's writings. Notes are not given to the myriad passages cited from *The Renaissance*. Those who know Pater's writing will find them easily, and others less familiar with Pater will need to read them not in isolation but in context. The Selected Bibliography will furnish the few interested readers with my other principal sources in both imaginative literature and scholarship.

A word should be said here about some implications of my endeavor. I will not tax the reader, at least not just yet, with a detailed account of the writing of this study, of its invention and seemingly infinite revisions, although at this stage I should like to thank the editors of *Antioch Review, Artibus et Historiae, Kunsthistorisk Tidskrift, Journal of Pre-Raphaelite Studies, New Criterion, Pater Newsletter, Poetry East, Studies in Iconography,* and *University of Hartford Studies in Literature* for permission to reprint revised versions of essays that previously appeared in these journals. At every stage of composition I saw new possibilities of investigation, and as I write these final prefatory words, I already see beyond this book, as I hope my reader eventually will.

I have deliberately tried to avoid explicit reference to Pater's relevance for the contemporary theory of criticism—since so much of this theory has been transformed, despite the efforts of serious thinkers, into a form of intellectual chic—but a word should be said about the role Pater has played in current hermeneutics. Pater's form of impressionism, for example, is not unrelated to recent phenomenological criticism and to "reception theory" so called. It is no accident that one of the principal proponents of the latter theory wrote a monograph on Pater, although it is little cited by Pater critics and "hermeneuts" alike.

Pater stands apart from most contemporary theorists because his theory of knowledge and aesthetics is implicit in his poetical style, whereas most current theoretical discourse is devoid of such grace and tact. In a period when Herbert Read's *English Prose Style* (1980) is reprinted with little academic interest, scholarly writing is often a stew of jargon, of terms appropriated too easily from philosophy, psychology, linguistics, sociology, and other disciplines, in accord with the latest intellectual fashion. A number of contemporary literary scholars have rediscovered Pater, however, seeing his work as the epitome of criticism as art, but these academic admirers have not precisely followed such Paterian criticism because they fail to write a truly fine prose that gives pleasure in itself. We must turn instead to such works as Julian Barnes's beautiful and haunting book, *Flaubert's Parrot* (1984)—biography,

criticism, fiction, history, theory, all and none of these—for the living presence of the Paterian ideal.

Pater is embraced by some literary scholars, who skeptically indulge themselves in notions of "indeterminacy" (which they define with remarkable exactitude), as if skepticism were a new philosophy. Pater's writing reminds us, on the other hand, that we are now witnessing the latest phase in the centuries-old history of such skepticism or Pyrrhonism. Pater evocatively approaches the original meaning or intention of works of art and literature without lapsing into the extremes either of those who regard the understanding of intention as utterly impossible or of others who consider such interpretation as perfectly possible. His notion of interpretation, diaphanously inhering in his work, thus resists the rigid excesses of what is now called, in a curious turn of phrase, "methodology."

The intellectual climate of art history has not made it easy to write appreciatively about Pater, whose influences on my own discipline have been ignored, strangely regarded as pernicious, or treated with ambivalence—as if the outrage at the notorious "conclusion" of his *Renaissance* had lingered over a century after the publication of his slim but parturient book. During the last eight years, the period in which this essay has slowly taken shape, I have incurred enormous debts to a large number of individuals, friends, colleagues, students, acquaintances, editors, and others—some known fleetingly or indirectly, many not seen in years, a few sadly gone—who have helped me either with suggestions and criticism, with encouragement and moral support, through the example of their work, or in still other ways, difficult to define. James Ackerman, Harold Acton, Anne Barriault, Eugenio Battisti, Staige Blackford, Peter Bondanella, Miles Chappell, Bruce Cole, Daniel Ehnbom, Irvin Ehrenpreis, William Eiland, Philipp Fehl, Jessica Feldman, Robert Fogarty, Lelia and Ugo Fontana, Alastair Fowler, Fernanda Fracassini, Sydney Freedberg, Christopher Gardner, Lydia Gasman, John Gere, Virginia Germino, Francis Golffing, Józef Grabski, Helene Harth, Frederick Hartt, Paul Hills, Cherene Holland, Richard Jones, Walter Kaiser, Hanna Kiel, Sigrid Knudsen, Valerie Krall, Hilton Kramer, Gloria Kury, Andrew Ladis, Robert Langbaum, Ralph Lieberman, Steve Margulies, Christoph Meckel, Ulrich Middeldorf, Barbara Mustain, Konrad Oberhuber, JoAnne Paradise, Ricardo Quinones, Patrik Reuterswärd, Charles Ross, Ira and Dianne Sadoff, Ernest Samuels, Mark Samuels Lasner, Roger Shattuck, Penelope Smith, Craig Smyth, Margaret Stetz, David Summers, Denys Sutton, Suzanne Sweet, Judy Thomas, A. Richard Turner, Steve Wegener, Philip Winsor, and David Winter compose a partial list. This book could not have been written without the help of fellowships from the University of Virginia, Harvard University, and the Leopold Schepp Foundation, which supported research in 1980–81 at Villa I Tatti, whose staff assisted me with warm cordiality.

There are more specific debts that I wish to acknowledge. Throughout the

entire period of this book's genesis and realization, Cecil Lang has been an inspiration and guide. He has furnished me with books and bibliographies, criticism and suggestions, words and phrases, tips and hunches, ideas and hypotheses, nothing less, during regular matinee meetings—a veritable eight-year Victorian tutorial—which have influenced my work beyond all measure. Equally important has been the correspondence I have had over an even longer period with another friend and colleague, Norman E. Land, whose comments on Pater, poetry, criticism, and art history have found their way into this study. I am not altogether sure he didn't write part of it. He was in fact the co-author of an earlier version of the chapter on Giorgione. I must also mention here the work of Carolyn Williams, who provided me with a key to Pater in her dissertation on Pater (University of Virginia, 1978). The full implications of Ms. Williams's study have yet to be realized either by Pater scholars or by this amateur.

During the composition of this work there have been brief moments of insight but far longer periods spent in a kind of dark wood of false starts, perplexity, and doubt. My wife, Ruth, and children, Deborah and Daniel, inevitably led me from this melancholic bosk with their affection, humor, and very example. Ruth's work at the piano reminded me daily that all art does indeed aspire to the condition of music. Deborah, whose poem on nothing-ness prefigured by several months my chapter on the same subject, reintroduced me to Sherlock Holmes, who figures prominently in the following pages. Daniel, living laboratory of the ludic, master of the perfect jest, drew me repeatedly from my melancholy with a variety of quips and the very nearly ironic refrain, "Cheer up!"

Over the years, as my library grew my father's shrank. His losses of books by Pater, Symonds, Proust, and other highly aesthetic writers (which did not go unnoticed without pithy commentary) have facilitated my work, and for such paternal largesse I remain eternally grateful. The seeds of this study were sown even earlier, long ago. I will never forget the gray Saturday morning around 1950 when my mother led me up the stairs to the studio of Eleanor Kleiner on Ellison Street in Paterson. That day we all made portrait drawings in charcoal, and for reasons I do not understand, no doubt will never under-stand, the experience filled me with awe. This is the earliest memory I have of what might be called aesthetic wonder, and I see now that it more than lingers in what follows.

Paul Barolsky
Charlottesville, Virginia

Introduction:
The Invisible Tapestry

And from his father's body, so they say, a little phoenix is born (renasci). . . .
—*Ovid*, Metamorphoses, *XV*

Except a man be born again, he cannot see the kingdom of God.
—*Gospel of St. John*

The new life begins.
—*Dante*, Vita Nuova

He [Giotto] brought the modern and good art of painting to life.
—*Giorgio Vasari*, Le vite

The Nature of my Work is Visionary or Imaginative; it is an Endeavour to Restore what the Ancients called the Golden Age.
—*William Blake*, A Vision of the Last Judgment

We know that the new form of social production, to achieve the good life, needs only new men.
—*Karl Marx*, "The Revolution of 1848 and the Proletariat"

This at least of flame-like our life has, that it is but the concurrence, renewed from moment to moment, of forces parting sooner or later on their ways.
—*Walter Pater*, The Renaissance

The Spirit *cannot be reborn until the vision of that life is completed and accepted.*
—*W. B. Yeats*, A Vision

I no longer remember exactly when I first took down from a shelf in my father's library his copy of Walter Pater's *The Renaissance,* although I believe it was about twenty-five years ago. I was then eager to learn about the historical epoch known as the Renaissance, but I initially found Pater's book mysterious, if not inaccessible. As time passed, I found myself increasingly returning to it, and as I read and reread Pater's strange and fascinating work, it slowly yielded up some of its secrets. What impressed me was the uncanny immediacy of Pater's pictorial language, the way in which his words brought to mind so vividly, indeed so sensuously, the paintings and statues he described or evoked. When I was younger, I both drew and painted with determination, but later, though I still drew on occasion, I was more interested in the mysterious art of translating visual images into words. More and more, Pater seemed to me a master of this art. If, in a personal way, his descriptions of light and shadow, of line and color, called to mind childhood attempts to render images in charcoal and watercolor, his words, more objectively, also seemed true to the works of Renaissance art that he described. It appeared that, although Pater never spoke simply and directly, he penetrated the surfaces of Renaissance art, fathomed the very intentions of its creators.

Over the years, I began to discuss Pater in various undergraduate and graduate courses and seminars in art and literature; and, doing so, I discovered that Pater anticipated much in the modern art-historical scholarship—that his interpretations, however elliptical, foreshadowed particular twentieth-century exegeses of works by Botticelli, Leonardo, Giorgione, and Michelangelo. This reclusive academic don, as elusive personally as the precise meanings of his writing, had helped shape our vision of Renaissance culture far more than had been supposed, even by his admirers. I became interested in the broader literary context and significance of his work. How did Pater come to have these particular insights? How did he come to write as he did? To what point did he move as he revised this deeply disturbing book? I identified with the poet Shelley, or his speaker, confronting the residue of Rousseau in "The Triumph of Life": "'Whence camest thou, and whither goest thou? / How did thy course begin,' I said, 'and why?'" These were among the questions I asked as I delved into the subject and pursued Pater eagerly with such literary colleagues as Carolyn Williams, who introduced me to Pater's typology, and Cecil Lang, who, like the centaur tutoring the young Achilles, led me to Pater and Swinburne, Pater and Rossetti, and much, much more.

I began to see less darkly why Pater, as one of the great prose stylists, was profoundly rooted in the very history of English literature, just as I came to situate him commandingly in the history of writing about art. Indeed, although art history and criticism are generally viewed only peripherally in relation to imaginative literature, it finally struck me with full force that we

cannot fully understand Pater (or for that matter any great writer on art) without taking into account the context of imaginative literature in which he wrote about art.

As time passed, however, it puzzled me that while I shared Pater's art-historical and critical insights with students of art history, literary scholars seemed to be writing about another Pater. They were especially interested in Pater's station in Victorian literature, in his influences on twentieth-century literature. I, on the other hand, was trying to define his place in the history of modern writing about art from Vasari to contemporary art history. Fascinated, challenged, perhaps even obsessed, I began to contemplate writing about *The Renaissance* in order to understand better its significance and literary ramifications. When Donald Hill's critical edition appeared in 1980, I asked the editor of *Apollo,* Denys Sutton, if I might write a review of it, since *Apollo* seemed to be one of the very few art-historical journals that still consciously espoused the principles of Pater's aesthetic criticism. He replied affirmatively and called my brief essay "The Inspiration of Walter Pater" (*Apollo,* March 1981). I wrote there that although Pater's book was a literary classic, much discussed and glossed, we still had no overview of it. I further suggested that if many great writers of the twentieth century were deeply indebted to Pater, art historians, who generally ignored Pater, might ponder the implications of this fact. What did Yeats and Woolf see in Pater that most members of the College Art Association did not? Did art historians not have something to learn from Pater?

I then set out to explore these and other aspects of Pater's book, both literary and art-historical, in a series of essays, some printed in literary journals, some in art-historical periodicals, in this country and abroad. Although I thought of my subject as one, it still seemed that there were two Paters—the Pater usually ignored or undervalued by art historians, the Pater prized by scholars of literature. It seemed increasingly important to bring the two Paters together. I thus decided to compose this book, which is partly fashioned from previously printed essays, here revised and in many cases rewritten, but which also comprises other essays, not previously published, rounding out my exposition. Together, these essays are both a sustained meditation on the literary character of *The Renaissance*—its structure, sources, influences, and relations to Pater's other writings—and an assessment of Pater's role in the modern history of writing about art.

The first part of my study is an investigation of the overall literary form and content of *The Renaissance*. I examine Pater's relations to Flaubert, Gautier, Hugo, Baudelaire, and Mallarmé, his influences on such writers as T. S. Eliot, William Butler Yeats, Virginia Woolf, Arthur Conan Doyle, and Vladimir Nabokov. Some of these relations have been tentatively discussed by others before me, but I believe that many of the particular points or connec-

tions made here will be new to Pater scholars, and I believe that they will deepen our sense of the centrality of Pater's place in the history of literature during the last hundred years.

Fundamental to this reading of Pater's book is the conviction that *The Renaissance* is a work of exceptional playfulness—a playfulness more often than not overlooked by Pater's readers, who tend to stress the apparent gravity, if not morbidity, of his style. Nevertheless, *The Renaissance* is a playfully elaborate construction of paradoxes. If its subject appears to be the historical epoch called the Renaissance, it is not primarily about the Renaissance. If it seems that Pater's book is largely about himself, we never find him in it. Surveying Western thought from antiquity through the nineteenth century, Pater suggests that the very history he records seems to be vanishing away. Although Pater philosophically posits the existence of a self, he questions its existence, analyzes its dissolution. He speaks of facts; however, these data do not exist as such. All together—or not at all—Pater contemplates the totality of consciousness, all modes of thought, at the same time tracing its disappearance into nothingness. Pater is in a perpetual state of dubitation, but his skepticism is balanced by an antithetical hopefulness, a conviction of the puissance of art.

Just as Pater's matter is, paradoxically, the absolute totality of thought and nothingness, so is its form paradoxical. Pater writes in prose, but it is a prose so poetical that it seems to become poetry. But it is not really poetry. Or isn't it? *The Renaissance* is a series of essays, but these essays become cantos in a poem, the term "canto" being suggestive of Pater's creation of *poésie chantée,* of pure song.

Pater's artifice is forever playful. He is constantly ironical, continuously masquerading as his subjects. When asked if his family was related to that of the painter Jean-Baptiste Pater, he replied: "I think so, I believe so, I always say so." The very tone and structure of this utterance—of which the point is that his speech exceeds his grasp—are a perfect emblem of Pater, who both believes and disbelieves what he argues.

Pater's book has been a sort of touchstone against which I have often measured and defined other works, and it has served to define my own "sensations and ideas." It has especially taught me to see a variety of relations between books—seemingly disparate yet strangely united—to which I find myself drawn. It has, for example, special affinities with the detective story. Like Pater's Mona Lisa, *The Renaissance* is itself something of a "mystery." In it we pursue the impersonal Pater, who never lifts the veil that conceals him, and we thus barely detect the threads of identity, the skein of clues to his personality, woven so mysteriously through it. We find Pater's aesthetic principles assimilated by Sherlock Holmes, becoming part of the currency of

modern detective fiction. Pater's Mona Lisa is even reborn in the pages of a hard-boiled detective story by Raymond Chandler, despite or perhaps because of Chandler's aversion to the Paterian style.

But the relation of Pater to this kind of fiction plumbs yet deeper depths. Pater's notion of fathoming artistic personality is intrinsic to connoisseurship, one of the fundamental tools of formalist art history and criticism, from Bernard Berenson to Sydney Freedberg. The detective is a connoisseur, the connoisseur a detective. Already in the 1890s, the period of Holmes and the young Berenson, this relation was understood, for connoisseurship was called the "detective school" of criticism. The elitist connoisseur and popular detective are first cousins, descended both from Pater. A clue to their affinities is still found in the strong aesthetic element of detective stories, often set in magnificent townhouses and country estates filled with priceless antiques and works of art. Most readers of these stories, who have never heard of Pater, feel the suffusive force of his aestheticism, however subtly or indirectly.

Sometimes the detective and connoisseur are one—for example, S. S. Van Dine's once very popular Philo Vance, who both collected masterpieces and solved the most difficult crimes. As a literary character, Vance stands in the line of Pater and Berenson, very much as a caricature of this tradition, influenced by the outrageous wit of Pater's protégé, Oscar Wilde. Philo Vance is not only familiar with the methods of Holmes and Berenson, but he also exploits the principles of Freud, who was so fashionable among the "smart set" during the 1920s and 1930s. Freud brings us back to Pater, since the great Viennese psychoanalyst's insights into Leonardo's psychology can be traced back to Pater's earlier evocations of the artist's personality. Like the connoisseur and the detective, the analyst focuses on personality, and Pater is as relevant to Freud as he is to Holmes and Berenson.

More broadly, Pater's *Renaissance* belongs to the tradition of romance. Merging diaphanously with his subjects—with Pico, Botticelli, Leonardo, and Michelangelo—Pater disappears into his prose, thus becoming a sort of "invisible man." We detect only traces of him as he journeys in historical make-believe through the kingdom of imagination. *The Renaissance*, which begins with medieval romance and is colored throughout by elements of Renaissance romance, is itself a sustained romance, its subjects becoming the heroes of the book's adventures. They are not traditional but aesthetic heroes whose adventures take place in the fairy realm of art and mind, aesthetic or philosophical knights-errant who journey forth in quest of beauty and the perfection of form, battling to the death the dragon of time. Becoming his subjects, or seemingly so, Pater is a sort of Time Traveler *avant la lettre*, who travels in counter-Wellsian fashion through all of history. A stranger in the modern world of flux, he is no less an exile in the exotic wonderland of the

past. It is well known that Pater is the father of Stephen Dedalus, a relative of Proust's Marcel. Not so well known is the fact that he is also the father of H. G. Wells and a not-distant ancestor of Vladimir Nabokov.

The fictions of Nabokov illuminate and illustrate Pater's elusive personality and art. Although Pater never figures in Nabokov's writing, he is there by implication, since the childhood heroes of Nabokov, who appear over and over again in his fiction, descend from the Victorian tapestry into which Pater's art is threaded. Nabokov is forever playing peekaboo with his readers, transparently disguising himself as his characters, while we, his detective-readers or aesthetic critics, follow him (the *Durchlaucht* of twentieth-century literature) into the abyss and trap of his imagination. Pater does not quite so self-consciously play this game when he dresses up as Abelard, masquerades as Giorgione, or disguises himself as Winckelmann, but seeing his imagination through Nabokov's sharpens our sense of his own playfully crystalline impersonality. To paraphrase Pater, Nabokov is one of Pater's "true sons," and he helps us to understand Pater, as Pater "in turn interprets and justifies" Nabokov. Through Nabokov we come closer to appreciating fully the droll wit of Pater, embodied in the smile of his beloved Lady Lisa. The bridge between Pater and Nabokov, as we will see, is found in such romances as Wells's *The Invisible Man,* whose unseen subject is an analogue of the aesthetic hero as exile, and Virginia Woolf's *Orlando,* which makes parody of Pater's work. The aestheticism of Pater can be related as well to the romances of Robert Louis Stevenson and the adventure stories of the Scarlet Pimpernel, both important to Nabokov.

The taste of the arch-aesthete Nabokov for the aestheticized popular romances of Pater's day draws our attention to the fact that aestheticism has become widely assimilated in the popular imagination. Consider the work of H. Rider Haggard, whose exotic *She* (1887), admired by Kipling and leaving its mark on Wells, has endured, transmogrified into the more vulgar forms of "Flash Gordon" and "Indiana Jones." When the narrator of *She* says that "the man does not live whose pen could convey a sense of what he saw," he suggests that his description of the romance's *femme fatale* is a sort of *summa,* surpassing all such descriptions in Gautier, Flaubert, Baudelaire, Rossetti, Swinburne, and Pater. Pater's Mona Lisa, who epitomizes this tradition, is especially in Haggard's mind. Like the Mona Lisa, she rises by the rocks from a grave, is as "old as the ages," and is associated with the paganism and spirituality of Helen and the Virgin, respectively. She is a figure of "grief and passion," who is both "ancient" and "modern." In the very language of Pater, Haggard speaks of the "web of her fascination"; she is the embodiment of the "weary ages." She is as saturated with Pater's Mona Lisa as is Wilde's "Sphinx," and like Wilde's subject (or, for that matter, the *femme fatale* later glitteringly reborn in Hollywood), she is virtually a caricature or parody of the ideal embodied in Pater's

alluring icon. Those who still read Haggard, and also Stevenson, Conan Doyle, the Baroness Orczy, Wells, Van Dine, Woolf, Nabokov, and Raymond Chandler, often remain impressively oblivious of the ways in which these authors echo, sometimes not so faintly, the themes, methods, sonorities, indeed the very playfulness, of Pater.

The threads of Pater's prose woven into the fabric of twentieth-century fiction are seemingly infinite. In his short story "The Gioconda's Smile" (*Mortal Coils,* 1920), Aldous Huxley not only endows a principal character with the Mona Lisa's smile, but he makes a mockery of Pater's virtually canonical description of her. He surrounds his modern Gioconda, living in London, with "coloured prints of Italian masterpieces," which reflect a rather pretentious and shabby taste. He thus mocks refined Paterian aestheticism, just as elsewhere he ridiculed Paterian formalism, reflected in Roger Fry's doctrine of significant form. Pater's Mona Lisa, we recall, is of "a beauty wrought out from within upon the flesh, the deposit, little cell by cell, of strange thoughts and fantastic reveries and exquisite passions." In mocking response and with an antithetical staccato burst, Huxley exclaims, "What a queer face she had! That small mouth pursed forward by the Gioconda expression into a little snout with a round hole in the middle as for whistling—it was like a penholder seen from the front." Not quite so precious as Pater's beloved, Huxley's beauty is nevertheless like her, a woman of "passions," who commits, in an utter farce, one of the "sins of the Borgias." Whereas Pater's Mona Lisa is a figure of deep fascination, Huxley's version is, despite her crime, actually rather dull!

If Pater's relations to fiction are extensive, so too are his associations with poetry. Although many of these poetic connections have been glossed, we have yet to see the way in which the overall structure of Pater's book is poetical. The form of *The Renaissance,* I will suggest, depends on the poetry of Baudelaire, whose influences on Pater have otherwise been detected or surmised only in particular lines or phrases. We have only begun to see in turn how emphatically Pater contributed to modern poetry, and to the examples already cited by other scholars I will add cases of Pater's influences on the poetry of Joyce, Eliot, Yeats, Stevens, and, more recently, John Ashbery. The most dramatic example is found in Yeats's "Leda," written in a decidedly Paterian idiom. Pater's Mona Lisa, who stands behind so much modern fiction, is an important forebear of Yeats's Leda. Yeats made her, Pater begot her.

Historians and art historians have been more recalcitrant than literary scholars. Whereas the latter now acknowledge Pater's considerable influence on modern literature, the former ignore or dismiss him. When Wallace Ferguson reviewed five centuries of interpretation in *The Renaissance in Historical Thought* nearly thirty years ago, he typically mentioned Pater's book in pass-

ing, saying only that *The Renaissance* "has achieved the permanent status of a minor classic and served to introduce generations of readers to the culture of the age." If it was an "introduction" for Pater's Victorian and Edwardian readers, who brought in various degrees a general culture to their reading of *The Renaissance,* it is no longer so, since nonspecialist readers today generally lack sufficient knowledge of the Hellenic and Hebraic cultures that Pater so suggestively illuminates in their Renaissance synthesis. Now Pater's readers are largely specialists. But they are inclined to see historical interpretation as divorced from art, from a poetical mode of discourse. Since *The Renaissance* is so cunningly artful, it is thought or assumed that the book is unhistorical. Not even the recent interest in what is called "metahistory" has resulted in a serious consideration of Pater's historical or art-historical insights. Meta-historians appreciate the poetic or fictive devices of such Renaissance historians as Michelet and Burckhardt, whereas Pater's contribution to our understanding of Renaissance culture and his imaginative and poetical manner of historical exposition both remain unexamined.

Indications of a recent change in orientation, however, are to be found in Jules Lubbock's essay, "Walter Pater's *Marius the Epicurean*—The Imaginary Portrait as Cultural History," which appeared in 1983 in *The Journal of the Warburg and Courtauld Institutes.* In an exceptional way, the author suggests that Pater's fictive manner enriches his history of ancient Rome, of early Christianity, that the "imaginary portrait" is indeed a valid form of cultural history in a tradition that extends from Hegel to Warburg. Such a view is not shared by most historians or art historians, who are professionally wary.

Art historians, despite current intellectual fashions, still adhere on the whole to the positivist principle of verifiability. Not surprisingly, they therefore dismiss or ignore Pater, who never presents his evidence directly. They are also highly mistrustful of his poetical style of writing. Such lyrical prose cannot be truthful. The "critic" who becomes an "artist," to paraphrase Pater's follower Oscar Wilde, cannot be speaking truthfully, or so it is thought. When art historians write about the history of art history, they trace this history in relation to philosophy, from Plato and Aristotle to Kant and Hegel. They have little or nothing to say about the role of poetry and fiction in the interpretation of art, for they are persuaded that poetical criticism distorts the meaning of art. When we consider that Pater dwells on the appreciation of art, on the critic's impression of artistic form, and on the pleasure he derives from this form, it is easy to see why he is subject to stricture for his "aestheticism," "appreciationism," "hedonism," "formalism," and "impressionism." Among art historians today these are usually terms of opprobrium, too easily applied to writing about art that does not conform to the current conventions of professional art history.

Moreover, Pater is held responsible for the worst sins of modern art history

and criticism because he so powerfully influenced the now fashionably dis-
paraged tradition of formalism and connoisseurship. Formalists or aesthetic
critics do indeed emphasize both the form of a work of art and one's manner
of perceiving it, but close attention to their work also reveals that within their
descriptions of form reside observations on the iconography, ideology, and
context of art. It might even be supposed that many art historians who
dismiss the formalist tradition in which Pater figures so prominently have not
learned how to read this writing, which is often highly imaginative, indeed
poetical, in character.

In the second part of this book, I make a larger claim: that the entire
history of art needs to be reassessed from the vantage point of imaginative
literature. I discuss the insights and poetical manner of writing in this tradi-
tion from Vasari to the present, focusing on the tradition of Pater—on
Gautier, Rossetti, Hazlitt, and the Goncourts before Pater; on Vernon Lee,
Berenson, Michael Field, Sturge Moore, Laurence Binyon, Richard Offner,
Adrian Stokes, Sydney Freedberg, and Kenneth Clark afterward. Vasari, for
example, who was so important to Pater, is read by art historians today as if
he were a failed positivist. Pater encourages us to see, however, the poetical
and allegorical character of his writings, to recognize the truths contained
within his fictions, which are never mere anecdotes. When we begin to see art
history not merely in relation to history and philosophy but in relation to
poetry and fiction, we begin to recognize that our understanding of Renais-
sance art is not purely a historical phenomenon, for poetry helps shape our
historical vision. Just as Dante contributed to Vasari's history, so did Keats
and Wordsworth help mold Pater's history of art. Our understanding of
Venetian art depends on these poets, whose sense of myth and diction were
assimilated by Pater. It does not follow that because Pater's perception of the
school of Giorgione was determined in part by nineteenth-century poetry
that what he has to say about these painters is untrue to their work and is
merely a curiosity in the history of taste. Indeed, although not acknowledged
as often as it might be, modern iconographical readings of the pastoralism of
Venetian painting have more than a little to do with Pater's poetical, but
nonetheless historically valid, interpretations of this art.

If for no other reason, Pater would still be remembered today as the
trouvère responsible for the critical and historical rebirth of Botticelli. Unfor-
tunate for his reputation is the fact that many who followed him in the late
nineteenth century were so effusive in their responses to the painter that his
influence on the Botticelli scholarship has been perceived as a curse, as a kind
of aesthetic poison—as if he were his own Borgia-like Mona Lisa. In 1908
the poet, critic, and art historian Herbert Horne published his great mono-
graph on Botticelli, which was dedicated to Pater. Its status as a classic is
thought to result from a scholarly rigor and precision that stand apart from

Pater's impressionism. Less is said, however, about the way in which Pater stimulated Horne and such Paterian scholars of the early twentieth century as Laurence Binyon and Yukio Yashiro, whose books on Botticelli, though no longer read, are filled with fine observations and insight into the painter's work.

The formalist, impressionist, aesthetic, and poetical approaches to Botticelli are still shunned by art historians, while the supposedly more rigorous iconographical investigation of his work, especially of his mythologies, now dominates the field. What is not sufficiently recognized, however, is the fact that just as Pater stands behind the iconographical interpretations linking Giorgione's painting to poetry, so does he provide a foundation for the investigation of Botticelli's poetical iconography. Even more to the point, Pater provided scholars, as we shall see, with a key to decoding an important aspect of meaning in the *Primavera* when he linked Botticelli with Dante. Pater only alludes to this great painting, but he offers us clues toward the unveiling of its symbolic intention. Pondering its iconography, we might observe that just as the formalist critic is a detective, so too is the iconographer. Not surprisingly, the great proponent of iconography, Erwin Panofsky, who unknowingly followed Pater when he explicated Botticelli's poetical sources, invoked on occasion the famous methods of the great detective. The procedures of the iconographer, like those of the formalist, who employs a different but interrelated sign-system, have roots in the methods defined by the great Victorian detective and fictional protégé of the invisible Pater.

Because art historians are now questioning many of their methods and assumptions, this seems to be an especially good moment to be writing about Pater's contribution to the field. As I followed Kenneth Clark's example, writing essays in the early 1980s on Pater's role in the history of art, I saw that other art historians were beginning to cite or acknowledge Pater anew. The scholar of Venetian art David Rosand discussed the Giorgionesque *Fête Champêtre* in relation to Pater's essay on the school of Giorgione (*Portfolio*, September/October 1981), and he referred, if still equivocally, to Pater's writing on Venetian color in his book *Painting in Cinquecento Venice* (1982). In his compendious volume, *Michelangelo and the Language of Art* (1981), David Summers noted and employed one of Pater's insights into Michelangelo. Similarly, Sydney Freedberg invoked and explored Pater's iconographical aperçu, adapted from Gautier, of a link between the iconography of St. John and Bacchus in paintings by Leonardo (*Burlington Magazine*, May 1982); and, more recently, Webster Smith (*The Art Bulletin*, June 1985) pointed out one of Pater's contributions to our understanding of Leonardo's *Mona Lisa*. These acknowledgments of Pater must be seen, however, as part of a larger view of Pater's contribution to art history and crit-

icism, just as they must be viewed in relation to the history of imaginative literature, which helped shape this history and criticism.

Pater's writing is a reminder of the fact that when historians describe the past, they not only talk about historical works, events, circumstances, and personalities, but they imitate the forms of the very age that they record. Pater not only writes about the life and art of Du Bellay, for example, but he writes in a poetical style imitative of his subject. Discussing the theology of Pico, Pater assimilates some of the conventions of theological rhetoric to his description of Pico. Doing so, Pater conveys a living or vital sense of his subject. No less did Burckhardt imitate aspects of Renaissance culture in his history of the period. His book, for example, is organized according to hundreds of topics, and we sense that one of the principles at work here is that of Renaissance topics or *topoi,* so fundamental to the pedagogical theory of the humanists, who were Burckhardt's subject. In more recent cultural and art history, this principle of imitation still obtains; it is alive in the wise and carefully crafted prose of Gombrich and Panofsky, whose rhetoric, like that of Pater and Burckhardt, harks back to the tradition of classical rhetoric, important to the Renaissance culture that these writers both describe and celebrate. Their finest writing not only describes the world of Botticelli, Raphael, and Michelangelo but evokes the sophistication and urbanity of Poliziano, Erasmus, and Montaigne. Despite Panofsky's mistrust of poetry and Gombrich's discomfort with the relation of criticism to history, these writers are much closer to Pater intellectually than we or they had supposed.

As poet, critic, and historian, Pater reminds us that the history of interpretation and the history of imaginative literature are interwoven. The iconography of Panofsky, the formalism of Freedberg, the involutions of Ashbery, the aestheticism of Nabokov, all have roots in Pater. Nabokov's appreciation of Parmigianino's *voluptas* in *Ada,* for example, has affinities with Ashbery's poem on the painter, which, in turn, was influenced by Pater and the Paterian writing of Freedberg, just as Pater's own writing on Mannerism is associated with the writing of Gautier and Swinburne. As we will see, the aestheticism of modern poetry and fiction have contributed to the modern historical definition of Mannerism. This is but a single example of the way his imaginative literature contributes to the formulation of a historical definition of an epoch. Pater's role in the historical reappraisal of Mannerism confirms our sense that history and art history are not written as pure history but are part of the total fabric of literature, its taste and sensibility. Nabokov and Freedberg, Freedberg and Ashbery, Ashbery and Pater, Pater and Warburg, Warburg and Rossetti, Rossetti and Keats, Keats and Yeats, Yeats and Blake—poets and critics, critics and historians, historians and poets, together, all sharpen and illuminate our sense of a period as a cultural entity. Pater teaches

us that all his forebears and followers have contributed both directly and indirectly to our sense of the Renaissance. The history of the concept of the Renaissance and of various aspects of its culture is far deeper and more subtle than we have supposed, and Pater's range as a writer helps us to see that this is so.

Pater's *Renaissance* is a book about a particular period called the Renaissance, but it is also a book about the very phenomenon of cultural rebirth through the ages, from Christian rebirth to Modernism. Published shortly after Burckhardt's *Civilization of the Renaissance in Italy*, it is thus close in date to the writings of Baudelaire. Pater both refines the Burckhardtian definition of the Renaissance as the origin of the modern world and at the same time ponders the art of his own day, its own possibility for cultural renewal, in terms of Baudelaire's definition of modernity. Like Baudelaire, and like Vasari and Dante earlier, Pater thinks of cultural renewal in the language of the Bible, and like Pater and his antecedents, a recent writer on abstract art has spoken of avant-garde movements as seeking "to transform the world—to create a New Jerusalem." Thinking of Burckhardt and Baudelaire together, we ponder the emergence of the definition of the Renaissance as the way in which Modernism defined its very origins. Pater played an important role in this formulation, linking the historical definition of the period to the idea of cultural rebirth in the modern epoch. When Clive Bell contemplated writing a book in 1906 on a new cultural age, to be called *The New Renaissance*, he considered using a Paterian title that both carried within it Pater's sense of a historical period and Pater's prophecy of a new art that was to be assimilated by Yeats, Joyce, and Eliot. Walter Pater's *Renaissance* is alive in the modern imagination as an ideal of cultural rebirth, absorbed into twentieth-century definitions of modern culture, just as it is reanimated in the pages of historians and art historians, who, like Pater, do more than describe the past, who participate in its vitality and carry forward to a new age a belief in cultural continuity and renewal: "C'est un cri repété par mille sentinelles / Un ordre renvoyé par mille porte-voix."

Part I:
The Renaissance:
Its Life and Afterlife

1 *Correspondances* of Art

Like long-held echoes, blending somewhere else
into one deep and shadowy unison
as limitless as darkness and as day,
the sounds, the scents, the colors correspond.
—Charles Baudelaire, "Correspondances"

A flood of publications on the elusive Victorian scholar-aesthete Walter Pater has appeared during the last two decades. As work progresses on a critical edition of his writings, the scholarship on him continues to flow from the presses, threatening to submerge his achievement in its vastness as it seeks to sustain his art. Books, articles, anthologies, dissertations, symposia, and recently the May 1981 issue of *Prose Studies*—where the interested reader will find a detailed summary of recent bibliography on Pater—have scrutinized seemingly every facet of the man, from his place in the history of literature to the significance of his moustache.[1] This is not to say that even Pater's best-known works are now conveniently available to a broad audience in paperback editions sold in drugstores and airports. The Pater boom is wholly an academic phenomenon.

Few writers as distinguished as Pater have lived lives as diaphanous as his. Between birth in London in 1839 and death fifty-five years later he lived in quiet reverie among books and works of art, seeking to divine the magical powers of beauty, journeying invisibly among sensations and ideas in quest of their ineffable essences. The center of this private existence was Oxford, where the scholar-gypsy of the academic cloisters, a seemingly disembodied consciousness, dwelt for more than twenty years as student, fellow, and tutor, gravely and fastidiously measuring the exquisite nuances of aesthetic experience in prose of incomparable refinement. He occasionally traveled without incident in Germany, France, and Italy, imperceptibly absorbing impressions under a dreamlike veil. One of the singular, rare facts of Pater's physical existence, if one can even speak of it as such, was the decision to print the first edition of *The Renaissance* on ribbed paper, thereby giving to his thoughts a

certain faintly tangible reality. As one of Pater's finest critics has observed, "he seems almost to have succeeded in passing through his times with hardly a trace." Not a flesh-and-blood historical personage, he appears in retrospect smaller than life, like some fiction from the labyrinth of Jorge Luis Borges's imagination. Pater chose to live "his true life," it is said, in his art, and not surprisingly, a recent biographer has had to acknowledge that "the real reasons for re-examining" Pater lie in his writings. It is hard to say whether on the day that Walter Pater began to write he came to life or disappeared.

Revisionist scholars always tend to exaggerate the weaknesses of their forebears. And, to hear recent Paterians speak, one might think a true understanding of Pater dated from the mid-1960s, even though an extensive body of writings throughout this century, including essays by Arthur Symons, Logan Pearsall Smith, and Maurice Bowra, has offered valuable perceptions concerning the character of his work.[2] The most fashionable aspect of Pater's writings at present is the role they are understood to have played in the emergence of Modernist literature and, some would say, of post-Modernism. Literary historians are now investigating his influences on Woolf, Conrad, Joyce, and Proust; on Yeats, Pound, Eliot, and Stevens; and they are beginning to surmise his relevance to the reading of Beckett, Borges, and Nabokov.[3] Yet these are fields of investigation still only partially explored. More attention might especially be paid to the ways in which Pater influenced T. S. Eliot. Although Eliot's attacks on Pater are supposed to mark the beginnings of the decline of Pater's critical fortunes, Eliot wrote in many respects as his perpetuator. Eliot's critical stance in "Tradition and the Individual Talent," for example, which stresses the impersonal "significant emotion" in literary art, depends on Pater's preoccupation with "impersonal" style, or "*form* in all its characteristics."[4]

Of all Pater's works *The Renaissance* is probably his greatest single achievement. Fascinating as they are, his more apparently imaginative efforts, *Marius the Epicurean* and *Imaginary Portraits,* so deficient in dramatic interest, are flawed as fiction. And his other essays—gathered in *Appreciations, Miscellaneous Studies,* and *Greek Studies*—are not so subtly harmonized and orchestrated, individually or integrally, as those in *The Renaissance,* which remains the heart of Pater's literary career. The chapter on Winckelmann, one of Pater's first essays to appear in print, was first published in 1867; the essay on Giorgione was not added to the book until 1888; and, continuing to hone its prose, Pater made revisions in subsequent printings, down through the 1893 edition, published the year before his death. In recent years *The Renaissance* has received considerable philological attention. Not only do we now have an excellent critical edition of it, with extensive notes by Donald L. Hill, but Billie Andrew Inman's valuable commentary on Pater's reading during the period of its composition has also recently appeared. These scholarly works

augment our knowledge of Pater's numerous sources, but, modestly refraining from consideration of larger questions of interpretation, they are written, to use Nietzsche's words, *in usum Delphinorum*. Yet, we might ask, what kind of a book is *The Renaissance*? What are its distinctive characteristics?

Reviewing the first edition, published in 1873 as *Studies in the History of the Renaissance*, Mrs. Mark Pattison objected that the "historical element" was lacking, prompting Pater to change the title in the subsequent edition to *The Renaissance: Studies in Art and Poetry*. Historians of art and literature alike have since continued to comment on Pater's unhistorical approach to his subject. This claim has been much repeated during the recent period of Pater's "rehabilitation." Yet it goes unnoticed even by his admirers that Pater's suggestions were the first general indications of the extensive role of Neoplatonism in Renaissance theology, philosophy, poetry, painting, sculpture, and architecture. Of Michelangelo's poetry he observes that the great artist "is always pressing forward from the outward beauty . . . to apprehend the unseen beauty . . . that abstract form of beauty, about which the Platonists reason." And, contemplating the Medici Chapel, he sees Michelangelo here as a "disciple" of the Platonists. These remarks on Michelangelo's poetry, sculpture, and architecture are closely related to Pater's appreciation of Pico della Mirandola's "love of unseen beauty." Appropriately comparing Pico himself to an archangel Raphael or Mercury by Piero di Cosimo or Botticelli, Pater seemingly alludes in part to the Mercury in Botticelli's *Primavera*. This *divinus amator* gazes beyond the clouds, toward an "unseen beauty," like that beloved of Pico and Michelangelo.

If we take a broad view of Pater's book, we see that its sustained evocations of Platonism are, as though a form of verbal cartography, a historical outline of the place that Neoplatonism occupied in Renaissance culture. In this respect *The Renaissance* prefigured and influenced the more detailed historical account in Nesca Robb's *Neoplatonism in the Italian Renaissance* (1935), a work which in turn stimulated the most distinguished art-historical scholars of Renaissance Neoplatonism, Erwin Panofsky, Edgar Wind, and E. H. Gombrich, all of whom followed, if distantly, in the wake of Pater, and much of whose work depends on his implicit historical formulation.[5]

Pater's historical intuitions, seminal though they are, lie almost concealed by the poetical form of his prose. It is thus not surprising that, reading *The Renaissance* primarily as art rather than as history, scholars have overlooked these aperçus. To identify Pater's "errors" of fact or "misrepresentations" is to ignore his fundamental definition in his essay "Style" (in *Appreciations*) of the "sense of fact." The historian, according to Pater, becomes the author of *fine* art, as he comes to transcribe not mere fact but his sense of it. Given his "absolutely truthful intention," the historian "amid the multitude of facts presented to him must needs select, and in selecting, assert something of his

own humour, something that comes not of the world without but of a vision within." A distinguished art historian has recently argued that "the historian is not a critic and should not aspire to be one." Pater would not object to this scholar's quest for historical truth. But he would ask: Even if it is possible to separate "intention" and "significance" in theory, is it possible in practice for the historian to understand this truth apart from his own critical sense of its significance?

The soundness and longevity of Pater's critical evaluations of Renaissance art should not be forgotten. In an admirable monograph on Luca della Robbia, John Pope-Hennessy speaks of the aesthetic affinities between the sculptor's work and Greek art, referring to the recent observations on this topic by Italian scholars. But it was Pater who first observed so forcefully that "Luca della Robbia and the other Tuscan sculptors of the fifteenth century" partook "of the *Allgemeinheit* of the Greeks, their way of extracting certain select elements only of pure form and sacrificing all the rest."

Elaborating on this point, Pater observes that the Greek sculptor Phidias and his followers sought "to purge from the individual all that belongs only to him," and "in this way their works came to be like some subtle extract or essence, or almost like pure thoughts or ideas." It is evident that Pater, whose thought is steeped in Platonism, draws an analogy between the idealism of Greek sculpture and Platonic idealism, connecting the "pure form" of this sculpture to the "pure ideas" of contemporary philosophy. More than this, he hints that the Platonic philosophy provides a theoretical framework for the discussion of Greek art. As he later said in *Plato and Platonism,* Plato is the "earliest critic of the fine arts," by which he might have meant as well that he was the earliest theorist who illuminated the "tendency of Platonism in art." Scholars have written voluminously about Plato and Greek art, emphasizing a belief that Plato banished all poetry from his ideal republic. They have insufficiently recognized what Pater pointed to—that the Platonic epistemology provides us with a historically apt and valid way of looking at the idealizing tendency of Greek art, which approaches the Platonic perfection of pure form.[6]

In every essay Pater offers useful insights that have either been adopted by others or that might provide the basis for further discussion. For example, in the essay on Pico della Mirandola, he compares "the efforts of artists trained in Christian schools to handle pagan subjects," adding that Pico's were "but the feebler counterpart." It is hard not to suppose, given his particular interest in Raphael, that Pater has in mind the aesthetic and intellectual reconciliation of sacred and profane themes in the artist's frescoes of the Stanza della Segnatura. Raphael's decorations have been amply discussed in relation to Renaissance literature, but the analogy of their syncretism and poetic theology to that in Pico, to which Pater points, has surprisingly not been the focus

of much discussion—although in *Pagan Mysteries* Edgar Wind discussed Renaissance art generally in terms of Pico's thought. Whereas countless attempts have been made to read various meanings—mythical, biblical, moral, and historical—into such works as Giorgione's *Tempesta,* recent scholars of art, despite the current aversion to "formalism," still adhere to Pater's sense of the "perfect interpenetration" in such pictures "of the subject with the elements of colour and design." They also still explore Pater's sense of the pastoral poetry in Giorgionesque art, treating these paintings as "pictorial poetry," as "'painted idylls.'" Indeed, if unwittingly in the spirit of Pater, one recent scholar presented an elaborate iconographical interpretation of the *Fête Champêtre* as an allegory of poetry, and her implicitly Paterian analysis has been widely followed by other scholars.[7]

Pater probes the very poetics and theory of Renaissance painting. Having described the Sistine Chapel ceiling frescoes, and in particular the role of the "Creator" in *The Creation of Adam,* he concludes that "the creation of life . . . is in various ways the motive of all his work." Returning to Vasari's Neoplatonically inspired connection between Michelangelo and the "Creator" in *The Creation of Adam,* Pater in a similarly Neoplatonic way associates the poetry of Michelangelo's art, its emphasis on creation, with divine creation. He adds here, speaking of *The Last Judgment,* also in the Sistine Chapel, "Not the Judgment but the Resurrection is the real subject of his last work." He thus foretells recent scholarship that emphasizes the theme of resurrection or spiritual re-creation in Michelangelo's fresco, although characteristically Pater is not mentioned in this scholarship.[8] By emphasizing the creative aspect of Michelangelo's painting, the poetry and creative theme of Botticelli's mythologies, especially *The Birth of Venus,* and the contemporary "poetical painting" of Giorgione, Pater points to the fact that there is a new self-consciousness on the part of artists at the end of the fifteenth and in the beginning of the sixteenth century, who increasingly focus upon or allude to their own poetic or creative powers in paintings about poetry and creation.

Pater encourages art historians to probe more deeply into the matter. Suggesting that Botticelli is a "secondary painter" in relation to Michelangelo, who is one of the "few great painters," he speaks of the way in which Botticelli is "absorbed" into Michelangelo's work. This relation is rarely, if ever, mentioned in scholarship, since Michelangelo's manner is so exalted and grandiloquent in character that it stands apart from Botticelli's. But, pursuing Pater's suggestion, we observe that Botticelli's animated rhythms in general and draftsmanship in particular were of special interest to Michelangelo. It is hard not to see, in light of Pater's insights, a specific connection between Botticelli's *Birth of Venus* (Fig. 1) and Michelangelo's *Creation of Adam* (Fig. 2), especially the relation of Michelangelo's boldly animated God the Father to Botticelli's similarly soaring and fluent Zephyr, who is analogously cre-

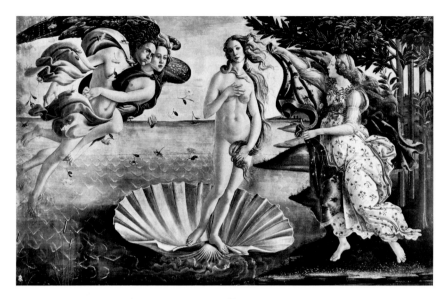

Fig. 1. BOTTICELLI, *The Birth of Venus*. Uffizi, Florence.

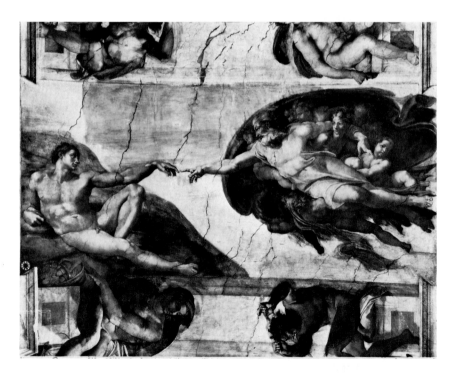

Fig. 2. MICHELANGELO, *The Creation of Adam*. Sistine Chapel, Vatican.

ative. Both images call attention to the creative powers of art itself in the illustration of creation. And if Michelangelo was inspired by Neoplatonism to meditate on the relation of artistic creation to divine creation, as Pater hints, he also, absorbing Botticelli's art, learned how to visualize such ideas from his quattrocento forebear. Pater's sequence of essays on Pico, Botticelli, Della Robbia (which has to do with Michelangelo and Platonism), and Michelangelo is suggestively organized to catalyze our thinking about the interconnections between art and poetry and divine creation. Leonardo had already epitomized Pater's theme when he spoke of painting as a *seconda creazione*.

Pater's writing on Leonardo is similarly suggestive. He isolated "the motion of water" as one of the central themes of Leonardo's work long before the professional art historians E. H. Gombrich and Martin Kemp looked into the matter.[9] His association of "the smiling of women" in Leonardo's art with "childhood" and "dreams" kindled the imagination of Freud, and his discussion of the way in which Leonardo "plunged into human personality" further inspired Freud, as well as Freudian art historians who have written since about the psychological character and implications of Leonardo's art. Pater's interpretations of Leonardo can be remarkably pregnant, even when very brief. Referring to the "animated angel of Leonardo's hand" in Verrocchio's *Baptism,* Pater speaks not only poetically and critically of the angel's outer motion or energy, but he also evokes with his adjective, in its Latin implication, the distinctive breath or inner vitality of the figure. Penetrating the psychological aspect of Leonardo's art, he characterizes the "treacherous smile" of Leonardo's *St. John the Baptist* (Fig. 3), which "would have us understand something far beyond the outward gesture." Pater is not merely recalling Gautier's fascination with Leonardo's strangeness; he is calling attention to the ambiguity and, ultimately, the irony of the painter's vision. Although the pointing figure of the saint seems to draw the beholder's attention heavenward, "his delicate brown flesh and woman's hair" are such that "no one would go out into the wilderness to seek" him. On this discomforting aspect of the image—which is not just Pater's impression, reflecting his own erotic impulses—modern scholars remain reticent. Finally, we should note that Pater relates Leonardo to Dante, just as he associates Botticelli, Michelangelo, and Raphael with the poet. Like Vasari before him and like André Chastel among scholars afterward, he recognizes the fundamental importance of Dante to the visual imagination of Renaissance artists.[10] The subject has often been discussed since Pater, but it has by no means been exhausted.

Although the critical and historical insights and implications of Pater's book are often ignored, Pater is esteemed as a prose poet. And the most famous example of his poetry is the often-quoted description of the *Mona*

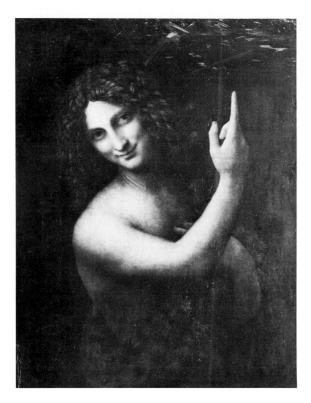

FIG. 3. LEONARDO DA VINCI, *St. John the Baptist*. Louvre, Paris.

Lisa, rendered in the very shape of poetry by Yeats in *The Oxford Book of Modern Verse*. Possibly the single most familiar passage of nineteenth-century prose, it has lost none of its sensuous enchantment for those today who find pleasure in a prose that conveys "the sound of lyres and flutes." For Pater, that "presence that rose thus so strangely beside the waters" is expressive of Greece, Rome, the Middle Ages, the Renaissance, and modernity—of "all modes of thought and life." But there is another related passage which, although usually overlooked, helps us to appreciate more intimately the nature of Pater's book. This is his rendering in the chapter on Winckelmann of another aesthetic experience, this one in Rome (Fig. 4):

> In one of the frescoes of the Vatican, Raphael has commemorated the tradition of the Catholic religion. Against a space of tranquil sky, broken in upon by a beatific vision, are ranged the greatest personages of Christian history, with the Sacrament in the midst. Another fresco of Raphael in the same apartment presents a very different company, Dante alone appearing in both. Surrounded

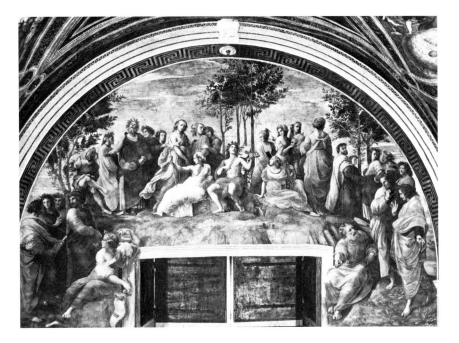

FIG. 4. RAPHAEL, *Parnassus*. Stanza della Segnatura, Vatican.

by the muses of Greek mythology, under a thicket of laurel, sits Apollo, with the sources of Castalia at his feet. On either side are grouped those on whom the spirit of Apollo descended, the classical and Renaissance poets, to whom the waters of Castalia come down, a river making glad this other "city of God." In this fresco it is the classical tradition, the orthodoxy of taste, that Raphael commemorates. Winckelmann's intellectual history authenticates the claims of this tradition in human culture.

Raphael's frescoes in the Stanza della Segnatura, which also include the *School of Athens* and *Civil and Canon Law,* have been appropriately called "one ideal temple of the human mind." They express the "harmony" and "correspondences" between pagan and religious truths, Greek and Roman, Hebrew and Christian, like those to which Pico aspired. Indeed the relation between Pico's art and Raphael's, implicit in Pater's text, is yet another example of his vivid sense of historical analogy. Just as Raphael created an ideal harmony among theologians, philosophers, poets, and lawgivers, Pater creates a unified picture of visionary thinkers. Speaking of the "spirit of Apollo," and

implicitly of the "new Apollo," Pater observes that the medieval poet Dante participates in "both" visions as a poet of Christ and, like the other "classical and Renaissance poets," as a poet inspired by Apollo. When he refers to Castalia as the river "making glad this other 'city of God,'" Pater is not only alluding to the "city of God" of Psalm 46 but also, aptly, to Augustine's *City of God*. For, seated with a copy of his *City of God*, Augustine is one of the "great personages" beholding the vision of Christ in Raphael's *Disputa*.

What Pater has done here is to delineate a history of what he elsewhere calls "visionariness"—from Apollo and the Old and New Testaments to Augustine, Dante, and finally to Raphael himself. But the history does not stop at this point. The art of Greece, inspired by Apollo, is one of "pure thoughts or ideas"—a Platonic art. And Pater reveals to us a similar Platonic character in Raphael's painting. Speaking of Raphael in *Miscellaneous Studies*, he observes that in his work "painted ideas, painted and visible philosophy, are for once as beautiful as Plato thought they must be, if one truly apprehended them." We might recall that in Raphael's fresco Apollo is inspired by the music of the spheres, which is painted in the ceiling of the stanza. And appearing in the adjacent *School of Athens* with his *Timaeus*, Plato points toward these heavenly harmonies. In modern historical scholarship the Platonic meaning of these frescoes has been much discussed, especially by Edgar Wind.[11] And we can now see that these discussions, like the Neoplatonic interpretations of Michelangelo, return to Pater. Yet whereas scholars of Neoplatonic iconography usually speak of what art illustrates—that is, its Neoplatonic content—Pater evokes the manner in which Platonism informs Raphael's art.

Pater's visionary history extends further to Winckelmann, the inspired writer on Apollo, whom he compares to both Dante and Plato. If Winckelmann's history—a bridge between the Renaissance and the modern age—"authenticates" this classical tradition commemorated by Raphael, Pater's writings in like manner authenticate this tradition. Amidst the flux of modernity, in which "universal culture" is "perhaps a lost art," *The Renaissance* is itself self-consciously conceived as a renaissance. And Pater himself, like Heine's gods of an earlier epoch, is an Apollonian "exile" in the modern world.

Although the book is ostensibly about the Renaissance, we find that in various ways Pater relates the period to antiquity, the Middle Ages, and the Enlightenment, as well as to the modern or Romantic epoch. Recalling the ancient world, the book begins in twelfth-century France, and the impact of the awakening there is pursued to the quattrocento; the influence of Leonardo (who traveled to France) and that of the Renaissance in general are then traced back to the France of the Pléiade. As part of his general cultural history, Pater discusses, notes, or appropriates ideas and forms from principal figures of European literature. The French tradition is traced beyond the Renaissance to Pascal, Rousseau, Hugo, Stendhal, Gautier, and, finally, to

Baudelaire. Just as the allusions to Chaucer, Shakespeare, Milton, Blake, Wordsworth, and Arnold chart the history of English literature, references to Lessing, Kant, and Hegel, not to mention Winckelmann and Goethe, hint, and more than hint, at the story of the new German literature, which is seen as a rebirth or renaissance of the classical tradition. Aspiring to the ideal of the "unity of culture," Pater seeks to define the harmony between the classical and biblical traditions and their unity in European culture.

The poetical structure of Pater's intellectual history is so overwhelming that its historical value has to be excavated. This structure is also so very intricate that it is almost impossible for the reader to grasp all of the analogies or correspondences as they "cross and re-cross" his book. Endless affinities are established or suggested, as between Botticelli and Dante, Dante and Michelangelo, Michelangelo and Blake, Blake and Shakespeare, Shakespeare and Giorgione, Giorgione and Du Bellay, Du Bellay and Leonardo, Leonardo and Pico, Leonardo and Paracelsus, Leonardo and Bacon, Leonardo and Goethe, Goethe and Winckelmann, and Goethe and Pater himself. The numerous artists and writers referred to by Pater, or who have been shown to have influenced him, are not merely present as sources, but, to use Pater's language, they are artistically "threaded through" the text to establish a coherent pattern of cultural wholeness. To express this *Allgemeinheit* Pater deploys a veritable thesaurus of interrelated words: connection, affinity, analogue, twin, correspondence, repetition, counterpart, equivalent, combination, reconciliation, resemblance, similitude, identity, congruity, *doppelgänger,* double meaning (and reflex), union, unison, wholeness, integrity, centrality, interweaving, interfusing, blending, interpenetration. In their analyses of the continuities of Western culture, the great scholarly books of our own time—Curtius's *European Literature and the Latin Middle Ages,* Seznec's *The Survival of the Pagan Gods,* Bolgar's *The Classical Heritage,* and Panofsky's *Renaissance and Renascences*—all follow the path that Pater struck.

As critics have always observed, Pater's book is also autobiographical, or at least an intellectual autobiography, in which Pater becomes all of his subjects or their creations.[12] Like Luca della Robbia's, Pater's is "a life of labours and frugality, with no adventure." It is a life of the mind resembling that of Pico and the Neoplatonists, who seek "order and beauty in knowledge." With Leonardo, Pater is primarily motivated by the "desire of beauty." As with Giorgione and Du Bellay, he aspires to lyrical purity. But in the modern world Pater is an exile, like Michelangelo, "a ghost out of another age." He shares Winckelmann's "wistful sense of something lost to be regained." His solitary journey as an "alien" is paradoxically that of the knight Tannhäuser or the "knight-errant of philosophy," Pico. He is these pilgrims to Rome, just as he is Abelard, Botticelli, Leonardo, Du Bellay, Winckelmann, and Goethe, all journeying to the Eternal City.

The examples of Pater's identification with the subjects of his book can be multiplied indefinitely, but it gradually becomes clear that he is building a series of biographies not merely into a diaphanous autobiography but into an incipient novel. The historical actors merge into a single protagonist in search of beauty and truth. In his different guises, this character is himself handsome. The angelic Pico is "of feature and shape seemly and beauteous," Leonardo is noted for his "charm of voice and aspect," and Giorgione is of a "presumably gracious presence." Pater's historical personages are protean manifestations of a single fictionalized self who, however uneventfully, lives through history. Pater later developed this fictional form in *Marius the Epicurean*; and, nourished by it, Virginia Woolf parodied it affectionately in *Orlando*.

The Renaissance is conspicuously about philosophy. Himself a Platonist, Pater constantly writes in pursuit of an ideal beauty. In addition to observing the beauty of scholars and artists, Pater denominates their lovely creations— Botticelli's "comely" persons, Leonardo's "bright animated" angel, and, above all, the "beautiful multitude" of the Parthenon, rendered in Platonizing terms. When Pater describes the comeliness of artists and their works, he proceeds like Plato in the *Symposium*; for, like his Greek hero, Pater ascends from specific examples of beauty to the more abstract idea of the beautiful, to "pure form." The counterparts to Pater in the visual arts are Botticelli, whose beauteous Mercury gazes toward the Sun, and Raphael, whose suave Apollo turns his eyes toward the heavenly spheres.

Works of literary art are written in mixed genres, but in this respect perhaps no work is quite like *The Renaissance*. The most "modern" thing about Pater's book may be that it is the first truly antigeneric work in English literature, without a rival until the appearance of *Flaubert's Parrot*. *The Renaissance* constantly aspires to history, criticism, biography, and autobiography: to poetry, novel, and philosophy.[13] But all of these forms seem almost to disappear as they fuse in utter unity. At the same time Pater seeks to create an art that transcends literature, becoming a visual art in its very "visionariness." Pater's essay "Style" in *Appreciations* serves as a key to our understanding of this aspiration in *The Renaissance*. Here he speaks of a "literary architecture," which, "if it is to be rich and expressive, involves not only foresight of the end in the beginning, but also development or growth of design, in the process of execution, with many irregularities, surprises, and after-thoughts; the contingent as well as the necessary being subsumed under the unity of the whole." In this manner is the "architectural design" of Pater's book classically proportioned and ordered. But Pater's is also, antithetically, a romantic architecture analogous to that of Renaissance France, where one "often finds a true poetry, as in those strangely twisted staircases of the *châteaux* of the

country of the Loire, as if it were intended that among their odd turnings the actors in a theatrical mode of life might pass each other unseen."

The prose poetry approaches sculpture in its ambition. For Pater the clarity of the Greek vision manifests itself in sculpture, so lucid in its incisiveness. In the essay "Style" Pater defines the writer's quest, like that of the sculptor, to remove "surplusage, from the last finish of the gem-engraver blowing away the last particle of invisible dust, back to the earliest divination of the finished work to be, lying somewhere, according to Michelangelo's fancy, in the rough-hewn block." Pater seeks in a similar way to carve and chisel away in prose in order to embody a Platonic essence in words. Speaking of those " 'Mothers' who, in the second part of *Faust,* mould and remould the typical forms that appear in human history," he is expressing his own goal, to mold and remold sculpturally as he gives birth to the idea of history.

If sculpture is the essence of antiquity, painting is the art form more nearly associated in its abstraction with modernity, especially the paintings of Giorgione and his school, in which one beholds a "perfect interpenetration of the subject with its form." Again in the essay "Style," Pater implicitly reflects on his own aspiration to paint in words: in the prose of the artistic writer the "elementary particles of language will be realised as colour and light and shade." Thus, writing of Venetian art, Pater becomes a Giorgionesque painter in words: "And it is with gold dust, or gold thread, that these Venetian painters seem to work, spinning its fine filaments, through the solemn human flesh, away into the white plastered walls of the thatched huts."

In the end, for Pater all art aspires to the condition of music, which most completely expresses the modern world. Like Giorgione's painted music, a "modulated unison of landscape and persons," Pater's prose aspires to the condition of the lyric. No less so, his writing is inspired by the "double-music" of Du Bellay's poetry, especially its quality of *poésie chantée.* Pater also admires the lyrical character of Shakespeare's poetry, which in *Measure for Measure* "seems to pass for a moment into an actual strain of music." At times Pater's prose achieves a sensuous abstraction and evocativeness related to musical experience: "A sudden light transforms some trivial thing, a weather-vane, a windmill, a winnowing fan, the dust in the barn-door. A moment—and the thing has vanished, because it was pure effect; but it leaves a relish behind it, a longing that the accident may happen again." In the music of Walter Pater, memory is continuously drawn into play as it absorbs, one upon another, the sensations of history, condensing these into perfect moments, exquisite pauses in time. The ripple of a faint breeze across a still stream, the wondrous whispering of wind-wafted wheat in soft sunshine, the distant murmur of unfamiliar voices at dusk—these, then, among the vagrant undulations of sound, at once present and past, are refined in Pater's reverie

into purely Platonic music, etherealized, at the last, into ghostly silences of unheard melodies.

Just as Pater attempts among these so numerous antitheses to reconcile modernity and the classical tradition, he tries to bring the basic literary genres, indeed all forms of art, into synthesis, paradoxically dissolving these forms as he unites them. One can read *The Renaissance* as poetry, autobiography, philosophy, or even as the origins of some weird fiction. But for all of these aspects of the work, Pater's omnipresent sense of history is the *point d'appui*. His own efforts he viewed as "scholarly," and I have tried to suggest something of the soundness and significance of his highly suggestive historical scholarship. Even so, *The Renaissance,* metaphorically becoming architecture, sculpture, painting, and music, and finally all and none of these, becomes in its perpetual striving beyond limits a network of almost Baudelairean *correspóndances*: "Comme de longs échos qui de loin se confondent / Dans une ténébreuse et profonde unité." As we only dimly perceive these Symbolist ambitions and their realization in *The Renaissance*—at once a perfect synthetic form of all art and a "vanishing away" of form—we begin to perceive that our reading of his strange, solitary book has only just begun.

2 Unity of Being

In the judgment of Walter Pater, Goethe's art is universal, "the complete-ness and serenity of an exigent intellectualism," his works "high examples of modern art dealing with modern life." The inception of what is called modern art—one of dissolution, crisis, estrangement, self-consciousness, and formal complexity—has been dated to various historical moments. It has been divided into particular phases from Romanticism and Symbolism to the more aggressive Modernism of our own century, and we are now living, it is even said, in a post-Modernist world. Yet *The Renaissance* encourages us to take a long view of modern art, dating it from the advent of what is called Romanticism—identifying Goethe as a central transitional figure between the older, Hellenic tradition and the new, more fragmentary culture of the modern world.

Goethe's notion of a unified culture is the foundation of Pater's own concept of harmony in *The Renaissance*—a book ever new, though now more than eleven decades old. Pico della Mirandola's attempts to reconcile Chris-tian and pagan truths, his ambitions to make a "union of contrasts," are seen as typical of such universality, and Leonardo's "boundless curiosity" is under-stood as an essentially Faustian quest for wholeness. It is from the marriage of Faust and Helena that "the art of the nineteenth century" was born, but in the "perplexed light of modern life," the ideal of unity is "a problem"—a goal harder to achieve than in the past. Pater seeks to maintain the sense of cultural unity while expressing the "perpetual change" of modernity. In *The Renais-sance* he transparently rewrites history in a modern idiom, charting Western thought from Greece to the moderns, not merely in the form of a linear progression but as if a unified flux. In a verbal kaleidoscope, Pater presents a

vision of history that is both ordered and perpetually changing, and these transformations are understood only as one rereads his little book, recognizing different historical configurations born of "multiplied consciousness" and, in the root sense, of constant revision.

Pater searches for the ideal of harmony in the period of the Renaissance itself, but even more fundamentally in the "continuities" of cultural history, for he traces the threads of this historical fabric from Plato to Goethe. Pater views cultural history typologically; of the Hellenic thread, Plato is the principal type, as of the Christian thread Dante is the central figure. Plato and Dante are similar in their "worship of the body" and their "visionariness," and just as Pico creates a variation on the Platonic theme, Botticelli envisions Dantesque images. In Michelangelo, Plato and Dante are interwoven, and later in Winckelmann, who "authenticates" the classical tradition, these two threads are again entwined. Abelard, Chaucer, Montaigne, Shakespeare, Bacon, Pascal, and Voltaire are but a few of the numerous literary figures touched upon by Pater in his broad historical perspective. Although the classical tradition is a focus of his book, so too is the romantic or modern current of thought: Lessing, Kant, Schiller, and Goethe, Fichte, Novalis, and Hegel, all inform Pater's concept of culture; Rousseau, Hugo, Gautier, and Baudelaire are central to it as well. Not least, modern English literature is Pater's subject: the poets Blake, Wordsworth, Shelley, Byron, Keats, Browning, Swinburne, and Rossetti, and the prose writers Hazlitt, Mill, Carlyle, Ruskin, and Arnold, even when unnamed, all shape his vision and revision. Blake and Hugo are the "true sons" of Michelangelo and thus "help us to understand him." The sensuousness of Keats and the feeling for nature in Wordsworth guide our appreciation of Giorgione's "unison of landscape and persons." Goethe's aspiration to "transmute ideas into images" is a key to the understanding of Leonardo's strange art, and his universality helps us approach Pico della Mirandola's syncretism. In like manner the Romantics, the "intensely modern" Hugo, Gautier, and Baudelaire, make us sensitive to the music of Du Bellay and his contemporaries, in which "the matter is almost nothing, and the form is almost everything." If sculpture corresponds to the "emphatic outlines of Hellenic humanism," painting to the mystic depth and intricacy of the Middle Ages, "music and poetry have their fortune in the modern world." Pater himself uses the very lyricism of modern or romantic poetry to trace the richly variegated development of thought from stone to sound.

Just as cultural history constantly redefines itself, the very subject and form of Pater's book continually change, for it is written to be read from multiple, subtly shifting points of view. One may read in it a series of biographies of central types of the Renaissance, a general discourse on Renaissance culture, or an essay in universal history. It is, to use the title of Pater's last book, a sustained

historical meditation on "Plato and Platonism" in which Platonism is seen, explicitly or implicitly, in the works of Phidias, Della Robbia, Botticelli, Giorgione, Leonardo, Michelangelo, and Raphael, in writings from Pico and Ficino to Winckelmann. Pater's continuous reflections on Sainte-Beuve, Taine, Arnold, Ruskin, and Carlyle, among others, become a treatise on modern culture, and the probing analyses of art forms constitute an essential tract in aesthetics. Some have read *The Renaissance* as a Wordsworthian essay on nature; others have approached it as epistemology, fiction, or pure poetry. And it is a type of *ars moriendi,* in which, meditating on mortality, chapter by chapter, Pater reflects on his (and our) death—the "last curiosity," as he says. In its shifting shapes, Pater's book becomes abstract, its very themes and forms fusing in musical prose. The distinction between "matter" and "form" is gradually obliterated, and this musical effect is everywhere evident in Pater's expressed "appetite for sweet sound." In delicate reveries he melodiously dreams through "the faint light of eclipse" of "strange" houses, webbed with "fantastic interweaving of thin, reed-like lines," surrounded by trees "like flowers," and of "the shadows of the leaves upon the wall on autumn afternoons"—all this tinged with "the sentiment of the grandeur of nothingness." Rendered in an almost Ravel-like mode, Pater's abstract fantasia stems from a country of the "half-imaginative memory."

Such a transformation of prose into poetry or music is typical of much romantic writing and is especially powerful in the prose poetry of Pater's immediate forebear, Baudelaire, whom he greatly admired and whose influence we detect in the *correspondances* of Pater's prose.[14] In his *Salon* of 1846 Baudelaire poetically describes an imaginary sunset, the changes of light and colors that vibrate perpetually, and aspiring to the law of universal motion, his own prose becomes music—a music evident even in translation:

> Let us imagine a beautiful expanse of nature where the prevailing tones are greens and reds, melting into each other, shimmering in the chaotic freedom where all things, diversely coloured as their molecular structure dictates, changing every second through the interplay of light and shade, and stimulated inwardly by latent heat, vibrate perpetually, imparting movement to all the lines and confirming the law of perpetual and universal motion. Beyond, a vast expanse, sometimes blue and very often green, stretches to the horizon; it is the sea. The trees are green, the grass is green, the moss is green; green meanders in the tree trunks, the unripe stalks are green; green is nature's basic colour, because green marries easily with all the other colours. What strikes me first of all is that everywhere—poppies in the grass, garden poppies, parrots etc.—red is like a hymn to the glory of the green; black, when there is any—a solitary and insignificant zero—begs for help from blue and red. Blue, the sky in other words, is cut into by light white flakes or by grey masses, which pleasingly soften its monotonous harshness, and since the seasonal haze, winter or summer,

bathes, softens or engulfs the outlines, nature resembles a top which, when spinning at high speed, looks grey, although it incorporates all colours within itself.

The sap rises and, itself a mixture of elements, flowers in a mixture of tones; the trees, the rocks, the granites cast their reflections in the mirror of the water; all the transparent objects seize and imprison colour reflections, both close and distant, as the light passes through them. As the star of day moves, the tones change in value, but always they respect their mutual sympathies and natural hatreds, and continue to live in harmony by reciprocal concessions. The shadows move slowly and drive before them or block out the tones as the light itself, changing position, sets others vibrating. These mingle their reflections, and, modifying their qualities by casting over them transparent and borrowed glazes, multiply to infinity their melodious marriages and make them easier to achieve. When the great ball of fire sinks into the waters, red fanfares fly in all directions, a blood-red harmony spreads over the horizon, green turns to a deep red. But soon vast blue shadows chase rhythmically before them the crowd of orange and soft rose tones, which are like the distant and muted echoes of the light. This great symphony of today, which is the eternally renewed variation of the symphony of yesterday, this succession of melodies, where the variety comes always from the infinite, this complex hymn is called colour.

In its abstract lyricism and impressionism, Baudelaire's "hymn" to color prefigures Pater's own more refined modulations of color into sound, especially the sonorous evocations of Giorgione's chromatic art—the very "waves of wandering sound." Baudelaire's text is particularly relevant to our present reflections, since it is inspired by Victor Hugo, who, along with Goethe, is the other giant of modern literature, according to Pater. It recalls the great symphonic picture of Paris at the end of Book 3 of Hugo's great *Notre-Dame de Paris*:

And if you would receive from the old city an impression which the modern one is quite incapable of giving, ascend, on the morning of some great holiday, at sunrise, on Easter or on Pentecost Sunday, to some elevated point from which your eye can command the whole capital, and attend the awakening of the chimes. Behold, at a signal from heaven—for it is the sun that gives it—those thousand churches starting from their sleep. At first you hear only scattered tinklings from church to church, as when musicians are giving one another notice to begin. Then, all of a sudden, behold—for there are moments when the ear itself seems to see—behold, ascending at the same moment from every steeple a column of sound, as it were, a cloud of harmony. At first, the vibration of each bell mounts direct, clear, and, as it were, isolated from the rest into the splendid morning sky. Then by degrees, as they expand, they mingle, unite, and are lost in one another. All are confounded in one magnifi-

cent concert. They become a mass of sonorous vibrations, endlessly sent forth from the innumerable steeples—floating, undulating, bounding, and eddying over the town, and extending far beyond the horizon the deafening circle of its oscillations. Yet that sea of harmony is no chaos. Wide and deep as it is, it has not lost its transparency: you perceive the winding of each group of notes that escapes from the several chimes; you can follow the dialogue by turns grave and clamorous, of the *crescelle* and the *bourdon*; you perceive the octaves leaping from steeple to steeple; you observe them springing aloft, winged, light, and whistling from the silver bell, falling broken and limping from the wooden bell. You admire among them the seven bells of Saint-Eustache, whose peals incessantly descend and ascend. And you see clear and rapid notes running across, as it were, in three or four luminous zigzags, and vanishing like flashes of lightning. Down there in Saint-Martin's Abbey is a shrill and broken-voiced songstress; nearer is the sinister and sullen voice of the Bastille; and farther away is the great tower of the Louvre, with its counter tenor. The royal carillon of the Palace unceasingly casts on every side resplendent trillings, upon which fall at regular intervals the heavy stroke from the great bell of Notre-Dame, making sparkles of sound as a hammer upon an anvil. Frequently, many tones come from the triple peal of Saint-Germain-des-Prés. Then, again, from time to time that mass of sublime noise half opens, and gives passage to the finale of the Ave-Maria, which glitters like a cluster of stars. Below, in the deeps of the concert, you distinguish the confused, internal voices of the churches, exhaled through the vibrating pores of their vaulted roofs. Here, certainly, is an opera worth hearing. Ordinarily, the murmur that escapes from Paris in the daytime is the city talking; in the night, it is the city breathing, but here, it is the city singing. Listen then to this ensemble of the steeples; diffuse over it the murmur of half a million people, the everlasting plaint of the river, the boundless breathings of the wind, the grave and distant quartet of the four forests placed upon the hills in the distance like so many vast organs, immersing in them, as in a demitint, all in the central concert that would otherwise be too raucous or too sharp, and then say whether you know of anything in the world more rich, more joyous, more golden, more dazzling than this tumult of bells and chimes, this furnace of music, these ten thousand voices of brass, all singing together in flutes of stone three hundred feet high—than this city which is no longer anything but an orchestra—than this symphony as loud as a tempest.

It has gone unnoticed that with consummate poetic wit Baudelaire rewrote this mighty *crescendo*; his symphonic sunset transformed Hugo's sonorous vibrations of bells into more abstract vibrations of color. Reflecting what Pater calls a "secret influence," Baudelaire wrote a variation on Hugo's musical theme, since Hugo had already refashioned Paris into the dazzling music of landscape—of river, wind, and distant forests, orchestrated, finally, in that "furnace of music," the "symphony." Whereas for Hugo "the ear itself seems to see," Baudelaire, inverting Hugo's nearly Symbolist transformation of city bells into lights, suggests that the eye seems to hear. In Hugo, but even more

in Baudelaire, sound and image saturate each other and interpenetrate. Feeling the vastness of nature, both Hugo and Baudelaire render the synesthetic perception of its mysterious order. Written with Delacroix in mind, Baudelaire's *Salon* in fact refers to the commonplace comparison then made between the painter and Hugo. We come to see that, not merely repeating this association, Baudelaire consciously brings color to Hugo's vibrations; he makes a new creation, a fusion of color and sound that transcends Hugo's poetry and Delacroix's palette—a truly universal art. It is an ideal of cosmic wholeness to which Goethe's Faust, and Pater after him, would have aspired.

Influenced by both Hugo and Baudelaire, Pater sought continuously to transform his protean prose into all forms of art. He thus conceived of *The Renaissance* as architecture, a kind of *House Beautiful,* populated by the statuesque heroes of cultural history, "moulded and remoulded," given color and "fine gradations," touch by touch, through the "elementary particles of language." Constantly re-forming itself, this architectural, sculptural, and pictorial creation ultimately becomes music, the consummate universal art in its utter identity of form and matter. Its suave and rhythmical effects, as of a sustained *largo,* are epitomized in Pater's description of Leonardo's *Mona Lisa* (Fig. 5):

> The presence that rose thus so strangely beside the waters, is expressive of what in the ways of a thousand years men had come to desire. Hers is the head upon which all "the ends of the world are come," and the eyelids are a little weary. It is a beauty wrought out from within upon the flesh, the deposit, little cell by cell, of strange thoughts and fantastic reveries and exquisite passions. Set it for a moment beside one of those white Greek goddesses or beautiful women of antiquity, and how would they be troubled by this beauty, into which the soul and all its maladies has passed! All the thoughts and experience of the world have etched and moulded there, in that which they have of power to refine and make expressive the outward form, the animalism of Greece, the lust of Rome, the mysticism of the Middle Age with its spiritual ambition and imaginative loves, the return of the Pagan world, the sins of the Borgias. She is older than the rocks among which she sits; like the vampire, she has been dead many times, and learned the secrets of the grave; and has been a diver in deep seas, and keeps their fallen day about her; and trafficked for strange webs with Eastern merchants: and, as Leda, was the mother of Helen of Troy, and, as Saint Anne, the mother of Mary; and all this has been to her but as the sound of lyres and flutes, and lives only in the delicacy with which it has moulded the changing lineaments, and tinged the eyelids and the hands. The fancy of a perpetual life, sweeping together ten thousand experiences, is an old one; and modern philosophy has conceived the idea of humanity as wrought upon by, and summing up in itself, all modes of thought and life. Certainly Lady Lisa might stand as the embodiment of the old fancy, the symbol of the modern idea.

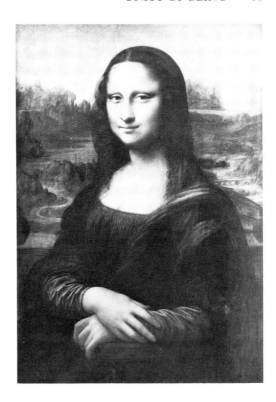

FIG. 5. LEONARDO DA VINCI,
Mona Lisa. Louvre, Paris.

Pater's prose is sound art criticism, for it appropriately emphasizes the manner in which the Mona Lisa's beauty emanates outward through the flesh. Building upon Vasari's description of the Mona Lisa's every pulse beat, Pater shrewdly describes Leonardo's intention, which was to mirror the soul. The historical context of the Mona Lisa that Pater defines is also just. Place her beside the archaic, classical, or Hellenistic effigies of Hera, Demeter, and Aphrodite, so reposeful and serene, and we perceive by contrast a troubling, complex psychology, finally, as Pater suggests, the uneasy relation of soul and body, brought into a perfect suspension, despite a certain fundamentally Neoplatonic or Christian disharmony.

As the personification of history from the ancient myths of Greece to Rome, the Middle Ages, Renaissance, and modern world, the Mona Lisa is born and reborn anew. In Pater's picture she has become an almost Baude-lairean "symphony of today, which is the eternally renewed variation of the symphony of yesterday." Like the unity of correspondences aspired to by Pico and pictured by Raphael in the Stanza della Segnatura, in which great

men from all epochs coexist in a timeless harmony, historical development is summed up in a single creation. But in an antinomical manner Pater also musically renders the Mona Lisa in the modern fashion of evolving, ever-changing consciousness—the perpetual vanishing away and re-forming of self. If, at bottom, Pater's goal is to achieve "the identity of European culture," this synthesis must now embrace the final union of opposites, the eternal order of the Hellenic with the flux of modernity: the synthesis of the romantic and the classical.

The Mona Lisa is the essential synthesis of antitheses. Nature and art, myth and history, body and soul, paganism and Christianity, all, she personifies life and death, eternity and change, combined in their total sweep. Mona Lisa is Faustian in her knowledge of the earth—its full circumference, East and West, North and South—its very depths. Perpetually reborn anew, she has been called a type of Persephone;[15] and, as she "rises" beside the waters, we discern her association with Venus, the birth of Venus being for Pater "the central myth." Mona Lisa is the type of types, the center of Pater's thought and being—indeed, an idealized intellectual self-portrait: thus, the wholeness of both sexes, an androgyne. Rendered in prose that becomes poetry, she is sculpturally "moulded," pictured with changing "lineaments," and like Milton's "temple of the mind," she is the universal cathedral of thought, re-formed finally into song: "and all this has been to her but as the sound of lyres and flutes."

Classically inspired, the synthesis that Pater makes is compounded out of distinctly modern sources. It is itself the creation of modern art from modern art. Pater echoes Michelet's sense of the Mona Lisa as an "unknown abyss of the ages," blending this perception with Gautier's identification of her as a "sphinx of beauty," with Baudelaire's love of the bizarre.[16] She is Adam's wife, Lilith, as Rossetti describes her: "And still she sits, young while the earth is old, / And, subtly of herself contemplative, / Draws men to watch a bright net she can weave, / Till heart and body and life are in its hold."[17] She is the mythic beings of Michelangelo's drawings described by Swinburne: "all mysteries of good and evil, all wonders of life and death lie in their hands and feet." But essentially the Mother type, she is "those 'Mothers' who, in the second part of *Faust,* mould and remould the typical forms that appear in history." Ultimately, she is Goethe's Eternal Womanhood.

In like fashion, Pater's typology is informed by the unifying art of Hugo, whom he identifies with Goethe as "one of the great moderns." Pater surely recognized that, in his deep response to *Faust,* Hugo became Goethe's "double." In *Notre-Dame de Paris* Hugo meditates profoundly on Goethe's tragedy and likens the passionate scholar of Notre-Dame, Claude Frollo, to Faust. The great cathedral, a kind of cosmic diagram, becomes the symbol of universal history, a "unified, complex ensemble, like the Iliads and Roman-

ceros." It is "a sort of human creation" and a "divine creation," having the "double character of variety and eternity." Notre-Dame is an ensemble of Grecian columns, Roman arches, Gothic vaults—all combined in "diversified unity." Like the Mona Lisa, the church is both "perpetual life" and the "summing up in itself of all modes of thought and life." When we recall that Pater conceived of his own writing as "literary architecture," we detect the subtle wit that assimilates the very type of Notre-Dame, "Our Lady," to the building of "Lady Lisa."

Pater's great re-creation of Mona Lisa was to play its part in modern literature. Even before Yeats adapted it in the form of free verse in *The Oxford Book of Modern Verse,* his own poetry reflected its seminal force. The historical implications of Pater's condensation of history in a single image, his sensuous musical language, and, more specifically, his identification of Lisa with Leda, "mother of Helen of Troy," is a source of Yeats's historical epiphany in "Leda."

> A sudden blow: the great wings beating still
> Above the staggering girl, her thighs caressed
> By the dark webs, her nape caught in his bill,
> He holds her helpless breast upon his breast.
>
> How can those terrified vague fingers push
> The feathered glory from her loosening thighs?
> And how can body, laid in that white rush,
> But feel the strange heart beating where it lies?
>
> A shudder in the loins engenders there
> The broken wall, the burning roof and tower
> And Agamemnon dead. Being so caught up,
> So mastered by the brute blood of the air,
> Did she put on his knowledge with his power
> Before the indifferent beak could let her drop?

Just as for Pater the Mona Lisa is the embodiment of all history, commencing with the "animalism" of ancient Greece, so for Yeats the moment of Zeus's insemination of Leda contains within it the seeds of Greek history. It is as if Yeats, departing from Pater's very words, "and, as Leda was the mother of Helen of Troy," invested his own historical poetry with a Paterian "sound of lyres and flutes." Yeats's poetic meditations on such dualities as animal and human, human and divine, order and discord, all echo Pater's theme. No less are Pater's syntheses of antitypes, antinomies, and contraries into equivalences and identities—the very unity of being in Mona Lisa—a source of inspiration to Yeats's creation of a new mythology in *A Vision.* And perhaps,

too, Pater's theme of renaissance or rebirth contributed in some measure to Yeats's developing notions of reincarnation.[18]

In its ever-changing, exquisitely intricate unity, Pater's *Renaissance* has quietly taken its place with "some excellent work done *after*" Hugo and Goethe. His Mona Lisa stands as the modern symbol of artistic rebirth or rejuvenescence, for if she has died many deaths, she has continually been reborn, re-created as Yeats's Leda, Joyce's Molly Bloom, Eliot's Madame Sosostris, Woolf's Orlando, and in Freud's psychological investigations. Suspended in near orphic song between discord and unity, between the very weaving and unweaving of self, she smiles the ultimate ironic smile of modernity—ever reflecting upon modern life the vibrant breadth and ambiguous serenity of Pater's ineffable vision.

Through Pater's vision we have come to see Mona Lisa as an icon of modern consciousness. His description of Leonardo's painting is one of the best-known passages of nineteenth-century literature and the first modern poem, as Yeats suggested, not only on account of its sheer lyricism and beauty but also because of what it says, implies, or holds together in suspension as a cultural vision. Pater moves from pagan rebirth through Persephone, to spiritual rebirth through St. Anne and Mary, to cultural rebirth defined by Michelet, and finally to artistic rebirth aspired to by Hugo and Baudelaire. He follows the old Heraclitean flux through the centuries, seeing its new form in the Baudelairean sense of modernity as "the transient, the fleeting." He pursues the Absolute from the ancient world of Parmenides to its modern reconstruction by Hegel. And his capacity to reconcile these antitheses is part of the legacy he has received from Plato, St. Paul, Petrarch, Montaigne, Kant, and Hegel, who are embryonically present in Pater's mind, especially when unnamed.

Pater's image of Mona Lisa is like no other description of a painting in modern literature. An icon of historicism, it epitomizes the nineteenth-century sense of historical consciousness so powerfully determined for Pater and his contemporaries by Hegel. Pater is correct when he sees all of history from ancient Greece through the Renaissance in her visage, for is her sensuousness not related to the revival of ancient paganism in the Renaissance, is her psychological content not determined by Christian spirituality? Glossing Pater's text fully—and I have only partially done so here—we see that our perception of the *Mona Lisa* through Pater is shaped by the accumulation or totality of all that has eventuated from the time that Leonardo painted through the moment Pater wrote. Vasari's sense of the artist's strangeness is absorbed by Michelet, Gautier, and Baudelaire, who see him as a *miroir profond,* and this image is further colored by Goethe, Shelley, Rossetti, and Swinburne. In Pater's composite image Hegel's historicism and Baudelaire's Symbolism interpenetrate, as all of history fuses with all sensory experience in the Absolute:

the *correspondances* of all art reflecting the totality of consciousness. "Diver in deep seas," Mona Lisa even seems to foresee the very subconsciousness that the Faustian Freud would explore when, like Leonardo, "he penetrated into the most secret parts of nature."

Strangely enough, Pater's modern sense of Leonardo and his painting is not in utter disaccord with Leonardo's *Mona Lisa*. Revealing to us that Mona Lisa's thoughts and fantastic reveries are "wrought out from within," Pater points to the very psychological content of the painting—a content of psychological consciousness that indeed sets it apart from contemporary portraits by Botticelli, Ghirlandaio, Lorenzo di Credi, and those painted under Leonardo's influence by Raphael and his followers. In a richly poetical manner, Pater embellishes the goals of Leonardo, who remarked that a good painter not only paints man but "the intention of his soul." As the bridge between Leonardo and Freud, Pater not only suggests the psychological implications of Leonardo's art but teaches us that Leonardo's work belongs to the history of psychology itself—that through his art Leonardo is, in a sense, one of the founders of modern psychology, if not its inventor.

3 The Poetry of Nothingness

Too precise a meaning erases your mysterious literature.
—Stéphane Mallarmé, *"Tout l'âme résumée. . . ."*

I t is the peculiar identity of Pater's Mona Lisa—the epitome of the very unity of being and, paradoxically, the disappearance of this unity—that makes her so alluring. As sorceress, she is the twin of Goethe's Faust; as the embodiment of beauty, corruption, and flux, she is the ideal mistress of Baudelaire; and as the personification of psychological depth, she is Freud's double. She is the impersonal *doppelgänger* of Leonardo and, finally, of Pater himself, and thus she is the central figure of Pater's book. If she belongs to a particular moment, she is swept up in the flood of time and belongs to all of history, which is being swept away into nothingness. Where, then, in this receding history of literature do we place her and the book she personifies?

The Renaissance has been generally treated as a late reflex of Romanticism and as a source of the aesthetic movement, important for Modernism as well. Perhaps Pater's own concern with historical transition has encouraged critics to consider his work itself as transitional. Yet if we take a broad view of modern literature, as we did in the previous chapter, we find that *The Renaissance* occupies a central place in this tradition, for it expresses the fundamental tendency of modern art toward abstraction. Previous explications of Pater's text, focusing on its ostensible subject, have failed to explore fully the book's underlying abstractness, its tendency toward formlessness, indeed nothingness. This aspect of Pater's book becomes evident to us only upon closer consideration of its diction, imagery, and form. Although *The Renaissance* can be read in many different ways, I think perhaps we can consider it most effectively as poetry, rather, as a prose poem.[19]

Before writing *The Renaissance*, Pater had written poetry of no distinction, most of which he burned, but, following the example of Baudelaire, he developed as an essayist into a superb prose poet. In the Preface to *The Renaissance*,

Pater speaks of art "casting off all debris, and leaving us only what the heat of the imagination has wholly fused and transformed." Pater's own exquisitely wrought prose poetry is such a creation or transformation, intricate, but spare and refined. It stands apart in this respect from the more exuberant and profuse poetical prose of Ruskin or Carlyle, and his essays are united to each other through the nuances of poetical imagery into a network of subtle interrelations that we do not find in the collected essays of Hazlitt, Lamb, Swinburne, or Arnold. All of these writers influenced Pater's prose, but in contrast to them Pater weaves his essays on the Renaissance together into a unified, extended poem. Not the poetry of nature as in Wordsworth or the poetry of myth *à la* Keats, Pater's prose poetry is neither Browning's poetry of situations nor Rossetti's and Morris's "aesthetic poetry." Neither is it quite the sensuous abstraction of Swinburne nor the eclecticism of Matthew Arnold—although it is indebted to all of these poets. The subject of Pater's prose poem instead is the history or motions of a disembodied spirit—"the Platonic dream of the passage of the soul through one form of life after another."

If we associate *The Renaissance* with Yeats's comparable *A Vision,* written under Pater's spell, we find that the poetical accomplishment of Pater's prose is far richer than that in Yeats's influential book. As an essayist, T. S. Eliot also never rivaled the lyrical finesse of Pater's prose, and although Virginia Woolf could, she did not gather her essays into the same kind of unity that Pater aspired to in the "poem" called *The Renaissance.* One might say that whereas Swinburne, Arnold, Eliot, and Woolf, among artists who were major critics, realized their artistic powers most fully in their own poetry or fiction, Pater, far more than these literary artists, treated the essay as art. Even more than Hazlitt, Lamb, Ruskin, and Carlyle, all writing prose inspired by romantic poetry, Pater sought to transform the essay into poetry, extending the sequence of essays into a sustained poetical narrative.

Pater's poetry is of an abstract type. All of the principal characters in his book fuse into a single being living through all of time. Impersonally and transparently rendered, this consciousness is, of course, Pater's idealized self. We gain insight into both the unity and abstraction of Pater's prose poem if we follow this abstracted, ideal being, ever re-forming itself, from the very beginnings of the book through its conclusion. To read *The Renaissance* in this way is to savor something of its intellectual romance, to discover that for all Pater's weaving together a coherent historical tapestry, he is continuously unweaving this fabric in his poetry of nothingness. As we read through the book chapter by chapter, canto by canto, let us note the way in which Pater journeys into an abyss.

At the outset of this journey of the mind, consciousness first manifests itself

as Abelard. He lives in "dreamy tranquillity" in "a world something like shadows"—an "uncertain twilight." And he knows "so well how to assign its exact value to every abstract thought." Speaking of his subsequent writings, Pater once remarked: "Child in the House: voilà, the germinating, original source, specimen, of all my *imaginative* work." Yet already in the essay on medieval French literature and in the other essays of *The Renaissance,* first written in the 1860s, Pater had sown the seed of his imaginative writing. Abelard and the subsequent Renaissance manifestations of dreamy idealism are prototypes of the Paterian child in the house, of Marius the Epicurean, of Sebastian van Storck, and other imaginary subjects.

Like Abelard, who journeyed to Rome, the Neoplatonic Pico is a "knight-errant of philosophy." His life, similar to that of all of Pater's selves, is perceived as many wanderings, "wanderings of the intellect as well as physical journeys." There is something "not wholly earthly" about this "mystic," "as if the chilling touch of the abstract and disembodied beauty" of the Platonists had passed over him. Indoctrinated with Pythagoras in "mysteries," Pico is a "master of silence," and for him and his Neoplatonic fellows, the word *mystic* means "*shutting the eyes,* that one may see the more, inwardly." Although Pater praises the humanist culture of Pico and his contemporaries, his panegyric is euphuistically presented in the language of negatives: "For the essence of humanism is that belief of which he seems *never* to have doubted, that *nothing* which has ever interested living men and women can wholly *lose* its vitality—*no* language they have spoken, *nor* oracle beside which they have *hushed* their voices, *no dream* which has once been entertained by actual human minds, *nothing* about which they have ever been passionate or *expended* time and zeal" (italics added).

A "visionary" counterpart to the Neoplatonists, Botticelli creates an art of "wan," "cold," and "cadaverous" colors, circumscribed by "abstract lines." His abstraction is not only formal but psychological. His characters are infused with "the wistfulness of exiles," with "a sense of displacement or loss." Botticelli's own life is "colourless," like the lives and works of the Tuscan sculptors, in which "all tumult of sound and colour has passed away." Like Abelard, these sculptors exist in shadow, and "one asks in vain for more than a shadowy outline of their actual days." Their art suggests "the wasting and etherealization of death." This quality is symbolized even later in Michelangelo's snowman made for Piero de' Medici—an art of "incompleteness, which suggests rather than realizes actual form." The sculpture of the Tuscans is rooted in Greek sculpture, which is platonically "like some subtle extract or essence, or almost like pure thoughts or ideas." It still has in it the "pure form" and "abstraction" of Greek art, from which "mere accidents of particular time and place" are purged away. Working in this "abstract art of sculp-

ture," Luca della Robbia and the other sculptors of his school bring a profound expressiveness to their art, like "the passing of a smile over the face of a child, the ripple of the air on a still day over the curtain of a window ajar."

The art of Della Robbia is "midway" between the "pure" sculpture of the Greeks and the even more abstract work of Michelangelo. In its very strangeness Michelangelo's art has "something of the blossoming of the aloe" about it. The creation of life "is in various ways the motive of all Michelangelo's art," and we feel in it "that power which we associate with all the warmth and fulness of the world." But discovering this emergent force in "the cold and lifeless stone," Michelangelo expresses the creativity of nature without rendering its elements, all of which "disappear"—"woods, clouds, seas, and mountains." He "has traced no flowers" in this primordial world filled but with "blank ranges of rocks, and dim vegetable forms as blank." "Incompleteness" is central to Michelangelo's art, and one "trusts to the spectator to complete the half-emergent form." Michelangelo's is a world of "dreams and omens"; his "capacity for profound dreaming" is embodied in the *Bacchus*. Like Pico, he is a Platonic wanderer, whose madrigals express the sentiments of such a "wanderer returning home." As in Della Robbia's sculpture, his drawings capture fleeting moments; his "unfinished sketches" arrest "some salient feeling or unpremeditated idea" as it passes. He is drawn to the "shadowy" figure, Vittoria Colonna, meeting with her in an "empty church" in Rome, tasting there "the sunless pleasures of weary people." Ever seeking the pure, abstract, divine ideal, he remains homeless, as "a traveller might be resting for one evening in a strange city." A "ghost," a *revenant,* as the French say, he is always "dreaming" in a "worn out society . . . on the morning of the world's history, on the primitive form of man." No less does Michelangelo dwell on death and its effect: "the lines become more simple and dignified; only the abstract lines remain in great indifference." Death, in its abstract purity, is the theme of Michelangelo's "hopeless, rayless" Pietàs. It is the subject of the sacristy in San Lorenzo, filled with "vague fancies" that are "defined and fade again" when one tries to "fix" on the "surroundings of the disembodied spirit." Pondering death, Michelangelo returns to a "previous state of existence," penetrating the very "formlessness" that preceded life, "far off, thin and vague."

As if upon Paterian "wings of the dove," we next approach Leonardo. In his youth Leonardo trained with Verrocchio, whose studio was filled with "things for sacred or household use . . . with the reflexion of some far-off brightness." Seeking to fathom the powers of nature through art and science, "he seemed to those about him as one listening to a voice silent for other men." Yet the "mystery" of Leonardo's "over-clouded" life never quite lifts, and "we but dimly see his purpose." His character is marked by "restlessness," his art by "retouchings," his life by "years of wandering," from Florence to

"fugitive, changeful, and dreamlike" Milan and back, on to Rome and then France, where he enters the "vague land" of death. The leitmotif of Leonardo's life is motion; "all the solemn effects of moving water" are a source of continual fascination to him. It flows endlessly through his paintings, "springing from its distant source among the rocks on the heath of the *Madonna of the Balances,* passing, as a little fall, into the treacherous calm of the *Madonna of the Lake,* as a goodly river next, below the cliffs of the *Madonna of the Rocks,* washing the white walls of its distant villages, stealing out in a network of divided streams in *La Gioconda* to the seashore of *Saint Anne*—that delicate place, where wind passes like the hand of some fine etcher over the surface, and the untorn shells are lying thick upon the sand, and the tops of the rocks, to which the waves never rise, are green in the grass, grown fine as hair." The "perpetual motion" that we experience in Leonardo's art is the very passage of time—a "stream" of "impressions," or the "stream of consciousness," as William James was to call it, in Pater's wake.

Leonardo's landscapes are "places far withdrawn," for it is through the "strange veil of sight" that things appear to him: "in no ordinary night or day, but as in faint light of eclipse, or in some brief interval of falling rain at daybreak, or through deep water." Like Michelangelo, Leonardo attends the very "refinement of the dead," rendering its "abstract grace" in his art. He draws the head of a child, whose skull within is "as thin and fine as some sea shell worn by the wind." He renders "the Daughters of Herodias, with their fantastic head-dresses knotted and folded so strangely to leave the dainty oval of the face disengaged." His figures of "some inexplicable faintness . . . feel powers at work in the common air unfelt by others," passing "them on to us in a chain of secret influences." Under his spell Leonardo's protégés are "ready to efface their individuality," and in Leonardo's own "fugitive" manuscripts and sketches—these "stray jottings"—we discern his own "self-forgetfulness," combined with the "solitary" culture of beauty. Like the exiled gods of antiquity, living still in disguise among the early Christians, Leonardo is an alien in his own age, and his "strange" *St. John* appears as if an exiled Bacchus. Such symbolic transformations are "the starting point of a train of sentiment, subtle and vague as in a piece of music." This imagery always "carries one altogether beyond the range of its conventional associations."

Leonardo's life is defined by negation—"this perpetual delay" gives him an "air of weariness and *ennui*." We find him "refusing" to work upon *The Last Supper* "except at the moment of invention." His technique is so "refined" that within fifty years the fresco had fallen into "decay." His eucharistic image has the "unreality" of the school of Perugino. "Finished or unfinished"—and we remain in doubt as to whether the central head of Christ was ever finished—the "whole company" of apostles are "ghosts . . . faint as the shadows of the leaves upon the wall on autumn afternoons." The figure of Christ is

"the faintest, the most spectral of them all." Leonardo's art of "faint light" and "fantastic rocks" is a sort of "after-dreaming": from childhood we find the image of the "unfathomable smile" "defining itself on the fabric of his dreams," present "incorporeally" in Leonardo's brain, absorbed finally into the *Mona Lisa.* "By what strange affinities had the dream and the person grown up thus apart, and yet so closely together," we might ask. The very strangeness of Leonardo is epitomized in the *Medusa,* then thought to be a painting by Leonardo; it is "like a great calm stone against which the wave of serpents breaks." The head that transforms the beholder into stone is itself transformed here into stone. Like the waving of hair that Leonardo so loved, the serpents become, finally, the waves of the unfathomable sea—the insuperable waters that are the very type of Leonardo's endless curiosity and consciousness.

Dependent on "colouring," the "weaving of light as of just perceptible gold threads," the painting of Giorgione and his school is no less abstract than Leonardo's. Above all "a thing for the eye," any great picture is indeed abstract, "has no more definite message for us than an accidental play of sunlight and shadow for a few moments on the wall or floor." It is like "a space of such fallen light caught as the colours are in an Eastern carpet" or a Japanese fan-painting, dependent on "abstract-colour." This "abstract language" is most complete in music, where the distinction between form and matter is obliterated. In the musical painting of the Venetians, "mere light and shade," backgrounds retain "certain abstracted elements only of cool colour and tranquilizing line." Informed by "passing light," this "music" occurs when a "momentary tint of stormy light" invests "a homely or too familiar scene with a character which might well have been drawn from the deep places of the imagination." In poetry this pure music is expressed by a "certain suppression or vagueness of subject," and in the painted poetry of Giorgione, which serves "neither for uses of devotion nor of allegorical or historical teachings," the subjects are refined "till they seem like glimpses of life from afar." As in his art, the "true outlines" of Giorgione's own life and person are "obscured"; he is thus like Abelard, Pico, Botticelli, and Leonardo, all living lives either colorless or in shadow. His musical art is about music itself, and with an "unearthly glow" he captures the "waves of wandering sound." This vague effect is that of "a momentary touch of an instrument in the twilight, as one passes through some unfamiliar room in a chance company," and one seems to hear the silence of "time as it flies."

Similar to the music of Giorgione, the poetry of Joachim Du Bellay is one in which "the matter is almost nothing, and the form almost everything." His poetical work, like the art of sixteenth-century France in general, exhibits a "fleeting splendour," an "aerial touch." He writes in "transparent" prose expressive of a "weird foreign grace," and the poetry of his time is of "an

exquisite faintness"—"fantastic, faded rococo." His life is made up of "slow journeys," his poetry of regrets, longings that certain moments or accidents "may happen again." His creations are touched by a "sense of loss" and "homesickness," further tinged "by the sentiment of the grandeur of nothingness—*la grandeur du rien.*"

If Abelard's life and writings prefigure the Renaissance, Winckelmann's career still commemorates the classical tradition. Like Du Bellay and Michelangelo, ghosts and exiles, Winckelmann has about him "a wistful sense of something lost to be regained." He considers himself a "stranger," who has "come into the world and into Italy too late." The "corpse-like" ideal of the Middle Ages and the "vagueness" of Oriental art both stand apart from the "abstract world" of Hellenic art to which Winckelmann aspires. But this "pure form" and "colourless abstraction" of the "sexless" Greek gods already has "a touch of the corpse in it," prefiguring the art of the Middle Ages. Like Helen of Troy, these "abstracted gods" "wander as the specters of the Middle Ages," and they become the symbol of the modern "exile"—of Winckelmann and of Pater himself, lost in the "perpetual flight of modernity."

Pater's idealism, his tendency toward abstraction, was nurtured by literature. Above all, the idealism of Plato and Platonism, from Plotinus to Pico, Ficino, and finally Winckelmann, informs Pater's own creation of "pure form." But this vision is also enriched by numerous modern writings. Kant's philosophy of "pure reason," Schiller's recognition that fine art annihilates "the material by means of the form" are part of Pater's perception. His tendency toward dream or reverie was encouraged by romantic literature in general— for example, Keats, De Quincey, and Ruskin—but particularly by Baudelaire. And the abstracting sensuousness of Pater's own style, its tendency toward the poetry of nothingness, owes much to Gautier, Rossetti, and especially Swinburne. Pater's literary vision is itself closely related to the art and thought of his age. His perpetual picturing of changing sensations and impressions in an impalpable world of dissolving form and flux is strikingly akin both to the impressionism practiced by French painters a short time after Pater began writing *The Renaissance* and to the later writing of Henri Bergson. In fact, for all the differences of temperament between, say, Monet and Pater, it can be argued that Pater's is one of the first, most coherent literary formulations of Impressionism—not just as a critical position but as a continuous analysis of consciousness in a world of continual change. This impressionism is not merely expressed in the notorious conclusion of his book but is sustained throughout, each chapter flowing necessarily into the next.

The suggestiveness of Pater's tone also intersects with Symbolist art. Although the refinement and exquisite intricacy of Pater's writing stand apart from the bold energy of Rodin's sculpture, Pater's emphasis on the aesthetics of the "half-emergent form," of "incompleteness," prefigures the related con-

cern in the works of the great French sculptor, in which form seems to come into being before our own eyes. His ethereal beings, pale or nearly colorless, isolated and in silence or inward vision, are remarkably close literary analogues to the disappearing faces rendered in faint, refined pastel colors by Redon—symbolic of silence and of vision beyond sight (Fig. 6). Most of all, Pater's Redonesque world resembles the analogous realm of Mallarmé. The French poet called Pater "le prosateur ouvragé par excellence de ce temps,"[20] and it is not unlikely that, if Pater stands in the direct line of modern French poetry, of Gautier and Baudelaire, he returned something to it, influencing Mallarmé. When the latter speaks of dissolution in his "Un Coup de Dés," describing the *plume solitaire éperdue* floating in an abyss, he evokes the Paterian "feather in the wind" and all the attending images marked by randomness and faintness. For Pater and Mallarmé both, the ideal of writing is the creation of a *vague littérature,* its reveries giving the reader the pleasure of *ce doux rien.*

It has recently been said that although "nothingness" or the "void"—the nonentity "nil"—was a dominant theme of French and American literature in the nineteenth century, it was not a topic of importance in English writing of the period.[21] Yet we come to see that nothingness is central to the creation of *The Renaissance.* Pater's abstract art is a perpetual taking away, purging, and refining. The world he envisions inwardly is pure, empty, abstract, blank, shut, and silent. Etherealized and siderealized, it is inhabited by an alien—a stranger and pilgrim—who wanders continuously in dream, in the vague twilight of passing instants, fleeting, momentary, and wandering impressions and stray sensations. He experiences isolation, the continuous effect of accident or change, and the sense of loss that is ever defined in negative terms of renunciation, retreat, disembodiment, displacement, and disappearance. Homeless and restless, this exile moves through an environment that is noiseless, rayless, colorless. As if itself effaced, this consciousness becomes faceless, helpless, even sexless. Confronting formlessness, it is unfixed in unreality; its journey is always unfinished. Incompleteness is the essence, incorporeally and inexpressibly experienced in invisibility.

Before Pater, Flaubert had aspired "to write a book about nothing . . . a book which would have almost no subject matter or at least whose subject would be invisible if that is possible." Following his great French master, Pater himself achieved such a *grandeur du rien,* as he calls it in Du Bellay's apposite phrase. Concerned with countless themes, Pater's book, at bottom, has "no subject matter" precisely because its ever-changing form and imagery dissolve the thematic matter into a vast void. What Pater says, discussing Michelangelo, is true of himself and indissolubly of his book, like "a dream that lingers a moment, retreating in the dawn, incomplete, aimless, helpless: a thing with faint hearing, faint memory, faint power of touch; a breath, a

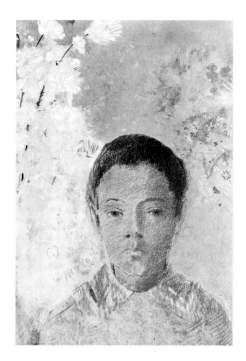

FIG. 6. ODILON REDON, *Portrait of Arï Redon, the artist's son,* 1894. Courtesy of The Art Institute of Chicago. Bequest of Kate L. Brewster.

flame in the doorway, a feather in the wind." In the root sense, poetry is making, and in the poetry of Walter Pater we discover the endless fabrication of "airy nothingness." Woven within a web of wonder, it is neither fiction nor exactly nonfiction. For all its similitude to the literature that influenced it and to writings afterward, *The Renaissance* stands alone as one of the eeriest lyrics in all of modern literature—the pathetic vision of nature, man, and history "vanishing away" in a white light, distant, pale, and waning.

4 Playful Artifice

Repetition, it has been said, is one of the essential characteristics of play. In the play of Pater's art, the repeated, simultaneous making of totality and nothingness are the warp and woof of his own literary fabric. Play, as Johan Huizinga observes, "creates order, *is* order." Precisely because of this "affinity" between play and order, he suggests, play belongs to the realm of aesthetics. When Huizinga wrote *Homo Ludens,* a study of the play-role in culture, he did so as an heir to the aesthetic movement of the nineteenth century, for Pater and his contemporaries made manifest the close connection between play and artifice.[22] This relation is abundantly clear in the sixteenth-century style known as Mannerism, about which Pater and other aesthetic critics wrote with understanding and sympathy.

Because Mannerism is notable for its playful artifice, it is especially appealing to the highly self-conscious modern temper. After centuries of neglect or ridicule, it was rediscovered or appreciated anew by art historians writing at the beginning of this century. Like Metaphysical poetry, closely related to it and also rescued from oblivion and ridicule in the same period, Mannerism is a style of exquisite wit, through which words and images alike are elegantly wrought into texts and objects of precious complexity. If Mannerism was eventually given a historical definition by twentieth-century scholars, the foundations for the revival of interest in it were laid in the nineteenth century by aesthetic critics who appreciated, in Gautier's words, *l'art pour l'art*—"art for art's sake."

Gautier himself admired the refined art of the sixteenth century, and in his neglected guidebook to the Louvre, he marks the qualities of the Mannerists, particularly of Parmigianino: "The elegant slenderness, the coquettish poses,

the somewhat affected, inclined heads, the turn of the hands, the slender fingers, the delicate oval faces, the lips with their sinuous smiles, the eyes with their lustrous glances, have a charm of their own, especially when it is Mazzola's [Parmigianino's] brush that has prepared the feast."[23] Gautier's taste for Mannerism was shared by his protégés the Goncourts, who described the Harlequin by their beloved Watteau "posed as if by a pen-stroke of Parmigianino," and by such critics as Gustave Geffroy and Eugène Plon, who wrote admiringly of the elegant works of Palissy and Cellini.

The appetite for such preciosity also informs the writings of Gautier's principal English follower, Swinburne. In his notes on the drawings in the Uffizi, the poet describes a mannered study of Cleopatra, then thought to be by Michelangelo, in an appropriately artificial and admiring prose: "Here also the electric hair, which looks as though it would hiss and glitter, if once touched, is wound up to a tuft with serpentine plaits and involutions." In a similar way, Henry James was captivated by the refinements of Bronzino's *maniera,* the elegant ideals of which are reflected in his fiction; for example, in the Bronzinesque literary portraiture of the *Portrait of a Lady.* But perhaps of all observations on Mannerism by nineteenth-century writers, the most generalized and, at the same time, most pointed are those made by Walter Pater in the essay on Joachim Du Bellay in *The Renaissance.* Like Swinburne, Pater admired Gautier, and along with both of these poets he was drawn to the *recherché* sixteenth-century art of extreme artificiality. Pater does not speak of "Mannerism" as such; however, he clearly defines its characteristics, and even though his observations have escaped the attention of virtually all students of Mannerist art and literature, his sense of this style still obtains in the formidable scholarship of Sydney Freedberg and John Shearman.

Like many art historians after him, Pater recognizes that French art and literature of the sixteenth century have their origins in the "French daintiness" of the Middle Ages and that this refinement is blended with an imported "Italian *finesse.*" Already in the first essay of his book, "Two Early French Stories," to which the chapter on Du Bellay is a pendant, Pater had stressed the "continuity" between the Middle Ages and the Renaissance (and that phase of the period we now call Mannerist), remarking upon the "connection" between "the sculpture of Chartres, the windows of Le Mans, and the work of the later Renaissance, the work of Jean Cousin and Germain Pilon." As if reacting to Jacob Burckhardt's *Civilization of the Renaissance in Italy,* a work that rather sharply defines the Renaissance as a break with the Middle Ages, Pater suggests that this purported rupture "has so often been exaggerated," and in doing so he introduces the theme embellished by Huizinga in *The Waning of the Middle Ages.* Pater observes: "What is called the *Renaissance in France* is thus not so much the introduction of a wholly new taste ready-made from Italy, but rather the finest and subtlest phase of

the Middle Ages itself, its fleeting splendour and temperate Saint Martin's summer." This is precisely the historical notion of continuity that Huizinga appropriated from Pater, although the great Dutch scholar focused instead on the court of Burgundy in the fifteenth century as the site of this medieval sunset.

Pater stresses the continuity between the Middle Ages and the sixteenth century—what he calls the "comely decadence" or later Renaissance, what we call the period of Mannerism—by observing the "daintiness of hand" in the intermediary art and literature of the fifteenth century: the poetry of Villon and the *Hours of Anne of Brittany*. This aerial delicacy and elegance, "*une netteté remarquable d'exécution*," as he calls it, presages the art of the sixteenth century, the "nicety" of Clouet's polished work, of Ronsard's and Du Bellay's refined poetry. Eventually the Italian taste begins to permeate the arts of France, the "attenuated grace of Italian ornament" veiling the Gothic in the *châteaux* of Chenonceaux, Blois, Chambord. The "correlative" of this Italian-ate architecture in painting is the work of "Maître Roux [Rosso Fiorentino] and the masters of the school of Fontainebleau," who bring a certain "Italian voluptuousness" to their exquisite work. As the "seriousness" of the French aesthetic recedes, "only the elegance, the aerial touch, the perfect manner remain."

Unequivocally celebrating the aesthetics of Mannerism, Pater asserts that "this elegance, this manner, this daintiness of execution are consummate, and have an unmistakable aesthetic value." He elaborates on this proposition when he speaks of the poetry of Ronsard and of the Pléiade, observing further that the interest of Mannerist literature depends on the fact "that it was once poetry *à la mode,* that it is part of the manner of a time—a time which made much of manner, and carried it to a high degree of perfection." This poetry, he adds, "is one of the decorations of an age which threw a large part of its energy into the work of decoration." The poetry of Ronsard is a poetry "not for the people, but for a confined circle, for courtiers, great lords and erudite persons, who desire to be humoured, to gratify a certain refined voluptuousness they have in them." Like the poetry of the Middle Ages, Ronsard's work is "to be entertained not for its matter only, but chiefly for its manner; it is *cortois,* it tells us, *et bien assis.*" Not marked by vigor or orig-inality, it is nevertheless "full of the grace which comes of long study and reiterated refinements, and many steps repeated and many angles worn down, with an exquisite faintness, *une fadeur éxquise,* a certain tenuity and caducity, as for those who can bear nothing vehement or strong; for princes weary of love, like Francis the First, or of pleasure, like Henry the Third, or of action, like Henry the Fourth." It is as if Pater were describing Mannerist portraits of "grace and finish, perfect in minute detail," depicting courtiers and rulers "a little jaded," who "have a constant desire for a subdued and delicate excite-

ment, to warm their creeping fancy a little"—the highly refined portraits by Parmigianino, Bronzino, and Salviati, the exquisite effigies of Clouet, Moro, and Hilliard.

Stressing the grace, elegance, decoration, delicacy, finesse, and studied artifice of this "manner," Pater is using the very language Vasari employed in the sixteenth century in his *Lives of the Artists* to describe the *grazia, finezza,* and *delicatezza* of the *maniera*. And what is "nicety" of execution in Pater's term, or *netteté,* is *nettezza* or *pulitezza* in Vasari's vocabulary, this "daintiness of hand" or "aerial touch" being what Vasari calls a certain *piumosità* or featheriness of the artist's stroke.

If Pater is one of the first modern critics of Mannerism on the one hand, he is, on the other, a latter-day Mannerist, still writing self-consciously in the tradition of those Mannerists whom he admired. To use his own characterization of Plato, with whom he feels kinship, Pater is "artist and critic at once." In his *Confessions* Rousseau spoke of how he learned to read books by "adopting and following up their ideas" without "any admixture" of his own, by thus identifying closely with the thought of their authors. In a similar way, Pater becomes the authors whose works he reads by adopting their way of writing, by writing as they do. He interprets them not by detailed analysis but by writing in their manner—by parodying them, in the Renaissance sense of the word, which intends emulation rather than mockery. The lesson of Pater's parody here, as in his fiction, was not to be lost on Joyce, whose better-known parodies in *Ulysses* demonstrate kinship with Pater's mannered virtuosity. It has been observed that the "Euphuism" of John Lyly is a characteristic manifestation of Mannerism in Elizabethan literature, and we find that Pater extols this style in the chapter "Euphuism" in *Marius the Epicurean,* himself writing euphuistically. Here Pater discusses the history of Euphuism from Roman Euphuism to the "Euphuism of the Elizabethan age, and of the modern French romanticists," foreshadowing E. R. Curtius's discussion in *European Literature and the Latin Middle Ages* of Mannerism as a recurrent tendency of literature. It is with such manner that Pater describes Flavian's literary ideals:

> It is certainly the most typical expression of a mood, still incident to the young poet, as a thing peculiar to his youth, when he feels the sentimental current setting forcibly along his veins, and so much as a matter of purely physical excitement, that he can hardly distinguish it from the animation of external nature, the up-swelling of the seed in the earth, and of the sap through the trees. Flavian, to whom, again, as to his later euphuistic kinsmen [and Pater, as we have observed, is among them], old mythology seemed as full of untried, unexpressed motives and interest as human life itself, had been occupied with a kind of mystic hymn to the vernal principle of life in things; a composition shaping itself, little by little, out of a thousand dim perceptions, into singularly

definite form (definite and firm as fine-art in metal, thought Marius) for which, as I said, he had caught his "refrain," from the lips of the young men, singing because they could not help it, in the streets of Pisa.

Pater exhibits skill as a Mannerist writer throughout his entire *oeuvre*, sometimes commenting on the very themes of Mannerism. It is widely recognized that Mannerist artists and writers alike developed the "grotesque" to a fine art, and Pater re-creates their grotesques in words: "Just so the grotesque details of the charnel-house nest themselves, together with birds and flowers and the fancies of the pagan mythology, in the traceries of the architecture of the time, which wantons in its graceful arabesques with the images of old age and death." Pater also creates his own Mannerist conceits or *concetti* in other architectural fantasies, as we have already seen "in those strangely twisted staircases of the *châteaux* of the country of the Loire." The artists of the cinquecento aspired to the *figura serpentinata,* and Pater finds such twisting forms in the spiral staircases of the period, re-creating them in his own serpentine "literary architecture."

The subtle wit of Pater's staircase, which exists somewhere between actual architecture and Pater's fancy, is typical of his irony, for we are made to envision ghostly beings unbeknownst to each other, spiraling upward and downward. Pater's playful invention is in sympathy with the very playfulness of Mannerist art, based on delightful surprises and soaring to strange effects and subtle irony. Such playfulness is found, for example, in Giulio Romano's bizarre treatment of architecture and grotesque frescoes in the Palazzo del Te, built for the court of Mantua. It is conspicuously evident in the decorations and fashions of the period—in satyr-laden, grotesque-filled dishes, bowls, and utensils, in fireplaces and doors rendered as the mouths of giants, in chairs and chests covered with strange beasts. This wit is seen in such formally self-conscious deformities as Parmigianino's *Self-Portrait in a Convex Mirror* (Fig. 7) and in the droll artifice of Bronzino's portraits. Strangely enough, although Pater's contemporaries commented on his sense of humor, and although *The Renaissance* is permeated by the appreciation of play, wit, and humor, the playful aspect of his own art is everywhere ignored, rendered all but invisible perhaps by the studied gravity and the fastidious morbidity that rises in his prose between his readers and their recognition of its buried life of play.

Pater's own sense of humor is continuously stirred by other artists and writers. He is thus charmed by the "childlike humour in the quaint figure of Mary" painted by Titian in *The Presentation of the Virgin.* He delights in the "burlesque element" of Provençal poetry, in which "one hears the faint, far-off laughter still." *Aucassin and Nicolette* is "tinged with humour," and morsels of it pass "into burlesque." Sometimes Pater's sense of playfulness is roused

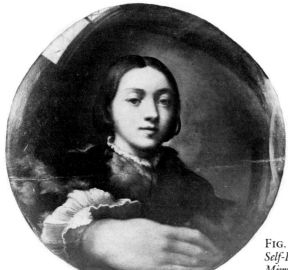

FIG. 7. PARMIGIANINO, *Self-Portrait in a Convex Mirror.* Kunsthistorisches Museum, Vienna.

by images devoid of humor but which seem childlike and thus charming in their naiveté. The medieval fresco in the Camposanto of Pisa depicting the "system of the world, held, as a great target or shield in the hands of the creature Logos" is a "childish dream" and seems to Pater "like a painted toy." Ancient mythology, although a subject both weighty and serene for the Italian poets, is also a "toy" in the hands of the French, and in their poetry it is filled with "play." Also a sort of sculptural toy is the snowman made for Piero de' Medici by Michelangelo, presumably "a work extracted from him half in derision."

For Pater, Leonardo typifies the spirit of play—the very play of the mind. He shares with Leonardo "the love of beautiful toys," those charming *objets* which come from his studio. Whereas "it was not in play" that Leonardo painted "that other *Medusa*" (the painting in the Uffizi no longer considered to be by Leonardo), the earlier picture of the same subject was, by contrast, the epitome of play. This picture, now lost, if ever painted, but described by Vasari, was prepared as a "surprise" for Leonardo's father. Upon seeing it he "pretended astonishment," or so Pater claims (or pretends). Thus in the play of Pater's imagination, Leonardo's father joined in his son's little illusionistic game. Speaking of Leonardo as a musician, Pater observes that he was a "player on the harp," amusing himself with the double sense of the word, for Leonardo both played the instrument and played with its very form, creating

"a strange harp of silver of his own construction, shaped in some curious likeness to a horse's skull." The play of Leonardo's mind is intertwined with his "love of the impossible—the perforation of mountains, changing the course of rivers, raising great buildings such as the church of *San Giovanni,* in the air." Leonardo's sense of humor (or actually Pater's) is of the subtlest kind, expressed in Pater's appreciation of the "half-humorous pathos of the diminutive, rounded shoulders of the child" in Leonardo's paintings. Even in the very last years of his life Leonardo surrounded himself with humorous devices or inventions, especially "strange toys that seemed alive of wax and quicksilver": for example, the grotesque beast invented by Leonardo in the Vatican, one of the artist's *pazzie,* as Vasari called them.

Perhaps of all Pater's allusions to play none is more fundamental to his own art than his pastoral prose poem in celebration of Giorgionesque idylls:

> In these then, the favorite incidents of Giorgione's school, music or the musical intervals in our existence, life itself is conceived as a sort of listening—listening to music, to the reading of Bandello's novels, to the sound of water, to time as it flies. Often such moments are really our moments of play, and we are surprised at the unexpected blessedness of what may seem our least important part of time; not merely because play is in many instances that to which people really apply their own best powers, but also because, at such times, the stress of our servile, everyday attentiveness being relaxed, the happier powers in things without are permitted free passage, and have their way with us. And so, from music, the school of Giorgione passes often to the play which is like music; to those masques in which men avowedly do but play at real life, like children "dressing-up," disguised in the strange old Italian dresses, parti-coloured, or fantastic with embroidery and furs, of which the master was so curious a designer, and which, above all the spotless white linen at wrist and throat, he painted so dexterously.

Pater's specific comparison of Giorgionesque actors to children at play is still Wordsworthian, but even more specifically his association of their performances to "masques" can be likened to Rossetti's shrewdly apposite description in his sonnet on Botticelli's *Primavera,* of the painting as a "masque." In the play of art, "the stress of our servile, everyday attentiveness" is relaxed, for as Pater asserts elsewhere, art is "an equivalent for the sense of freedom." His view of the pageantry of Renaissance art is not unlike that of Burckhardt, and it may even depend on the Swiss scholar's emphasis on it. However, his own focus on play as an expression of freedom prefigured and conceivably influenced the writing on "play-forms in art" in *Homo Ludens.* Asserting, as if in the manner of Pater, that "the first main characteristic of play" is "that it is free," Huizinga is somewhat less skeptical than Pater, who insists not that play is freedom but, more exquisitely, that it is an equivalent of the "sense" of such freedom.

It is commonplace in the writings on Pater that he becomes all of his subjects—that Pico, Della Robbia, Botticelli, Leonardo, Michelangelo, Giorgione, Du Bellay, and Winckelmann are Pater's own personae. Just as the actors of Giorgionesque pictures play the role of courtier, shepherd, and nymph, Pater becomes, for example, Giorgione, wearing the mask of the painter. Disguised as Giorgione, he writes a lyrical or Giorgionesque appreciation or re-creation of Giorgione's idylls. Like Michelangelo, whom Pater calls a *revenant,* in the manner of the French, Pater plays the ghost who passes through all of history, assuming the identities of each of its prominent cultural heroes from Plato to Goethe and Hugo.

This play of identity is linked to Pater's play with the very forms of his book, for just as Pater becomes all of his subjects, he adopts all of their forms, both literary and visual. We have already observed that Pater's book is essay, philosophy, biography, autobiography, history, art criticism, literary criticism, and poetry; that, metaphorically, Pater regards his prose, if one can even call it that, as a form of architecture, sculpture, painting, and music. But here I want to emphasize that Pater's preoccupation with form must be seen as a kind of play. By playing with the forms of his literary art, Pater treats it as if it were a sort of artistic "toy." Leonardo, as Pater asserts, perpetually transformed nature in his drawings, and Pater, in analogous fashion, is constantly transforming art. For example, the essay on the school of Giorgione can be read as a philosophical treatise on the forms of art and their limits, schematically as a biography of Giorgione, and, to the extent that Pater identifies himself with the painter's ideals, as an autobiographical reflection— a hint at Pater's own life of the mind. Contributing to our understanding of Renaissance culture by commenting on the courtly social ethos of Giorgionesque art, this essay is also history. Illuminating the creator's role as pastoral painter and celebrating the very pleasures of Giorgione's idylls, their tranquillity and harmony of vision, it is also both art history and criticism. When he celebrates the color and deft touch of the Venetians, Pater becomes himself a painter in words, and he achieves the "colour" of Giorgione in words woven of golden threads. Like Giorgione, he transforms art into music, reverberating in the very sonorities of his own prose, which emulates the sound of pipes. The forms and imagery of the essay on Giorgione are related to those in the rest of the book in the truly proportioned and ordered manner of Pater's "literary architecture," and finally, Giorgione is "moulded," as are all of Pater's subjects, into aggrandized imaginary statuary, sited in niches of his literary Valhalla.

As we read *The Renaissance,* we join in Pater's play, reading it now as one genre, now as another, or yet, simultaneously, as combinations of such genres. One of the special delights of Pater's book is that it can be read and reread in so many different ways as its various structures sharpen, dissolve, and re-form.

We can read it as a verbal equivalent of the visual arts or as literature. The literary forms are divided into various genres such as the pastoral. In every chapter Pater describes flowers, gardens, vast panoramas, or "morsels" of landscape—for example, Botticelli's "hillsides with pools of water" or the *Fête Champêtre*, "a landscape full of clearness, of the effects of water"—and we thus come to perceive his work as itself a sustained pastoral. To the extent that *The Renaissance* is an idealized "community" or "intellectual commonwealth," purged of controversy or discord, it is, like the world of Castiglione's *Il Cortegiano*, a species of utopia—the dream of the Renaissance as a Golden Age.

Pater's pastoral and utopian vision is tinged, however, with the "tragic" consciousness of death, the awareness that this perfection cannot endure. "*Et ego in Arcadia fui*," as Pater says in the last chapter on Winckelmann. Death, too, comes to Arcady, and as Pater's book unfolds, it becomes yet another genre of literature, an *ars moriendi*—a preparation for death. The very title of *The Renaissance*, moratory without mordacity, alludes to this theme of mortality, and Pater considers the lives of others as a "meditation on death." Preparing himself for his own end, Pater ponders death in every chapter, from the deaths of Amis and Amile, "united," to the murder of Winckelmann, meditating almost obsessively on the iconography of death in the texts, tombs, and effigies of Dante, Boccaccio, Botticelli, Rossellino, Savonarola, Dürer, and Michelangelo: "*Outre-tombe! Outre-tombe!*—is the burden of their thoughts." For Leonardo, as for Pater in anticipation, death is the "last curiosity," and almost as in a Northern Renaissance print, the figure of Death looms behind all of Pater's historical selves. At the very last, when his consciousness of its imminence is intensified, he exclaims, "Well! we are all *condamnés*, as Victor Hugo says: we are all under sentence of death but with a sort of indefinite reprieve." *Condamnés*, to be sure, but indefinitely reborn.

No wonder we ordinarily fail to see the play of Pater, for it is completely intertwined with and nearly disguised by his morbid sense of fatality. Whereas Renaissance art and literature are typified by a serious play, the *serio ludere* of Erasmus, Michelangelo, Rabelais, and Montaigne, Pater's play might more appropriately be called a type of *ludere sollemnis*. In the kaleidoscope of his literary art, all of the pieces of colored glass are tinted in subtle gradations of black. We recall that as a child Pater "played at being a priest, using sermons and costumed processions."[24]

The basic game that we have seen Pater playing in *The Renaissance* and in all of his writings is that of finding the "mid-point" between opposites. This is the procedure or "method," as Pater tells us in *Plato and Platonism*, of Plato, who invented the dialogue as the very means of articulating this dialectic. *The Renaissance* is a diaphanous "dialogue of the mind with itself," and just as Plato reconciled the "Absolute Being" of Parmenides and the "flux" of

Heraclitus, Pater re-creates this unity in his own work. He simultaneously establishes the unity of all beings in an all-embracing historical structure while reflecting on the dissolution of this totality, on the isolation of the individual. In *Plato and Platonism* Pater speaks of Plato's love of paradox, of his irony, commenting implicitly on his own play between opposites, for he both builds up a whole in *The Renaissance* and also shows how it vanishes in a "whirlpool." Type and antitype, classical and romantic, freedom and necessity; the finite and the infinite, the abstract and the concrete, passion and lethargy; unity and discord, curiosity and ennui, birth and death; home and exile, youth and age, permanence and change; attraction and repulsion, soul and body, perfection and imperfection, past and present—these are but a few of the seemingly infinite but finite dualities or oppositions that Pater playfully unifies in his dialogue with himself, creating a larger unity or "identity" from their totality which nonetheless approaches "nothingness" in its very schematism. Pater ironically grasps *la grandeur du rien* paradoxically contained within *le grand tout,* and this identity or unity of antitheses is the correlative of his playful fusion of all genres of art, the identity of all of its forms. Pater's Mona Lisa, we saw, is the very icon of his paradoxical method, for she is "all modes of thought and life," becoming abstract as "all this" has been but music to her. She is the symbol of Pater's double-self, her smile the symbol of his ironic vision, and perhaps, too, we can see this smile as an expression of the amused pleasure Pater takes in the play of his own mind or consciousness.

Although *The Renaissance* is dialogue, *ars moriendi,* pastoral, and utopia, it is no less a disguised novel.[25] Pater becomes all of his subjects, and, as they live through history, their lives become the stages in the life of his transparent protagonist. He is, we recall, the exiled pagan gods alive in the Middle Ages, then a series of Renaissance artists and writers, before becoming Winckelmann, Goethe, and Hugo in the modern world. The evolution of this single being is the development of Pater's own consciousness. If for Pico, or the Paterian protagonist at an earlier stage of development, "the world is a limited place," for Pascal, or the Paterian hero at a more sophisticated stage of consciousness, the universe is infinite. The incipiently novelistic structure of *The Renaissance* is one Pater would elaborate in *Marius the Epicurean* and in *Gaston de Latour,* novels in which the hero lives through important transitional moments in history. But since these works are more limited in their chronological scope, they are less fantastic than *The Renaissance.*

It has been observed that Pater's fiction was a source of inspiration to Virginia Woolf when she composed her novel *Orlando,* the lyrical story or fantasy of a character who lives through history from the Renaissance to the twentieth century, changing sex from male to female during this journey.[26] Even more than Pater's novels or his *Imaginary Portraits,* however, *The Re-*

naissance provides the overall structure for *Orlando,* for whereas the charac-
ters in Pater's fictions belong to a particular period, the protagonist of *The Renaissance,* like Orlando, lives through history. Just as Orlando is an Eliz-
abethan courtier, poet, ambassador, wife, and contemporary woman, living
through the Elizabethan period, the Restoration, the Enlightenment, and the
Romantic age, Pater's character lives through history, changing identities as
time passes. It has been remarked that Pater's Mona Lisa, a symbol of multi-
ple selves who lives through all ages, is, so to speak, the Ur-Orlando. When
we see that in his fiction Pater became the Mona Lisa, thus undergoing a
change of sex, the transformation, in reverse, of Orlando seems almost to be a
spoof of Pater. Woolf's fictional sex-change appears to be a playful travesty
(in the root sense of the word, from *travestir*) of Pater's "dressing-up," dis-
guised in the "strange old Italian dresses" of the Mona Lisa. In a sense Woolf
is the first critic of Pater's disguised fiction, recognizing the way this fiction is
woven into the seamless fabric of his book.

Orlando is conspicuously Paterian in various respects. If Pater rather som-
berly and meticulously ponders the problem of multiple selves, Woolf does so
with comic abandon, observing "these selves of which we are built up, one on
top of another as plates are piled on a waiter's hand." Just as Pater's painters
and poets are seers or visionaries, Orlando is endowed with (what Pater
himself would have called) "the capacity of the eye"—for, as Woolf says,
"sights exalted him." The Paterian protagonist is an alien or stranger, an
exotic set apart, and likewise, as Woolf delights in telling us with exaggerated
emphasis, Orlando loves "to feel himself for ever and for ever and for ever
alone." Toward the end of Woolf's novel, as the flux of history and con-
sciousness accelerates in a markedly Paterian way, "all is movement and
confusion" to Orlando. In the very caricatural pace of her motor trip through
London, Orlando seems to swirl in the Paterian whirlpool of impressions. As
time passes faster and faster, her clock ticks "louder and louder," and as the
flux of time and consciousness reaches a pitch, she is filled with mock "desper-
ation," lest she "fall into the raging torrent beneath." Her mind has become
"a fluid," like the incessant "flood" or "stream" of Pater's impressions.
Against this "continual vanishing away" the Paterian self seeks "profoundly
significant moments," "exquisite pauses in time." To counteract this flux,
Pater's personae aspire to the "ecstasy" or "exquisite passion" of art. And this
is what Orlando achieves at the end, in an epiphany of epiphanies (far greater
than anything in Wordsworth, Pater, Joyce, or even Proust): the pulsating
moment of vision of a toy boat on the Serpentine. "Ecstasy," Orlando cries,
"ecstasy: 'A toy boat, a toy boat, a toy boat,' she repeated." Here, then, in a
consummate mock-pastoral of pastorals, is the *reductio ad absurdum* of Pater's
vision of the work of art as "toy." For the metaphor of the toy has been made

literal, and how perfect is this mockery, since the boat floats above water—symbol for Pater of the time and consciousness momentarily arrested in this farcical rapture!

Making parody of these themes of flux, consciousness, and self, Woolf illuminates the multiple selves in Pater's work. Although Pater's writing is grave, Woolf nevertheless recognizes the very playfulness beneath the somber surface of Pater's work—the way in which, dressed up and disguised, Pater playfully assumes his various identities. The theme of "identity" is central to Modernist literature, and just over a decade after the publication of *Orlando,* Vladimir Nabokov played with it far more self-consciously in his first novel written in English, *The Real Life of Sebastian Knight*—the novel in which the narrator, V, attempts to correct the misleading biography by the critic Mr. Goodman of V's half-brother, the novelist Sebastian Knight. As if by coincidence—and how Nabokov loved coincidence!—Sebastian had planned to write a fictional biography with photographs illustrating the subject at different phases of his life, the very format of Woolf's recent book. Indeed V, Sebastian, and Goodman's Sebastian, all intertwined, are in a sense all Nabokov's selves in just the same way that the various Orlandos are Woolf or, for that matter, Pater's quasi-historical, quasi-fictional subjects are his own identities. V concludes: "I am Sebastian, or Sebastian is I, or perhaps we are both someone whom neither of us knows." They are like those *doppelgänger* who, unconscious each of the other, pass on the spiral staircase of Pater's consciousness.

The highly contrived literary games that Nabokov plays are grounded in the playfulness of modern aestheticism. Teasing with ambiguities of self and reality, exquisitely playing with language, Nabokov belongs to what we might speak of as a modern current of Mannerism. If it once seemed that the advent of Expressionism accounted primarily for the rediscovery of sixteenth-century Mannerism, it should by now appear that the sheer artifice and self-reflecting ludic character of nineteenth- and twentieth-century literature collectively contributed to the reevaluation of the earlier style. Seen in the broad context of Modernist art and literature—not merely in the narrow context of the historiography of art—Pater's appreciation of form, artifice, and manner, of Mannerism, seems scarcely anomalous. Just as the impersonal sitters for Bronzino's portraits and Parmigianino, in his much-admired *Self-Portrait in a Convex Mirror,* are ironically both present and concealed beneath their masklike faces, Pater is disguised in his literary portraits, for ever so artfully he plays the roles of the various subjects in his "gallery" of Renaissance heroes. Virginia Woolf's parody of Pater's mannered self-consciousness and manipulation of multiple identities or selves irresistibly draws our attention to the spirit continuously at play in Pater's refined and mannered prose—a spirit in quest of those fragile moments of "unexpected blessedness" that Nabokov called "aesthetic bliss."

5 The Case of the Domesticated Aesthete

What one man invents another can discover.
—*Sherlock Holmes*

Although Walter Pater is concerned with art for its own sake, he also associates the investigations of the ideal aesthetic critic with scientific inquiry. No wonder, as his readers have often remarked, that his metaphors are frequently derived from the language of biology and chemistry, that the conclusion of *The Renaissance* has been said to be related to such writings as Herbert Spencer's *The Principles of Biology* and John Tyndall's "On the Relations of Radiant Heat to Chemical Constitution, Colour, Texture."[27] Not surprisingly, Pater associates the aesthetic critic's isolation of aesthetic virtue with the way in which a chemist "notes some natural element." Like the Faustian Leonardo or the Leonardesque Goethe, Pater's ideal aesthetic hero combines scientific "curiosity" with artistic "desire for beauty." Such an aesthetic hero and Faustian type came into being the year before the third printing of *The Renaissance* in 1888. I am speaking, of course, of none other than the redoubtable Sherlock Holmes.

Although of recent invention, Holmes is one of the most popular characters in English literature. Some would say he is the most famous of them all. He has been called a version of the epic hero, a sort of Socrates, Sir Galahad, Hamlet, and even Superman. Sherlockophiles, and they are legion, have written about every facet of his life—his schooling, his study of chemistry, his literary taste, his love of music, his athletic skills, his religious beliefs, his philosophy, and his attitude toward women. They have traced his every step; in fact or fancy they have revisited every place he went. His residence, 221B Baker Street, has become a shrine, all the objects in it relics, Holmes himself a cult figure.

Curiously enough, however, Holmes stands outside of the history of literature. Scholars and biographers have written extensively about the influence

romantic fiction had on Arthur Conan Doyle's imagination, but students of Victorian and Edwardian literature have not placed Holmes squarely in a literary context. This is probably the case because, although he is indisputably a great character, the stories in which he appears are not what we consider to be major fiction. These writings thus remain marginal to the history of literature as it is currently written.

Holmes belongs to the current of nineteenth-century English literature in which the protagonist is a scientist. Dr. Frankenstein, Dr. Jekyll, and the Invisible Man are among the most notable examples of such characters, but Holmes stands apart from those mentioned here in that he employs his famous scientific methods of detection benevolently, whereas, intentionally or not, Mary Shelley's and Robert Louis Stevenson's physicians and H. G. Wells's chemist create evil. All of these characters reflect the nineteenth-century fascination with the Faustian powers of science, and there is even something disturbing about the seemingly omniscient and mysterious Sherlock. The scientist as hero or antihero in modern fiction is interchangeable with the ideal of the artist as hero, since in both cases the "creative" powers of these heroes are seen as problematic and disturbing. If Sherlock Holmes's scientific approach is abundantly evident in Doyle's stories and central to his myth, the detective's artistic or aesthetic qualities are no less important to his characterization.

Holmes is a typical figure of the *fin de siècle*. Flourishing in the 1890s, he has much in common with the aesthetes and decadents of his day, both real and fictional. In recent years critics have occasionally made this point in passing, but, perhaps because it runs counter to the conventional view of Holmes, its implications have not been fully explored.[28] Granted, Holmes is neither so precious as Walter Pater nor so artificial as Oscar Wilde, but in many ways he is like them, like Wilde's Dorian Gray, Huysmans's Symbolist aesthete Des Esseintes, and the exquisite young connoisseur of art Bernard Berenson as well. A central figure in the history of aestheticism—that current of modern art and literature concerned with aesthetic experience and pleasure, with the cultivation of art for its own sake—Holmes is a closet aesthete. If he is never mentioned in the histories of aestheticism that treat both actual and fictional aesthetes, this is because his creator disguised or domesticated the detective's aesthetic propensities, making them palatable to a vast, popular audience. Although Holmes flouts conventions, he is never scandalous in the manner of a Dorian Gray; rather, his aestheticism is tempered and mitigated. His *domus* or domicile is 221B Baker Street, his majordomo the sympathetic and legendary Watson, who plays the bourgeois fool, so to speak, to the refined and renowned "amateur" of crime.

Let us briefly consider the evidence for the theory linking Holmes to the notorious aestheticism of his day. Doing so, we will investigate his relations

not only to Pater but more broadly to the whole tradition of aestheticism, extending into the twentieth century. If Pater had reviewed Doyle's stories of Holmes, he would have appreciated the wit, impersonality, and ingenuity of the character. Most of all, he would have relished the association between Holmes's methods and the principles of his own aesthetic criticism. Such data connecting Holmes to the art of his aesthetic contemporaries are amply furnished to us by Dr. Watson—"Good old Watson," as Holmes calls him with affectionate condescension. Whereas Watson is conventional in his man-ner of thinking, Holmes is eccentric, a "Bohemian," as Watson describes him, and Watson should know, for he has read Mürger's *Scènes de la vie de Bohème*. Watson often pictures for us the "languid, lounging figure" of Holmes, ensconced in his "snug" quarters, seeking like all the distinguished aesthetes of his century—like Des Esseintes and Dorian Gray, like Poe, Baudelaire, Swinburne, and Pater—to escape from the "commonplace," to free himself from what Baudelaire denominates *les noirs ennuis*. Holmes's existence is spent primarily in "impassioned contemplation," as Pater would call it, or in "rêverie" *à la* Gautier. A recluse, like Des Esseintes and Dorian Gray in his essentially Esseintian ascendancy, he does not, for the most part, receive visitors other than his clients or his Boswellian companion. True, Holmes often ventures out and can be extremely active, but this activity is limited to the solution of mysteries, which depends, *au fond,* on "meditation."

As an aesthete, Holmes is obsessive, consumed by his "art" in the manner of a Flaubert. Just as the great French writer, whom Holmes quotes on one occasion, reads prodigiously in the service of his own writing, Holmes reads extensively to achieve an impressive technical knowledge essential to his work of detection. If Flaubert's Bouvard and Pécuchet comically echo their au-thor's own encyclopedic aspirations in their quest for knowledge, Holmes, in his technical studies, becomes a sort of Bouvard or Pécuchet, writing or planning treatises on cigar ashes, typewriters, handwriting, footprints, and tattoos—thus eliciting a smile of pleasure and amusement from the reader at such singular compulsion. Flaubert once remarked that in writing *Madame Bovary* he steered a precarious course between the vulgar and the lyrical. The same can be said of Holmes, who finds a sort of poetry in crime. Newspaper reporters and the police see only the vulgarity of crime, as Holmes remarks, because they fail to be selective in their analysis of the facts; such selectivity depends on aesthetic sensibility.

For Holmes, brilliant crime is "art." Great crimes Holmes considers "mas-terpieces," great criminals "artists." His point of view descends from Thomas De Quincey, who regarded murder among the "fine arts," who belonged to the society known as the "Connoisseurs of Murder." Holmes indeed speaks of himself as a "connoisseur of crime," and just as cognoscenti lament the decline of art in their own times, Holmes deplores the decline of the art of crime in his

day, the lack of criminal "audacity" and "romance." An exception is the notorious criminal Professor Moriarty, the greatest "master" of Holmes's epoch and thus his greatest rival; Holmes respects him more than any of his contemporaries. This admiration can be likened to Wilde's celebration in "Pen, Pencil, and Poison" of Thomas Griffiths Wainewright—"a subtle and secret poisoner without rival in this or any age." Holmes would have agreed with Swinburne, who deplored the unaesthetic murders committed by Henry Wainwright: "Having chanced on a grim subject I must express to you the deep grief with which I see the honored name of Wainwright associated with a vulgar and clumsy murder utterly inartistic and discreditable to the merest amateur. It is as though William Shakespeare were charged with the authorship (*pace Laureati*) of 'Queen Mary.' "[29] Holmes would also have understood the Baudelairean aesthetic of Degas's remark that one has to commit a painting the way one commits a crime. It is not surprising that an illicitly acquired painting by Greuze hangs behind the desk of Moriarty, for he is himself a connoisseur; nor is it unexpected that Holmes should know all about this work, its provenance, and the painter's place in the history of art.

The comparison of Holmes to the other aesthetes of his day, both real and invented, might appear strained were it not sound. For all his posturing, Wilde has a moral sense no less than does Holmes; and although he is never so preposterous as Wilde, Holmes himself, in his quiet way, rejects contemporary mores, as when he deems it necessary to commit burglary or withhold information from the police. Holmes's sense of justice also barely conceals the fact that the principal interest of his work is aesthetic. He refers to a murder as "charming" for the clues it affords, and he gives the impression that his love of crime even exceeds his commitment to justice. After all, as Holmes frequently asserts in the manner of Gautier, he practices his art "for its own sake." With his romantic forebears, from De Quincey to Pater, he is also attracted by what he calls the "queer," and what Pater describes in the wake of Baudelaire and Swinburne as "a life of brilliant sins." Blood-bespattered corpses and perverse instruments of crime are what arouse or excite him. He is, one might almost say, intoxicated by crime, carried to a feverish pitch of excitement by a challenging mystery, just as Des Esseintes is transported by perfumes or Symbolist pictures, or as Dorian Gray is uplifted by the sight of embroideries, tapestries, and jewels. When Holmes is not stimulated by his work, he succumbs to boredom and ultimately depression. He escapes from this tedium through the use of cocaine, and in this respect he belongs to the long and distinguished line of aesthetic users of drugs, including De Quincey and Coleridge, Poe and Baudelaire. When Watson finally cures Holmes of his habit, the detective becomes less of an outsider to the bourgeois world of Victorian England, but only somewhat less so.

As if reacting to the idea of Holmes as aesthete, the author of a recent

monograph on Doyle began a chapter by contrasting the virile author with the effete Oscar Wilde. Yet Sherlock Holmes is never described in words so purple or flowery as those used by Huysmans and Wilde to portray Des Esseintes and Dorian Gray, and Holmes appears to be very different from the arch-aesthete Thaddeus Sholto, whom he encounters in his London home, a sumptuous "shrine," an "oasis of art," filled with orientalia. Recalling the description of the entranced Holmes seated "like some strange Buddha" or of Holmes employing a piece of "real egg-shell pottery of the Ming Dynasty" to entrap an aesthetic adversary, we realize, however, that there is more than a little of Sholto in Holmes himself. Indeed, like Sholto, Holmes is something of a dandy, for Watson remarks on his "primness of dress," "debonair manner," "suavity," and "nonchalance." He may not, like Des Esseintes, possess a golden turtle or like Dorian Gray a collection of precious *objets,* but he does display exquisite objects—his bejeweled turquoise snuff box and emerald tie pin. Like Wilde, but not to the same degree, his speech is graced by witticisms and epigrams: "There is nothing more deceptive than an obvious fact," or "there is nothing so unnatural as the commonplace." When he receives an invitation, he remarks to Watson that he can attend and be "bored or lie," recalling Wilde's more ironic telegram of regret: "I cannot come. Lie follows." Holmes even sends a message to Watson in the manner of Wilde: "Come at once if convenient—if not convenient come all the same." At times the tone of Holmes's speech approaches Wilde's sharp patronizing tone, as when he mocks his plodding companion: "Watson! you scintillate today." Indeed, his air of superiority is strikingly like that of Gilbert toward his naive interlocutor, Ernest, in Wilde's "The Critic as Artist." Holmes also sounds like Wilde or Wilde's Lord Henry Wotton in *The Picture of Dorian Gray,* objecting to the philistine or "popular taste" that Watson appeals to in the "meretricious finales" of his accounts of Holmes's exploits. Watson is a kind of foil to Holmes's more "finely adjusted temperament," and the good doctor's literal-mindedness throws into relief the very "delicacy" and "finesse" of the detective, which are described in terms reminiscent of Walter Pater's critical vocabulary.

No less than Wilde and his literary heroes is Holmes a man of broad culture. A sparkling conversationalist, he discourses on Buddhism, violins, and warships. His speech is ornamented with choice phrases or words in German, French, and Latin, all redolent of a carelessly worn and ingrained culture. He compares Horace to Hafiz, carries a copy of Petrarch with him on a case, quotes from Shakespeare, Goethe, Jean Paul, and refers to De Quincey (not surprisingly!), Meredith, and Flaubert. His taste for the latter two writers especially reflects his highly developed aesthetic sensibility. Holmes is also an amateur of music, a violinist, a connoisseur of violins, and the author of a treatise on the motets of Orlando De Lassus. Sometimes while pondering a

case he plays strange melodies—on his violin—suggesting that his very medi-
tations, like all art, as Pater says, aspire to the condition of music. Working on a
case he plays Mendelssohn for Watson, and with marvelous aplomb, indeed
sprezzatura, he interrupts his investigations to visit Prince Albert Hall or other
concert houses to hear Chopin or German *Lieder.* These breaks are like those
disarming pauses when Holmes invites Watson to partake of the "epicurean"
delights of fine food and wines. There is ample evidence that Holmes has a
refined palate and is something of a gourmet; for example, he orders "a couple
of brace of cold woodcock, a pheasant, a *pâté de foie gras* with a group of ancient
cobwebby bottles." These "luxuries" were delivered by two visitors who
"vanished away, like the genii of the Arabian Nights."

In like fashion, despite Watson's claims to the contrary, Holmes is also
something of a connoisseur of paintings. As such, he attributes paintings in
the Baskerville collection: "I know what is good when I see it, and I see it
now. That's a Kneller, I'll swear, that lady in the blue silk over yonder; and
the stout gentleman with the wig ought to be a Reynolds." While working
on the Baskerville case Holmes stops off to see an exhibition of modern
Belgian paintings in a gallery on Bond Street. Not inconceivably he saw
works by the Belgian Symbolist Fernand Khnopff, who, much admired by
Oscar Wilde, exhibited in London toward the end of the century. Holmes
might very well have enjoyed the fantasy and morbidity of Khnopff, just as
Des Esseintes admired the macabre Baudelairean works of the Symbolist
Gustave Moreau. Even the language of art criticism tinges Holmes's descrip-
tion of a case. He suggests to Watson, adopting "art jargon," that they refer
to a bloody murder as a "Study in Scarlet." Scarlet is the color *par excellence* of
the 1890s, and his adaptation of Whistler's symbolist titles of paintings (as
studies in various colors) appositely aestheticizes murder in the very *mots
justes* of the day. Calling one of his *Intentions,* "Pen, Poison, and Pencil," a
"study in green," Oscar Wilde employed a similar description, and it is sug-
gestive to observe that Holmes's Whistlerian usage predates Wilde's use of
the similar subtitle and Doyle's first encounter with Wilde. "A curious con-
junction in the history of English letters," as it has been called, Doyle's
meeting with Wilde occurred in 1889 at a dinner party to which they had
been invited by an agent of *Lippincott's Magazine.* The creators of Sherlock
Holmes and Dorian Gray had much to talk about, and they both offered
works to the magazine: Doyle's *The Sign of Four* and Wilde's *The Picture of
Dorian Gray,* both published the following year.

Holmes, it is well known, insists that the investigator must be attentive to
"details." He should go beyond mere "impressions," by careful observation,
to analyze the important data of a case. This is precisely what Pater says of the
"aesthetic critic," who, having experienced impressions strongly, "drives di-
rectly at the discrimination and analysis of them." Just as Pater delves into the

"mystery" of Leonardo's personality—for example, analyzing its expression in art—Holmes carefully analyzes the "mind" of the criminal. Holmes's studies of criminal personality are in fact akin to Pater's investigations of artistic temperament. The Paterian critic has a finely developed sense of temperament, enabling him to extract the essence of artistic personality from a poem or painting; and in a similar way, Sherlock Holmes intuits the "master" behind a crime. Insisting that the detective relies on "imagination" and "intuition," Holmes refers to qualities essential to aesthetic criticism, and when Watson mentions Holmes's "acute set of senses," he marks an attribute fundamental to the aesthetic critic. Holmes repeatedly insists to Watson that it is not simply knowledge of facts that enables him to solve mysteries but his understanding of their significance. He has what Pater calls a "sense of fact," and it is this intuitive power that makes of him, as Pater would say, "an artist, his work *fine art*." Holmes's attitude toward his art is also decidedly like Pater's. When Watson calls him "a benefactor of the race," Holmes modestly quotes Flaubert's letter to George Sand: "L'homme c'est rien—l'oeuvre c'est tout." In his *Miscellaneous Studies* Pater had also quoted Flaubert, implicitly stating a similar ideal of impersonality: "It has always been my rule to put nothing of myself into my works."

There is one other curious way in which Holmes resembles Pater. The detective claims to be descended from the sister of the French painter Horace Vernet, insisting thereby that art is in his blood. In this respect he recalls Pater, who more than half-believed that he was a descendent of the eighteenth-century French painter and follower of Watteau, Jean-Baptiste Pater. Holmes was a master of disguises (more about which below), and in this regard we might say that Pater disguised himself as Jean-Baptiste Pater's sister, whose fictitious journal, "A Prince of Court Painters" in *Imaginary Portraits*, gives voice to some of Pater's own beliefs and desires.

Even to a greater degree than he resembles Pater does Holmes have affinities with Bernard Berenson, who was a follower of Pater. The American art critic never met Pater, but in his youth he regarded him as one of his "gods"; and Pater's writings had a profound impact on his own. Like Pater and Holmes, Berenson had a fine sensitivity to artistic temperament; he objected, however, to the lack of precision, of exact science, in Pater's work, faulting him for his acceptance of countless inaccurate attributions. Relying on the more "scientific" methods of the new connoisseurship developed by Giovanni Morelli, Berenson reattributed pictures by scrutinizing their precise structures—the ways in which draperies and anatomical forms were rendered in each. Not satisfied merely to discern the Giorgionesque or the Leonardesque, for example, Berenson, with magnifying glass in hand, examined paintings with the attention to details of a sleuth. Determining attributions on the basis of how ears, noses, fingers were painted, he more exactly identi-

fied the hands of Giorgione's and Leonardo's followers. Berenson thus became a detective of art, just as Holmes had become a "connoisseur of crime."

In numerous respects Holmes's professional procedures are akin to Berenson's. Both of them, the detective and the connoisseur, rely on anatomical classification in their work. Invoking the example of the great zoologist Cuvier, Holmes remarks that from the smallest detail the entire case can be reconstructed: "As Cuvier could correctly describe a whole animal by the contemplation of a single bone, so the observer who has thoroughly understood one link in a series of incidents should be able to accurately state all the other ones, both before and after." In the case of the cardboard box, Holmes recognizes, as Watson and Lestrade of Scotland Yard do not, the significance of two severed ears received in the box—that they are the result of murder. Berenson also closely attends to anatomical details in pictures, even earlobes, insisting that the way in which they are painted affords clues to the artists who painted them. The connoisseur and the detective also both apply a system of typology or classification to their investigations. Holmes is often able to attribute crimes to their perpetrators because he immediately recognizes the pattern of the crime through its relation to previous cases, of which he has a prodigious knowledge. Similarly, Berenson can detect the author of a painting by referring to his comparably vast knowledge of related works of art. Berenson maintained a huge file of notes and photographs for his work of detection, similar in purpose to Holmes's extensive "collection" of cases necessary to his connoisseurship. Both of them sought to publish their observations on method for future detective work and connoisseurship. Berenson published lists of attributions and essays exhibiting the results of his connoisseurship much in the way that Holmes wrote treatises on cigar ashes, handwriting, and footprints, useful in detective work. Holmes's studies of handwriting especially recall the work of the connoisseur, for, as Holmes observes, the criminal will betray himself in the very "mannerism" of his script; Berenson might well have added that, similarly, the artist reveals himself through his characteristic stroke of the brush or pen.

Like Holmes, Berenson was a dandy and epicure, a man of broad cultural interests, exquisite taste, and refined sensibility. Were Holmes to have come to life, he would surely have found his way to Berenson's famous salon of writers, scholars, artists, and politicians at his villa outside Florence, I Tatti, where they would have discoursed on art, music, language, and, not least, connoisseurship. Each would have admired the accomplished detective work of the other, charmed by the similarities between their apparently disparate professions. Berenson would eagerly have shown his collection to such a keen observer as Holmes, and they would have discussed Buddhism while standing before Berenson's splendid collection of Oriental works. Holmes's sharpness of observation would have charmed Berenson, as Berenson's inquiring

mind and sharp wit would have delighted his guest. Would that one might find among the countless letters to Berenson from distinguished correspondents still preserved at I Tatti just a few from Baker Street!

Holmes's "method" also has affinities with the critical principles espoused by Oscar Wilde, protégé of Pater and friend of Berenson. Exaggerating the principles of Pater's criticism, stiffening it into caricature, as Pater might have said, Wilde focuses on the "critic as artist." He finds such "art" in the criticism of Ruskin and Pater, and he recognizes the critical virtues of Rossetti's poems about painting. In Wilde's terms Holmes is a type of critic as artist. If the work of art is, as Wilde observes, a "starting-point for a new creation," so too is a crime a point of departure for the creative detective, who must in a sense "re-create" it in order to penetrate its mystery. Just as the great criminal is a "master," so too is the detective-critic. No less than great crimes are Holmes's solutions "masterpieces," and what we admire in them is the "delicacy" and "refinement" of their art. For Watson, and for us as well, Holmes, the critic-detective, is one of "the greatest artists."

I have postponed to the very last consideration of perhaps the single most significant likeness between Holmes and Wilde—that is, their shared theatrical gifts. Yeats and George Bernard Shaw both pointed out that, above all, Wilde was an "actor." As a *fin de siècle* Pierrot, he made his entire life into a stage performance, highlighted by brilliant theatrical soliloquies. Holmes, who regarded cases as "tragic" or "comic," was also a great performer. As Watson remarks, the stage lost a "great actor" when Holmes decided to become a detective, and throughout his career Holmes exploited these dramatic gifts, adopting numerous brilliant disguises or feigning illness to achieve his ends— sometimes fooling and stunning both Watson and the reader with such splendid performances. "Encore," his audience cried, and Doyle brought his great actor back for performance after performance, decade after decade. Even though Watson detects and hints at Holmes's feelings and sympathies, we never come to know the Holmes behind the mask. Forever "play-acting," Holmes suggestively asserts: "The best way of successfully acting a part is to be it." He could be speaking as well for Wilde, whose ironic identity is similarly inseparable from the part he played upon the stage of Victorian life.

T. S. Eliot once remarked that "every writer owes something to Holmes." Although exaggerated, this claim nevertheless reminds us that one of the greatest writers of our century, Vladimir Nabokov, owed more than a little to the great detective. The connection is significant in light of the present theme because after Proust and Joyce, to whom he was much indebted, Nabokov is one of the most distinguished writers of our time in the direct line of descent from nineteenth-century aestheticism. As one of his finest critics has observed, allusions to Sherlock Holmes abound in Nabokov's novels. In *The Defense,* Luzhin loves the stories about Holmes, who endows "logic with the

glamour of a daydream"; in *Despair,* Hermann imagines the perfect ending of the Holmes stories—Watson committing a murder. The narrator of *The Real Life of Sebastian Knight* employs a "Holmes stratagem" in his own investigation, and the narrator of *Pnin,* speaking for Nabokov himself, finds by his bedside in a furnished room an omnibus edition of Sherlock Holmes that had "pursued" him for years. Nabokov plays on the detective's name in *Lolita,* speaking of Shirley Holmes, and in *Pale Fire,* Holmes is mentioned in Canto I of John Shade's poem, a reference glossed by Charles Kinbote in his commentary.

The influence of the Holmes stories is evident in the very structure of Nabokov's novels as detective stories or mysteries—notably in *The Real Life of Sebastian Knight, Lolita,* and *Pale Fire.* For Watson, Holmes is a conjuror, a "magician"; and Nabokov, himself an amateur magician when he began to read Doyle as a child, aspired to Holmesian enchantments. Doyle spoke of his tales as belonging to "the fairy kingdom of romance," and in this way Nabokov understood all fiction, including his own, to be "fairy tales." Holmes could have been speaking for Nabokov when he commented on the strangeness of the commonplace, for *Lolita* is the sublime example of how the magical is found in the quotidian world. Speaking of himself as a "chess player," Holmes regards his profession as a "game" that he plays "for the game's sake," and in this way Nabokov creates gamelike fictions, filled with allusions to chess. The protagonist of *The Defense* is in fact a chess player who turns his entire life into a chess game—the exaggeration, we might almost say, of a Holmesian obsession. It may even be no coincidence that just as the Holmes stories seem to have ended with the image of the detective hanging over the Fall of Reichenbach, stalemated as it were in the grasp of Moriarty, *The Defense* concludes with Luzkin last described suspended above the chessboardlike "chasm" divided into "dark and pale squares."

On account of the very playfulness of his art, Nabokov has been called a type of *homo ludens.* The reference is to Johan Huizinga's classic study, *Homo Ludens,* which I have discussed briefly in relation to Pater. Like Doyle's stories and Nabokov's fiction, Huizinga's study was influenced by the playfulness of nineteenth-century aestheticism. The affinities between the highly playful aestheticism in court rituals, described by Huizinga, and the modern aesthetic rituals of Huysmans and Wilde, for example, are especially striking. Nabokov's youthful hero, Holmes, is also decidedly a sort of *homo ludens.* Always smiling, jesting, laughing, and performing "practical jokes," with a "mischievous twinkle" in his eyes, as Watson observes, Holmes "plays" out each case, inspired by the quality of the competition or the degree of mystery involved. Among his greatest assets are his "disguises," playfully employed to deceive his adversaries and admirers alike. Indeed, the uses he and his adversary Irene Adler make of concealments in the case of the scandal in Bohemia

carry the story into the realm of farce. Such Holmesian masquerades are the staple of Nabokov's fictions as well. Disguised as the narrator V in *The Real Life of Sebastian Knight,* Nabokov is also in a sense Sebastian Knight himself, creating a fiction that dissolves the apparent reality of the narrative into a more vertiginous realm of fiction. In other words, if it had appeared throughout that Sebastian Knight was the subject of Nabokov's book, at the end it almost seems that, having posed as the narrator, Sebastian Knight was instead the author.

In their deceptions, the Holmes stories ultimately raise the very questions about identity and reality that were to be embellished with far more nuance by Nabokov. Watson is always accusing Holmes of holding back pertinent facts as a case unfolds, and Holmes in turn perpetually complains of Watson's misleading, overly dramatic recounting of his cases. Whom do we believe? Or are they accusing each other of the same artistic vice? Playing on this ambiguity in the final volume of tales, *The Case Book of Sherlock Holmes,* Doyle has Holmes tell two of the stories—as if to correct the false impressions given by Watson. And as if Holmes himself were not to be trusted either, one of these tales is told by an impersonal narrator. The situation here is almost Nabokovian, approaching that in *The Real Life of Sebastian Knight,* in which Nabokov is writing about the narrator correcting the account of the critic Goodman, who is writing an account of Sebastian Knight and his writings.

Holmes once observed, "It is the first quality of a criminal investigator that he should see through a disguise." Nabokov's fictions are filled with such disguises, which we, as playful readers or investigators of his fictions, are asked to see through, although as master-deceiver, Nabokov is always one step ahead of us, beyond our Watson-like grasp. Nabokov implicitly suggested how we should read his own work when he called his course in European literature at Cornell a "detective investigation of the mysteries of literary structure." The numerous ground plans of the settings of novels that he drew for his students on the blackboard and his close attention to "details"—for example, his famous, scrupulous "anatomy" of Gregor Samsa—bespeak the Holmesian approach to criticism that informs his own fictions as well. In an age of prodigious literary theories, Nabokov's criticism is the supreme, possibly unique example of the subtle and clearheaded Holmesian kind of literary criticism, just as his fictions, elaborate criminal investigations, are the perfection of Sherlockian methods. Of all Nabokov's contrived, aestheticized literary games, perhaps *Despair* stands most clearly in the tradition of "murder considered as one of the fine arts" that I have sketched from De Quincey and Swinburne to Wilde and Holmes. Here the narrator, Hermann, having committed a murder, transforms his crime into art in his very narration—an artistic reenactment of the murder of his *doppelgänger,* Felix. Whereas Holmes's *doppelgänger* Moriarty was the "Napoleon of crime" in his own day, Nabokov

is both the Moriarty and Holmes of art in our own time. Through Nabokov's craft we come to see more clearly than before the aesthetic implications of Sherlock Holmes, and following his clues, we discover in a way what Holmes, or Doyle if you like, invented.

The story of the relations between aestheticism and the detective story does not, however, stop here. If Holmes descends from Edgar Allan Poe's detective, Dupin, he has determined the aesthetic character, in various degrees, of all subsequent fictional detectives down to the young Ellery Queen, Peter Wimsey, Nero Wolfe, and, most recently, Umberto Eco's William of Baskerville in *The Name of the Rose*. Holmes is the *haut vulgarisateur* of *bas esthéticisme,* the principal conduit through which aestheticism, including the Paterian strain, passed into the most popular literary genre of our century.

Perhaps *the* most obvious example of the Sherlockian type is Philo Vance, created in the 1920s by Willard Huntington Wright under the *nom de plume* of S. S. Van Dine. Himself an aesthete, painter, art critic, and one-time editor of *The Smart Set,* Van Dine molded Philo Vance into the aesthete *par excellence,* who embellishes the aesthetic principles of the prototypical Holmes. In his hands Vance becomes a connoisseur and collector of art, who is forever visiting museums and galleries or remarking on art. Endowed with a prodigious Oscar-Wildean wit and immensely cultivated, he is, in his aesthetic capacity to solve the most difficult problems, an aesthete's hero. For Vance a crime is a "work of art," and like a painting by Giorgione, it "bears the indelible imprint" of the criminal's "personality and genius—and his alone." The problem of *The Benson Murder Case* presents to Vance "the same difficulties as the *Concert Champêtre* affair—a question of disputed authorship, as it were." (Whereas this painting—so beautifully "re-created" earlier by Pater—had been often ascribed to Titian, Vance, according to Van Dine, convinced the curator at the Louvre, M. Lepelletier, that the work was by Giorgione. More recently art historians, including the Paterian Sydney Freedberg, have generally reascribed the painting to Titian, and Vance's attribution is no longer cited in the literature.) Seeking to identify the "personality" of the criminal, Vance used the critical methods of Bernard Berenson. If my researches in the archives at I Tatti have failed to establish evidence that Sherlock Holmes and Bernard Berenson were acquainted, Philo Vance did indeed know Berenson, and their discussion of Cellini plays an interesting role in *The Bishop Murder Case.*

Van Dine's extensive experience of paintings is reflected in his descriptions of characters and corpses. Like Stendhal, he is reminded of pictures by faces. Thus in *The Benson Murder Case* Miss St. Clair "possessed that faintly exotic beauty that we find in the portraits of the Carracci, who sweetened the severity of Leonardo and made it at once intimate and decadent." In *The "Canary" Murder Case,* the strangled songbird, Margaret Odell, "had the

traditional courtesan's full, red lips, and the wide, mongoose eyes of Rossetti's 'Blessed Damozel.'" Pater's harmonies, too, are his harmonies, as Van Dine wittily sees "in her face that strange combination of sensual promise and spiritual renunciation with which the painters of all ages have sought to endow their conceptions of the Eternal Magdalene." "Hers is the head," said Pater of the *Mona Lisa,* "upon which 'all the ends of the world are come,'" and Van Dine's is the pen that transforms her "lust" and "mysticism," her "fantastic reveries and exquisite passions," her association with the "sins of the Borgias," into those of the Aspasia of Broadway: "hers was the type of face, voluptuous and with a hint of mystery, which rules man's emotions and, by subjugating his mind, drives him to desperate deeds."

Apparently diverse in kind from the highly aestheticized fiction of Van Dine are the detective novels of the nevertheless similarly cultivated Raymond Chandler. The tough talk of Chandler's Philip Marlowe is of a different order from the preciosity of Philo Vance's speech. In his essay "The Simple Art of Murder," Chandler celebrates the "spare, frugal, hard-boiled" manner of Dashiell Hammett at his best, which he sets apart from the "formalized" prose in *Marius the Epicurean.* We get a splendid sense of what Chandler means in the following passage from his *The High Window* (1942), brought to my attention in relation to Pater by the distinguished connoisseur of crime fiction, Daniel Ehnbom:

> I went over and opened the single drawer of the reed desk and took out the photo that lay all alone in the bottom of the drawer, face up, looking at me with cool dark eyes. I sat down again with the photo and looked it over. Dark hair parted loosely in the middle and drawn back loosely over a solid piece of forehead. A wide cool go-to-hell mouth with very kissable lips. Nice nose, not too small, not too large. Good bone all over the face. The expression of the face lacked something. Once the something might have been called breeding, but these days I didn't know what to call it. The face looked too wise and too guarded for its age. Too many passes had been made at it and it had grown a little too smart in dodging them. And behind this expression of wiseness there was the look of simplicity of the little girl who still believes in Santa Claus.

We at once recognize Chandler's revision of Pater's exquisite description of the *Mona Lisa.* The Leonardesque face that reflects "all the thoughts and experience of the world" is now delivered to us as "too wise and too guarded for its age." The Florentine lady, "expressive of what in the ways of a thousand years men had come to desire," becomes the face at which "too many passes have been made." If Pater's Mona Lisa is the pinnacle of sapience, Chandler's lady, with her "go-to-hell mouth," is "a little too smart." Chandler's delightful spoof of Pater conjures up a scene from an imaginary Humphrey Bogart movie directed by that playful arch-aesthete Alfred Hitchcock.

Playing a detective *à la* Marlowe trailing a suspect through the Louvre, Bogart stops before the *Mona Lisa* and, without taking his eyes off her, says to a companion out of the side of his mouth (and one can almost hear the inimitable nasal baritone): "This doll's been around." The "embodiment of the old fancy" has indeed become "the symbol of the modern idea."

6 Nabokov's Childhood Heroes—and Ours

> *. . . I keep repeating, in a kind of zestful, copious, and deeply gratifying incantation, the English word "childhood," which sounds mysterious and new, and becomes stranger and stranger as it gets mixed up in my small, over-stocked, hectic mind, with Robin Hood and Little Red Riding Hood, and brown hoods of old hunchbacked fairies.*
>
> —*Vladimir Nabokov*, Speak Memory

Less than a decade after his death and little more than a decade before the end of this, our weary millennium, Vladimir Nabokov has achieved a place among the greatest novelists of the age—of all time, some would say. His fiction is seen in relation to that of the great authors of the modern period, Bely, Kafka, Proust, and Joyce, whose works he admired above all others. Lolita has taken her place in the pantheon of modern fiction with Odette and Molly Bloom; Shade stands side by side with Samsa and Swann. If Nabokov's fiction is quintessentially Modernist in the very degree of its self-conscious artifice, it belongs more broadly to the tradition of romance. On the magic carpet of his language we soar vertiginously through time and space, through music and painterly color, to reach the enchanted gardens of memory, presided over by a benevolent demon, populated by wizards, harlequins, and ghosts. Merely to read Nabokov is to miss much of this romance; to reread him, however, is to yield oneself totally to a dreamland of love and beauty, imagination and adventure, to be held in the thrall of a kindly magician, a collector of butterflies and readers.

Nabokov's novels are themselves romances. In them Nabokov identifies with the romantic heroes of his childhood, making use of them imaginatively, transforming them into his own fictive creatures. Forever remaining a "child in the house" of imagination, Nabokov playfully assumes the identities, in various ways and degrees, of such heroes as Sherlock Holmes and the Invisi-

ble Man. If Nabokov, as invisible author, plays the role of Sherlock, we recall that in a way this part had been prepared for him by Pater and other nineteenth-century aesthetes. Perhaps, too, the Sherlockian aesthetic critic or Paterian sleuth will eventually detect the exact ways in which the diaphanous Paterian hero, this "clear crystal nature," came to Nabokov through Wells's Invisible Man. In any event, Nabokov's way of becoming the unseen subject of his own fiction, jocularly manipulating his characters, is reminiscent of Pater's playfully transparent presence as the quasi-fictive, quasi-historical, quasi-autobiographical subjects of his own romance.

Although Nabokov retains many of the themes of nineteenth-century romance—his books being adventure stories, love stories, stories of quests—much of this romance or adventure is internalized within the form of his art, becoming the romance of writing itself. Nowhere do we find such romance more abundantly, for example, than in *Pale Fire,* in its playful parodic fusion of poetry, scholarly commentary, and biography. Whereas nineteenth-century romances, from the tales of Scott and Dumas to those of Morris and Wells, were adventures set in the external world, Pater's romance was the romance of art itself—the journey, inspired by love, through the kingdom of artistic form, from prose to poetry to the visual arts to music. As such, it anticipated the twentieth-century romance of art in Nabokov.

Although Pater will not be mentioned again in this chapter, he shines through at every turn, illustrating Nabokov's transparency, as Nabokov's crystalline disguises help illuminate Pater's colorless masquerades. In a sense, Pater serves here as a sort of critical muse, as guide to our reading of Nabokov's romance. "So he lingers on," Pater might have said of himself, "a ghost out of another age." Does he not appeal to us today, we might ask ourselves as we contemplate Nabokov, because of his similar sense of aesthetic adventure—an adventure filled with the playful exploits of virtuosity within the wonderland of art, where the unseen author becomes a sort of knight-errant or magician?

As a young boy Vladimir Nabokov was a voracious reader of books and tales that were romantic—"romantic in the large sense," as he said. The echoes and resonances of this romance throughout his own work attest its centrality in Nabokov's own artistic accomplishment, an importance we can scarcely neglect if we are to understand something of his literary formation. Nabokov despised "biographies romancées," as he often remarked, but in writing his autobiography, *Speak Memory,* he transformed his own life into pure romance. He tells us that when his mother read to him in their country house tales about knights and damsels, she would place upon the page her hand "with its familiar pigeon-blood ruby and diamond ring," and like a "crystal-gazer," the young Vladimir would see the future in its "limpid facets": "a room, people, lights, trees in the rain." Going to bed every night, Vladimir would journey through

exotic realms. In his mirror he would behold "a strange castle in an unknown Spain"; through his door he would spy upon "the fantastic flotilla of swans and skiffs." Finally, at the end of his "vague navigation," he would reach the "island" of his bed. Above it hung an aquarelle that showed "eerily dense European beechwoods." He recalls an English fairy tale his mother once read to him in which a small boy stepped out of bed into a picture "and rode his hobby horse along a painted path between trees." The fictitious boundaries between "reality" and imagination disappeared as Vladimir, too, "in a mist of drowsiness," would imagine himself climbing into the picture above the bed— "plunging into that enchanted beechwood" that he "did visit in due time."

All his life Nabokov lived in the aura of fairy tales; his novels are saturated with them. In *The Gift* a transparent poplar resembles "the nervous system of a giant," a public toilet is transformed into "Baba Yoga's gingerbread cottage." When, in *The Real Life of Sebastian Knight,* Goodman describes Sebastian "'lying in bed like a sulky leopard,'" the narrator, V, suddenly sees "the nightcapped wolf in 'Little Red Riding Hood.'" With delight John Shade observes in *Pale Fire* "an absurd error" in the translation of La Fontaine's *La Cigale et la Fourmi.* Humbert gives his Lolita "a de luxe volume" of Andersen's *The Little Mermaid,* and in his autobiography Nabokov recalls the beloved Tamara of his childhood as Andersen's mermaid. Remembering the Yayla Mountains of his youth under a "translucent pink sky," where a self-conscious crescent shone, with a single humid star near it, Nabokov likens the scene to a pretty illustration in a "sadly abridged" edition of *The Arabian Nights.* For Nabokov all fictions are fairy tales, and, speaking for him, Charles Kinbote calls Proust's novel a "huge, ghoulish fairy tale, an asparagus dream." No wonder that in Sebastian Knight's library *Le Temps Retrouvé* rests on a shelf near *Alice in Wonderland*—another favorite book of the young Nabokov, which Sebastian's creator rendered into Russian.

All of Nabokov's books belong to wonderland. He calls the worlds of both Lolita and Ada a "wonderland." Not only is Lolita a sort of Alice, but Ada's very name suggests the moment when Alice wonders who she is: "'I'm not sure I'm not Ada,' she said, 'for her hair goes in such long ringlets, and mine doesn't go in ringlets at all.'" When Van plays croquet with Ada, he says that playing the game with her "'should be rather like using flamingoes and hedgehogs.'" Were Nabokov to have called his novel *Ada in Wonderland,* we should not have been a bit surprised. In fact, Nabokov speaks of "Ada in Wonderland" conjuring up the moment she was "deflowered." Such Alician allusions are part of the very fabric of Nabokov's childhood memories. He recalls a cousin, "a nebulous little blond of eleven or so with long Alice-in-Wonderland hair" who was later fashioned into the notorious nymphet combing her very same "Alice-in-Wonderland hair." In Nabokov's dream, his cousin, Alice, and Lolita are one. He also remembers a "'typographical'

portrait of Tolstoy" like "the tail of the mouse on a certain page in *Alice in Wonderland*." Looking again at that marvelous tail of words, we in fact almost see a face and, who knows, perhaps it *is* Tolstoy's profile?

Alice was a favorite book of Nabokov's Sebastian Knight as well. The narrator of *The Real Life of Sebastian Knight* quotes from Sebastian's *The Prismatic Bezel*—from the strange "artifices" of the text that reflects Sebastian's "inner life" and echoes the absurdity, rhythm, and play of Lewis Carroll: " 'I am merely happy,' said William. 'You don't look it,' said the solemn old man. 'May I buy you a rabbit?' asked William. 'I'll hire one when necessary,' the conjuror replied drawing out the 'necessary' as if it were an endless ribbon. 'A ridiculous profession,' said William, 'a pick-pocket gone mad, a matter of patter. The pennies in a beggar's cap and the omelette in your top hat. Absurdly the same.' " It is as if the absurdities of the Hare and the Hatter were dissolved in the upside-down world of Sebastian's playful, poetic pitter-patter. Not only Sebastian is fond of Lewis Carroll; so too is his half brother, the narrator, V, who compares the speech of a hotel manager to "the elenctic tones of Lewis Carroll's caterpillar." This is one of the countless clues that perhaps, in the end, Sebastian and V are the same person, the individual amateur of *Alice*. V concludes the novel in a play of identities that still makes us think of wonderland, of Alice wondering who she is: "I am Sebastian, or Sebastian is I, or perhaps we are someone whom neither of us knows." Could this "someone" else be the Cheshire Cat-like Vladimir, whose smiling disembodied presence shines throughout the book?

As a child, Vladimir read mostly "authors who are essentially writers for young people." Among them Captain Mayne Reid continued to occupy a special place on the shelves of Nabokov's memory. Largely forgotten today, his Wild West books were once widely read and were, as Nabokov recalls in *Speak Memory,* "tremendously popular with Russian children at the beginning of this century." They left the deepest impression on the young Vladimir; they even affected the way he read comic strips. Reading *Buster Brown,* brought to him from America by his uncle, Nabokov was moved by the "tremendous spanking" Buster received from his "powerful Ma," who "drew puffs of dust from the seat of Buster's pants." Since he had never been spanked, Nabokov regarded Buster's punishment as an "exotic torture not different from, say, the burying of a popeyed wretch up to his chin in the torrid sand of a desert, as represented in the frontispiece of a Mayne Reid book."

Initiated "into the dramatic possibilities" of the Mayne Reid books by his cousin Yuri, the young Nabokov and his cousin would act out scenes from these cowboy thrillers. In the storerooms of his house Vladimir and Yuri "used to pause with drawn pistols" on their way to Texas. Mayne Reid's *Headless Horseman,* which Nabokov read in the unabridged original, espe-

cially kindled his imagination. "Two friends swap clothes, hats, mounts, and the wrong man gets murdered—this is the main whorl," Nabokov recalls, with a witty pun, "of its intricate plot." In the play of their imagination Nabokov became Maurice Gerald, the hero of this saga, his cousin, Henry Poindexter. Nabokov pathetically remembers that just a few years before Yuri died attacking a Red machine-gun nest in northern Crimea, he, like "the doomed Henry Poindexter," wearing his friend's clothes, was dressed in Nabokov's own "white flannels and striped tie."

The romance of Mayne Reid's stories blazes through Nabokov's fiction. Kissing his cousin in a closet "one memorable night in St. Petersburg," the hero of *Glory*, Martin Edelweiss, keenly "sensed the romantic nature of his behavior." He thought of how Mayne Reid's hero Maurice Gerald "stopped his steed side by side with that of Louise Poindexter, put his arm around the blond Creole's limber waist." But Martin's kiss, O sigh, could not compare with Gerald's, which "provided a far greater erotic thrill." Again in *Lolita* the adventures of yesteryear are affectionately evoked when Nabokov describes Humbert and Quilty rolling in battle upon the floor: "In its published form, this book is being read, I assume, in the first years 2000 A.D. (1935 plus eighty or ninety, long live, my love); and elderly readers will surely recall at this point the obligatory scene in the Westerns of their childhood." Dreaming of Lolita's fame in the next century, Nabokov still dreams of his own reveries of "ox-stunning fisticuffs" during the "first years" of his own century—romantic dreams kindled by Mayne Reid's tales from the century before.

Rudyard Kipling and Robert Louis Stevenson loom among the favorite authors of Nabokov's boyhood. Martin Edelweiss describes his Anglomaniac grandmother, who "would discuss eloquently such topics as Boy Scouts or Kipling," and Sebastian Knight wrote in *Lost Property* of his "Kipling moods." In *The Gift* Fyodor teaches English to a young woman, using books by both Kipling and Stevenson. Alas, "their reading of Stevenson would never be interrupted by a Dantean pause." No Paola and Francesca were they, nor even Louise Poindexter and Maurice Gerald. Was the "remarkable novel" they were reading *Treasure Island*? And does Charles Kinbote have this same remarkable book in mind when in *Pale Fire* he speaks of "Charlie proceeding toward the remote treasure in the sea cove"? Humbert Humbert does when he finds "eight one-dollar notes and some change in one of her [Lolita's] books (fittingly— *Treasure Island*)."

No less than *Treasure Island* did the young Nabokov love Stevenson's *The Strange Case of Dr. Jekyll and Mr. Hyde*. When Vladimir and his Alice-in-Wonderlandish and proto-Lolitian cousin in St. Petersburg attended Mr. Lenski's edifying "Magic-Lantern Projections"—and how magical they must have seemed—another child, a ribald one at that, silhouetted his foot upon the

screen, and Nabokov wondered of the boy, "could it be I after all—the Hyde of my Jekyll?" Nabokov would later teach Stevenson's tale of Jekyll and Hyde at Cornell, insisting to his creatures that this fable was closer to poetry than ordinary fiction and therefore belonged "to the same order of art" as *Madame Bovary*. Flaubert's masterpiece was one of the books Professor Nabokov taught to Myra, Johnnie, Alfredo, and his other bright-eyed protégés high above Cayuga's waters, and already between childhood and Cornell Nabokov had placed it on a shelf of Sebastian Knight's library in proximity to *Dr. Jekyll and Mr. Hyde*.

The sequence of books on this shelf of Sebastian Knight's library "seemed to form a vague musical phrase, oddly familiar: *Hamlet, La morte d'Arthur, The Bridge of San Luis Rey, Doctor Jekyll and Mr. Hyde, South Wind, The Lady with the Dog, Madame Bovary, The Invisible Man, Le Temps Retrouvé, Anglo-Persian Dictionary, The Author of Trixie, Alice in Wonderland, Ulysses, About Buying a Horse, King Lear. . . ."* Describing the melody of titles, Nabokov seems to have in mind a remark from Stevenson's *Essays in the Art of Writing* that was typed in his Cornell folder: "Literature is written by and for two senses: a sort of internal ear, quick to perceive 'unheard melodies'; and the eye, which directs the pen and deciphers the printed page." Stevenson is speaking of alliteration, of the visual and acoustical effects that delight the eye and the ear, as in the sequence we find in Sebastian's library: "*Anglo-Persian Dictionary, The Author of Trixie, Alice in Wonderland, About Buying a Horse.*" Anglo . . . Author . . . Alice . . . About—these words do indeed play to our ear and eye, and very nearly with some kind of curiously familiar sense.

As a boy Nabokov read Jules Verne, who also fired his imagination. Verne's Captain Nemo in *Twenty Thousand Leagues Under the Sea*, we should observe, is not merely the mysterious hero of an adventure story for children. A man of great cultivation and refined sensibility, he spends much of his time in his great library playing on his "piano-organ," studying his underwater botanical treasures, enjoying the masterpieces of his collection—a miniature Louvre filled with paintings by Raphael, Leonardo, Delacroix, and Ingres. Like a Renaissance prince amidst the curiosities and *objets d'art* of his *Schaztkammer* or *studiolo*, he is also a modern aesthete, a precursor especially of Huysmans's Des Esseintes and Wilde's Dorian Gray, of Pater, Holmes, and the young Nabokov. Journeying reclusively, transparently, indeed invisibly, as Nobody through the exotic, translucent underworld, he participates in the supreme "aesthetic adventure."

Exploring the fields near his home in search of butterflies, Vladimir was, like Captain Nemo, in search of exotic plants and creatures in the magical world twenty thousand leagues under the sea. If, in gazing upon these fields, he saw "the bottom of that sea of sunshot greenery," Verne had evoked a marine pastoral of strange birdlike creatures flying in the midst of the most

fantastic plants: "Under these numerous shrubs (as large as trees of the temperate zone), and under their damp shadow, were massed together real bushes of living flowers, hedges of zoophytes, on which blossomed some zebrameandrines, with crooked grooves, some yellow caryophylliae; and, to complete the allusion, the fish-flies flew from branch to branch like a swarm of humming birds, whilst yellow lepisacomthi, with bristling jaws, dactylopteri, and monocentrides rose at our feet like a flight of snipes." In the oceanic fields of Nabokov's memory we similarly behold "a continuous shimmer of butterfly wings over a shimmer of flowers—daisies, bluebells, scabious, and others—which now pass rapidly by me in a kind of colored haze like those lovely, lush meadows never to be explored, that one sees from the diner on a transcontinental journey." It is as if the distant meadows that Nabokov saw from a transcontinental railway car were like the vistas he also beheld in imagination from the window of Captain Nemo's subtranscontinental vessel.

The other book of Verne's very special to Nabokov was *Around the World in Eighty Days.* In *Ada,* when Dan proposed to Marina in the Up elevator of a Manhattan building and was rejected, he "came down alone and, to air his feelings, set off in a counter-Fogg direction on a triple trip around the globe." Fogg's journey is also spoofed in the trek through *Pale Fire* of Gradus, who "availed himself of all varieties of locomotion—rented cars, local trains, escalators, airplanes." In Kinbote's mind we see the Fogg-like Gradus "as always streaking across the sky with black traveling bag in one hand and loosely folded umbrella in the other, in a sustained glide high over sea and land." The force that propels Gradus, as Kinbote observes, is the "magic action of Shade's poem" (or as we might note, Nabokov's art), just as the true power behind Fogg's journey is the dazzling imagination of Jules Verne.

Nabokov once remarked that in childhood "my heroes were the Scarlet Pimpernel, Phileas Fogg, and Sherlock Holmes." Like Captain Nemo, Phileas Fogg is imperturbable. This cool, phlegmatic gentleman is "exactness personified." The playful Nabokov no doubt loved the game player in Fogg, who played whist at the Reform Club "for the sake of playing, not to win," and bet his fellow club members that he could travel around the world in eighty days, not for the spoils of the bet but for the sake of the game. Pitting himself against seemingly impossible odds (the limits of time, the dangers of storm, breakdowns in transportation, not to speak of interference from Detective Fix of Scotland Yard, attacks by Hindus in India, by the Sioux Indians in the Wild West)—Nabokov's unflappable hero "employed every means of conveyance—steamers, railways, carriages, yachts, merchant vessels, sledges, elephants," in addition to the author's intervention. Having returned on time, announcing in his "calm voice," "Gentlemen, here I am," the "eccentric" Fogg "displayed in this affair . . . wonderful qualities of coolness and exactness."

In Fogg the young Nabokov discovered what Verne called the "genuine automaton," "always so mathematically the same thing, that the imagination, unsatisfied, sought further." He saw in the pattern of Fogg's journey an aesthetic intricacy that he also found in the labyrinth of Sherlock Holmes's thought. In *The Defense* the chess player Luzhin's meditations on this unity reflect Nabokov's own literary reveries:

> But it was not a thirst for distant peregrinations that forced him to follow on the heels of Phileas Fogg, nor was it a boyish inclination for mysterious adventures that drew him to that house on Baker Street, where the lanky detective with the hawk profile, having given himself an injection of cocaine, would dreamily play the violin. Only much later did he clarify in his own mind what it was that had thrilled him so about these two books; it was the exact and relentlessly unfolding pattern: Phileas, the dummy in the top hat, wending his complex elegant way with its justifiable sacrifices, now on an elephant bought for a million, now on a ship of which half had to be burned for fuel; and Sherlock endowing logic with the glamour of a daydream, Sherlock composing a monograph on the ash of all sorts of cigars, and with this ash as with a talisman progressing through a crystal labyrinth of possible deductions to one radiant conclusion.

The two characters are also similar, for, like Fogg, Sherlock is a sort of "dummy" or "automaton" shrewdly manipulated by Arthur Conan Doyle. Reminiscent of Fogg, Sherlock is a figure of coolness, precision, and Olympian detachment. Doyle, who admired Verne's writing, created a character who, in the manner of Fogg, aspired to Flaubert's ideal of impersonality. When Holmes quotes Flaubert, "L'homme c'est rien—l'oeuvre c'est tout," he might just as truly be speaking for his double, Phileas.

We have already considered in some detail the fascination the Paterian Sherlock held for Nabokov. Suffice it to say here that, as his critics have always observed, Nabokov was drawn to the structure of the Holmes stories as detective stories or mysteries. His own books in which Holmes is present in allusions or by implication—*Lolita, Pale Fire, Despair,* for example—follow Holmesian stratagems. If murder is the ostensible criminal subject of these works, it is in their "relentlessly unfolding pattern" that they echo the stories about Holmes. Reading Nabokov's Sherlockian stories, we pass through "a crystal labyrinth of possible deductions" in search of some "radiant conclusion." In the game Nabokov plays we too become sleuths, but precisely because of his superior cunning his strategies outdistance our deductions. Nevertheless, the Sherlockian Nabokov gradually illuminates the mystery for us. Thus in *The Real Life of Sebastian Knight,* when we seek to fathom the mystery of Sebastian Knight's identity, Nabokov offers us a series of clues, and with the radiant logic and playfulness of Sherlock, who also

played the game for its own sake, he offers us possibilities for the solution of the mystery.

The artful playfulness of Sherlock Holmes is nowhere more abundant than in his story "A Scandal in Bohemia"—a tale that affords us a clue as well into Nabokov's own Sherlockian art. It begins with the masked king of Bohemia appearing in disguise to Sherlock as Count Van Kramm. Seeing through the disguise, Holmes offers to help the king retrieve the compromising photograph of himself and his former mistress, Irene Adler, still in the latter's hands. He disguises himself as a "drunken-looking groom"—a disguise that fools "poor old Watson"—in order to reconnoiter her house. Much of Holmes's inventiveness resides in his skilled use of disguises, and, playing the role of an "amiable and simple-minded Nonconformist clergyman," he next goes to the house of Irene Adler. Through a clever trick he discovers where the photo is hidden and prepares to return for it later. But he receives a letter from his adversary, who has seen through his deception and fled. She mentions that she followed him home to confirm his identity and wished him "good night," herself disguised as a young man. Watson remarks that the stage lost a great actor in Holmes; Irene Adler, as she similarly reminds Sherlock in her letter, had been an actress as well. Thus ends one of the most delightful and farcical masquerades in all Victorian literature. Such a whimsical tale would have delighted Nabokov, not only for its parody of "The Purloined Letter" by Edgar Allan Poe, whose writings he himself affectionately spoofed, especially in *Lolita,* but for its very tongue-in-cheek theme of impersonation. In his own stories Nabokov appears similarly disguised, playing the parts of Kinbote and Shade, of V and Sebastian Knight, bestowing on them "treasured items" of his "former self." "Lolita c'est moi," he might have said.

Writing in *The Criterion,* T. S. Eliot once remarked, "I am not sure that Sir Arthur Conan Doyle is not one of the great dramatic writers of his age." Of Doyle he added: "Another, and perhaps the greatest of the Sherlock Holmes mysteries is this: that when we talk of him we invariably fall into the fancy of his existence. Collins, after all, is more real to his readers than Cuff; Poe is more real than Dupin; but Sir Arthur Conan Doyle, the eminent spiritualist, the author of a number of exciting stories which we read years ago and have forgotten, what has he to do with Holmes?" Doyle's biographers have always observed "the unmistakable identification between author and hero"—their shared physical strength, their love of boxing, their interest in French painting, their vast reading and study of ancient manuscripts. Yet Doyle, like Flaubert before him and Nabokov afterward, disappeared into his art. As Eliot might have added, "the emotion of his art is impersonal." When Sherlock quotes Flaubert or tells Watson that his own art is "impersonal," he speaks for Doyle. (We need to remind ourselves that in admiring Sherlock's "art," his brilliance and inventiveness, we are in effect appreciating Doyle's

art.) Like Sherlock disappearing into the old groom or the priest or, like Doyle, vanishing within Sherlock, Nabokov, in Eliot's terms, surrendered himself "to the work to be done." No wonder he so often unloaded his scorching wit on the "Viennese Quack," whose psychological detective work was based on an overly crude relation between biography and art—*biographie romancée psychologiquement*. As Nabokov knows, the psychoanalyst, whatever virtues he is said to have, is the enemy of romance, destroyer of aesthetic bliss.

The third fictional hero of Nabokov's childhood was the redoubtable Scarlet Pimpernel, created at the turn of the century by the long-since-almost-forgotten Baroness Orczy. Descending from the historical romances of Dumas, which "Mademoiselle" read to Nabokov as a boy, the Pimpernel novels recount the deeds of the swashbuckling hero—a historical crossbreed between D'Artagnan and Superman—who defended the Royalists from "the Terror" during the French Revolution. In his utter self-possession and suavity, his impersonality and chivalry, the Pimpernel is like Phileas and Sherlock. Like both of them, he is the match for any obstacle or villain; and let us not forget that he resembles the chivalric Maurice Gerald, who, silk handkerchief in hand, tosses the glass of whiskey into the face of his adversary. Most of all, however, in his mastery of disguises, the Pimpernel recalls the dramatic art of Sherlock.

In everyday life the Scarlet Pimpernel appears as the rich fop, Sir Percy Blakeney, "an exquisite of '92." Taking a flower as his emblem, and a scarlet one at that, he typifies the 1890s, although he flourishes in the 1790s. He hides behind the "mask" of his "lazy nonchalance" and "perpetual inane laugh" and apparent incompetence, for "with his worldly inanities, his foppish ways, and foolish talk, he was not only wearing a mask, but was playing a deliberate and studied part." In truth, he is the paradigm of courage and cunning. When in France on secret missions, he wears the "quaint and many disguises through which he had baffled the strictest watch set against him at the barricades of Paris." Playing the part of the Jew Rosenbaum, he liberates his Marguerite, against all odds, and escapes with her. The Pimpernel's use of the name Rosenbaum would also have amused Nabokov for its coy, almost defiant, yet ultimately corny allusion to the man behind the mask. This is the kind of silly play with names that Nabokov relished and teased in his own works. In *Ada* Nabokov speaks of "Nicky and Pimpernella," then of "Pimpernel and Nicolette," not only playing alliteratively and rhythmically on the possibilities in the name, but making farce out of the French romance *Aucassin and Nicolette*. Part of the appeal of the Pimpernel stories for Nabokov also resides in their ironic self-consciousness: "it all sounds like a romance," one character proclaims of the melodrama in *The Scarlet Pimpernel*.

Nowhere in Nabokov's fiction is the Scarlet Pimpernel and his romantic world more evident than in *Pale Fire*. Here Charles the Beloved once lived in the castle of his "fabulous Kingdom" until a riot forced him to flee through a

secret exit. His "scarlet silhouette" reflecting in a puddle, the "scarlet-clothed fugitive" fled in "scarlet wool." He would never have escaped "had not a fad spread among secret supporters, romantic, heroic daredevils, of impersonating the fleeing king." They dressed to look like him "in red sweaters and red caps, and popped up here and there, completely bewildering the revolutionary police." Long live the League of the Scarlet Pimpernel!

Phileas Fogg, Sherlock Holmes, the Scarlet Pimpernel—these three heroes of Nabokov's childhood all came together in the guise of a single persona. This persona was powerfully shaped by a fourth hero of Nabokov's youth, H. G. Wells, perhaps paramount among all Nabokov's childhood heroes. Before considering the unity of his other heroes in this persona we must consider Wells's special place in Nabokov's affections and art. Without reservation Nabokov spoke of him as a "great artist . . . my favorite writer when I was a boy." He once said that he "could talk endlessly about Wells, especially the romances," and talk endlessly about them he did throughout his career. *The Time Machine* is one of the romances that especially haunted the young Nabokov. Although his meditations on time were later much indebted to Proust, they were first inspired by Wells. In his own fiction he enters into his own "time machine" and, especially in *Ada*, savors "The Texture of Time." In *Ada* he also plays on *The War of the Worlds,* speaking of a "whirl of worlds," and more pathetically of Aqua's "sojourns in sanitariums" as her "War of the Worlds." Asked by Alfred Appel whether he associated Aqua's psychological decline with the horrible sounds made by the dying Martian invaders at the end of Wells's book, Nabokov replied, as if haunted by them, "Yes, I can still hear those creatures."

In *Speak Memory* Nabokov remarks that after the Revolution forced his family to flee St. Petersburg, he picked up a book in Berlin with his father's *ex libris.* "Very fittingly," he observes, "it turned out to be *The War of the Worlds* by Wells." "Fittingly," because it was one of his favorite books from childhood, but also because it may have called to mind an incident from the St. Petersburg years recounted in *Strong Opinions*: "There was an awful moment at dinner in our St. Petersburg house one night, when Zinaida Vengerov, his translator, informed Wells, with a toss of her head: 'You know, *my* favorite work of yours is *The Lost Worlds*.' 'She means the war the Martians lost,' said my father." Zinaida Vengerov's slip, like Nabokov's childhood games and reveries, had been prophetic!

Of all Wells's romances, the one that left the deepest impression on the young Nabokov was, I believe, *The Invisible Man.* As Nabokov said in *Ada*, it "is one of the greatest novels of English literature." At the very least it is one of the masterpieces of the 1890s and, along with his other romances of these years, it establishes Wells as one of the masters of the decade. Nevertheless, like the Sherlock Holmes stories, it is marginal to the history of literature as

currently written. Still often read, it has been relegated in its bright-colored paperback reincarnation to the "science fiction" shelves of our bookstores. For Nabokov, Wells's romance was far more than a popular book. As the tale of an evil chemist who makes himself invisible and then hopes to establish a reign of terror, the story is a marvelous metamorphosis of his beloved *Dr. Jekyll and Mr. Hyde*. Not surprisingly, we find Wells's novel on the shelf of Sebastian Knight's library. Twice it is mentioned in *Ada*: "They crossed lawns and traveled along hedges somewhat in the manner of objects carried away by the Invisible Man in Wells's delightful tale, and landed in Ada's lap whenever she and Van had their trysts." It is no accident that shortly after this passage Nabokov refers to the Albino Riots of 1835, for the Invisible Man was an albino—a point made explicit later in *Ada* when Van's course across a path reverses "the action of Dr. Ero, pursued by the Invisible Albino."

Wells's ghostly albino haunts the pages of Nabokov's fiction. He reappears as the principal character of *Laughter in the Dark*, becoming (who else?) Albinus, who decides "to vanish." Just as Wells's albino is introduced in the snow, Albinus is played off against his "white-washed" house. Not surprisingly, Albinus admires Udo Conrad's "The Vanishing Trick." If Nabokov's playfulness seems foreign to the horror of Wells's story, we might recall that for all its terror Wells's book is also decidedly comic. It is a "grotesque romance," as Wells calls it, filled with all sorts of absurdities: for example, the laughing invisible man moving furniture or toppling his adversaries. Pursuing him, they comically chase after "nothingness." The albino appears again in Sebastian Knight's novel *Albinos in Black*, reminding us that the play of black and white throughout Nabokov's works owes more than a little to the same Symbolist effects of color in Wells's book. In *Lolita* an amnesiac albino, Jack Humbertson, suddenly appears in bed with Humbert and Rita, only to be quickly dispatched. For the young Nabokov, as for Fyodor in *The Gift*, the white crayon pencil was an "albino" with which he "drew the invisible." One wonders whether Nabokov wrote his own novels with the white crayon, for using it "one could imagine lots of things."

Throughout his fiction Nabokov created a seeming infinity of invisible men, transparent ghostlike beings or specters: the transparent Fyodor who is "assimilated to the shimmering of the summer forest"; Cincinnatus in *Invitation to a Beheading*, who learned "to feign translucence," "to slip naturally and effectively through some chink of the air into its unknown coulisses to disappear"; the "transparent" Hugh Person in the translucent world of *Transparent Things*. But the ultimate invisible man of Nabokov's works is the author himself; he is everywhere, but invisible to his readers, ubiquitous but transparent in "the translucidity of the textual flow." In his "verbal adventures" the invisible author becomes a sort of invisible Phileas Fogg and Time-Traveler soaring through spacetime, an unseen Sherlock Holmes endowing

his text with the "glamour of a daydream." As Phileas and Sherlock at once, he is like the conjuror in *The Defense,* who "managed to blend in himself briefly both Fogg and Holmes." Constantly employing disguises, he is also an invisible combination of Sherlock and the Pimpernel. We the readers are made to play Detective Fix to his Fogg, Watson to his Sherlock, Chauvelin to his Pimpernel, ever trying to see him, to predict his next move, to arrest him, to hold him in our grasp, both physically and mentally. But in his heroic role as invisible author, who endlessly teases, beguiles, and tricks us, he ultimately eludes us. He is like his own Sebastian Knight, "that same type of writer who knows nothing ought to remain except the perfect achievement," and this perfect achievement is a luminous, transparent text—a prism, a crystal kingdom of diaphanous imagination. Assuming the role of Wells's invisible villain, Nabokov magically transforms the figure of unbounded evil into the lucent personification of goodness, the very agent of aesthetic bliss.

In the wonderland of his prose Nabokov retained the sense of magic and metamorphosis in his childhood readings. Although, as he once said, Jules Verne, Emmuska Orczy, and Arthur Conan Doyle eventually "lost the glamour and thrill they held for me," this loss of fascination occurred after their works had entered into the bloodstream of his imagination. Like Lewis Carroll, Robert Louis Stevenson, and H. G. Wells, they continued to nourish him throughout his career. With the exception of Orczy, all of these writers are in fact major figures, although their reputations are indeed curious and grow curiouser and curiouser. Lewis Carroll's Alice books seem to shift in our minds from their place as books of our childhood to their status as ingenious philosophical works for adult readers; and they continue to oscillate in our imagination between these two poles. Stevenson's and Verne's reputations are also equivocal, colored by the fact that most of us encountered them in childhood. It is as if, for all our attention to childhood—some would say our obsession with it—we scanted its importance in our literary culture. For what place do Stevenson's tales of adventure have in the current history of literature, and how is Verne regarded in the history of French literature? Yet there is something to be learned from that shelf of Sebastian Knight's library where *Alice in Wonderland* and *Ulysses* stand side by side. No, Lewis Carroll's book is not so ambitious or great a work as Joyce's novel, but their continuity in Nabokov's mind suggests, in addition to their shared word-play and parody, the fact that our literary culture, our taste and sensibility, are indissolubly compounded out of both childhood and adult reading. In Nabokov's sense of consciousness and memory, the childhood experience of books remains powerfully alive and fundamental to our mature experience of literature, perhaps more than we ourselves, perhaps more than anyone since Wordsworth, would allow.

By the same token, we are similarly skeptical that the popular writings of

Wells and Doyle, whether or not we first encountered them in childhood, can be regarded as major fiction. Part of our reluctance to take these works as seriously as we might has to do with the fact that they are stories of adventure, stories that are easily accessible, whereas our sense of the modern canon is of works formally and psychologically both complex and difficult. Without making the claim that the Wells or the Doyle of the 1890s, the heroes of Nabokov's childhood, are of the same stature as, say, Thomas Hardy, we can begin to see, thanks to Nabokov, that Doyle was "one of the great dramatic writers" of his age, especially in the comic vein, that early in his career Wells was indeed "a great artist." Because these and many of the favorite writers of Nabokov's childhood continue to be widely read and influential, Nabokov's wondrous transmogrification of their works into his own invites us to ponder their enduring role in our cultural life and to recognize the very art he discovered in them. They thus encourage us, at the last, to see Nabokov's and our connections to the world of late-Victorian England, over which a ghostly aesthete still hovers, holding us, its amateurs, in thrall.

Part II:
Pater and the Tradition of Aesthetic Criticism

7 Poetry in the Interpretation of Art

I sincerely believe that the best criticism is the criticism that is entertaining and poetic; not a cold, analytic type of criticism, which claiming to explain everything, is devoid of hatred and love, and deliberately rids itself of any trace of feeling, but, since a fine painting is nature reflected by an artist, the best criticism, I repeat, will be the one that is that painting reflected by an intelligent and sensitive mind. Thus the best accounts of a picture may well be a sonnet or an elegy.
—Charles Baudelaire, "Salon of 1846"

The history of writing about art is an indissoluble part of the history of literature itself. From Homer's description of the shield of Achilles to Wallace Stevens's meditation on "the necessary angel," we can trace a continuous tradition of writing in which poets and poetical prose writers have written about the beauty of paintings and sculptures, have evoked their own intense, often complex experiences of art and, at the same time, have implicitly interpreted the meaning of these works, often in a manner not inconsistent with the intentions of the artists who wrought them. Two basic threads of writing about art are woven through the history of literature, through poetry, fiction, history, and other literary genres. We can chart the course of poetry about art from Homer and Anacreon to Poliziano and Bembo, to Marino and Marvell, to Keats and Browning, and, finally, to Stevens and Ashbery. Or we can follow the tradition of rhetorical and poetical prose on art that descends from Philostratus to Vasari and Winckelmann, to Ruskin and Pater, to Baudelaire and Proust, to the poetical current of art-historical scholarship, reflected in the writings of Bernard Berenson, Kenneth Clark, and Sydney Freedberg.

Writing self-consciously in the poetical tradition of Ruskin, Pater, and Berenson, Kenneth Clark recently called attention to the literary character of

writing about art, speaking of "art history and criticism as literature."[30] His observation is a reminder that art history and criticism are a part of literature, that they were always thought of as such, at least before the advent of professional art history in the nineteenth century. Pater's writings on art can be seen either as pure poetry, as Yeats's rendering of his Mona Lisa suggests, or as prose poetry. But as we have also seen, Pater's poetical writing offers us valid interpretation of art. Pater's work is representative of the broad tradition of imaginative writing about art that renders valid interpretation in a poetical manner. Pater, we might say, brings poetry to scholarship, scholarship to poetry.

Poets have always aspired to be "painters" in words, seeking to create in Dante's phrase "visible speech." As Petrarch said, Homer was "the first painter" of the great deeds of ancient Greece, and Elizabeth Bishop spoke for all poets when, translating the words of Octavio Paz, written in contemplation of the work of Joseph Cornell, she said: "my words become visible for a moment." We have already seen that Pater sought to be a painter in poetical prose or pure poetry, equating in a Baudelairean way the lyricism of writing with the music of Venetian painting, re-creating its sonorous color in his own Giorgionesque idyll. One might say that Pater, like such writers before him as Vasari and like subsequent critics, aspired to "perform" paintings in words, as if his performances were comparable to musical interpretation upon an instrument. The writer's instrument is language and his performance is never arbitrary, for just as we always recognize the music of Beethoven or Bach, whatever license is taken by the musician, so we recognize Giorgione or Botticelli in Pater's performance, notwithstanding the fantasy in his playing of their works. Different musicians bring out different intentions or qualities in what they play, depending on their own musical temperaments. Just so, writers about art illuminate diverse qualities in the work they describe or play, as when Pater speaks of the "sweetness" of Michelangelo, what Vasari might have called his *dolcezza*, or when he refers to the artist's "strength," what Vasari might have denominated his *forza*.

Such writing is not just description, since descriptive writing, however unanalytic it might appear to be, is itself inevitably interpretive. Moreover, poetical descriptions or interpretations are not necessarily fanciful because they are highly metaphorical. On the contrary, metaphors often point to the truths that art itself seeks to express. The critic or historian may, in Oscar Wilde's or for that matter Pater's sense, become himself an artist in order to render these truths. If we take a broad view of writing about art as literature, in which poetry plays a principal role, we discover some of the interrelations between history, poetry, and fiction. Doing so, we define the tradition to which Pater belongs, a tradition that extends beyond the confines of the nineteenth century. Charting this history, we see that poetry about art is

doubly about art, because invariably it is not only the work of art it describes but the previous poetry about art that it emulates and assimilates. Not surprisingly, the poetry of Keats, which so influenced Pater's interpretation of Giorgione, has played, as we shall see, a significant role in the history of writing about art in the modern period.

In this period, and probably in the entire history of literature, Giorgio Vasari is the greatest writer about art.[31] Father of modern art history and criticism, as he is often called, Vasari is a highly imaginative writer who employs fictional or poetical devices to illuminate the art he describes and thus interprets. Vasari's biographies in his monumental work of the sixteenth century, the *Lives of the Artists,* are for the most part metaphorical, his amusing anecdotes meditations on the powers of art. For instance, he tells us that Spinello Aretino was visited in his sleep by a "horrible and deformed" demon he had painted in one of his frescoes. The painter awoke in terror, "half crazy," and died a short time later. Vasari's tale obviously is a reflection on the convincing illusion of the grotesque and diabolic, but it is also a commentary on the sheer force of the artist's illusion, what Vasari calls its *forza.*

Vasari's kind of art criticism has endured. In the nineteenth century Charles Dickens implicitly emulated it in his *Pictures from Italy.* Describing the brutish, monstrous figures of Giulio Romano's *Fall of the Giants* (Fig. 8), Dickens observes that these figures "are immensely large and exaggerated to the utmost pitch of uncouthness; the colouring is harsh and disagreeable; and the whole effect more like (I should imagine) a violent rush of blood to the head of the spectator, than any real picture set before him by the hand of an artist." As if assimilating Giulio's painted characters into a Victorian tale of horror, Dickens goes on to say, *à la* Vasari, that the "apoplectic performance was shown by a sickly-looking woman, whose appearance was referable, I dare say, to the bad air of the marshes; but it was difficult to help feeling as if she were too much haunted by the Giants, and they were frightening her to death." The playful spirit of Dickens's account is compatible with Giulio's amusing depiction of such oafish subjects. But what is important to notice is that both writers attempt to re-create the painter's illusion by employing a similar tone of immediacy, both physical and psychological. The art critic creates a literary interpretation of the work that evokes the painting's energies or force. Through language, the critic brings the painting to life.

The literary quality of Vasari's art criticism resides in large measure in the use of tall tales to express the character of art. Vasari's fictions about artists are conceived as analogues to their works. In his portrait of Fra Filippo Lippi, Vasari expresses the impulsive energies, high spirits, and vitality that mark many of the monk's paintings. According to Vasari, Lippi, famous for his amorous "appetites," attended so little to his work that his patron resorted to imprisoning the painter. "Having him paint a work in his palace, Cosimo de'

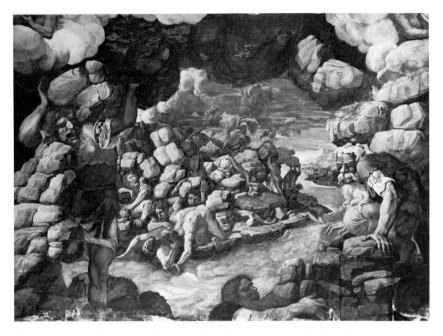

FIG. 8. GIULIO ROMANO, *The Fall of the Giants.* Palazzo del Te, Mantua.

Medici would close him in so that he would neither lose time nor escape; but remaining shut in for two days and driven by an amorous, indeed bestial, fury, one evening, with a pair of scissors, he made a rope from his bedsheets, and lowering himself with it from his window, he fled to pursue his pleasure." Finally, Cosimo was forced to give Lippi his liberty to leave the palace when he pleased. The story not only delineates both the patron's eventual wisdom and the painter's libidinous impulses, but it is also a metaphorical commentary on the sheer exuberance and dynamism of Lippi's works. Vasari's tale illustrates the basic dictum of the Renaissance, ascribed to Cosimo de' Medici: "Every painter paints himself." Recorded by Vasari, Cosimo's remark has found its way into the modern definition of the Renaissance as the period when the personal vision of the artist emerged.

Vasari's story was the source for Browning's nineteenth-century poem "Fra Lippo Lippi." Browning gives flesh to Vasari's sketch of Lippi by having the monk gab with great gusto about art and life:

> I am poor brother Lippo, by your leave!
> You need not clap your torches to my face.

> Zooks, what's to blame? you think you see a monk!
> What, 'tis past midnight, and you go the rounds,
> And here you catch me at an alley's end
> Where sportive ladies leave their doors ajar?
> The Carmine's my cloister: hunt it up,
> Do,—harry out, if you must show your zeal,
> Whatever rat, there, haps on his wrong hole,
> And nip each softling of a wee white mouse,
> Weke weke, that's crept to keep him company!
> Aha, you know your betters! Then, you'll take
> Your hand away that's fiddling on my throat,
> And please to know me likewise. Who am I?
> Why, one, sir, who is lodging with a friend
> Three streets off—he's a certain . . . how d'ye call?
> Master—a . . . Cosimo of the Medici,
> I' the house that caps the corner. . . .

Just as Vasari's Lippi emerged from Boccaccio's Florence, Browning's seems to flourish in Dickens's London. Browning has the monk talk a blue streak before the climax of the poem, a vivid description of *The Coronation of the Virgin* (Fig. 9):

> I shall paint
> God in the midst, Madonna and her babe,
> Ringed by a bowery flowery angel-brood,
> Lilies and vestments and white faces, sweet
> As puff on puff of grated orris-root
> When ladies crowd to Church at midsummer.

Lippi's sensuous view of the world is the antithesis of the ethereal vision of another painter-monk, Fra Angelico. Vasari tells us that Angelico never took up his brush without offering a prayer to God. Every time he painted the Crucifixion "tears flowed from his eyes." Angelico was good and pure and like the heavenly saints that he painted in his *Coronation of the Virgin* (Fig. 10). So "delicate" and "sweet" are the "blessed souls" depicted there that "it seems as if they were painted by a saint or by an angel." In the same period that Browning embellished Vasari's commentary on Lippi, the poet and art critic Théophile Gautier echoed Vasari's exalted picture of Angelico and of the painter's *Coronation* in his guidebook to the Louvre:

> Time has not dulled the ideal bloom of the painting, which is as delicate as a missal miniature, and the tints of which are borrowed from the whiteness of the lily, the roses of dawn, the azure of the sky, and the gold of the stars. . . . Fra Beato Angelico invented for these young saints a virginal, immaterial,

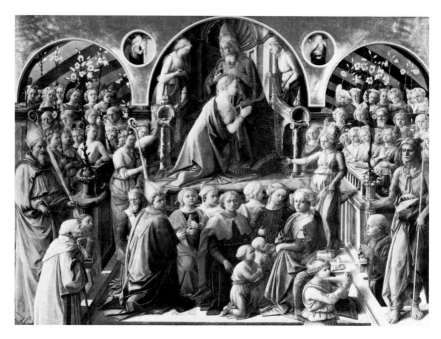

FIG. 9. FRA FILIPPO LIPPI, *The Coronation of the Virgin*. Uffizi, Florence.

celestial beauty of which no earthly type exists; they are souls made visible, rather than bodies, —forms of thought arrayed in chaste white, rose, blue starred, embroidered draperies, such as must be worn by the blessed who enjoy the eternal day of paradise. If there are any pictures in heaven, they must resemble those of Fra Angelico.

In Gautier's rendering of Angelico we recognize the same celestial aspect of the painter's art so precisely described by Vasari.

Vasari's fashion of describing artists can be found in the poetry of Gautier's protégé, Baudelaire. Relying on religious imagery, Vasari spoke of artists as "lights" shining brightly as examples to the artists of his own day. For Vasari those artists who restored art to life in the fourteenth century were *i primi lumi*, the first lights; Ghiberti was later a "saintly light," and finally Michel-angelo, the greatest artist, was a "lantern" who brightly illuminated the art of Vasari's times. In like fashion, Baudelaire would speak of artists as "guiding lights" in his poem "Les Phares." Carrying the history of art forward from the Renaissance to the present, Baudelaire evokes Rubens, Rembrandt, Watteau,

Puget, Goya, and Delacroix—their art being, in Baudelaire's words, "the beacon" that "shines upon a thousand citadels."

Works of art themselves are for Vasari exemplary lights. From Raphael's *Transfiguration of Christ* there radiates both the "splendor" of Jesus and the painter's luminous manner of picturing such "immense light." Vasari expresses the unity of the painting's form and content; his description of light combines both religious symbol and the artist's style. With the visionary fervor of Vasari, Lord Byron would later describe the *Apollo Belvedere* (Fig. 11). Playing on the fact that Apollo is a heavenly body, the poet nearly transforms the marble of the statue into sheer radiance in "Childe Harold's Pilgrimage"—picturing the bright flash and lightning of the "Sun in human limbs array'd."

As if with Byron's poem in mind, Rainer Maria Rilke would similarly describe an archaic torso of Apollo as glowing like a candelabrum—"wie ein Kandelaber," its contours like a star, "wie ein Stern." The dazzling effect of the torso is so intense that it seems to demand of us a transformation of our lives: "Du musst dein Leben ändern," it insists—"you must change your life." Just as the light of Apollo had been assimilated into the Christian

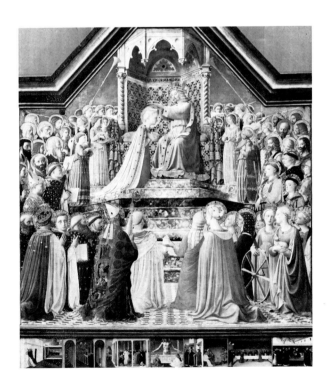

FIG. 10. FRA AN-
GELICO, *The Corona-
tion of the Virgin*.
Louvre, Paris.

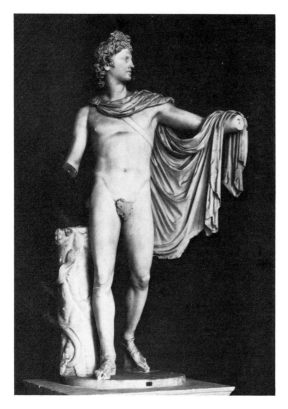

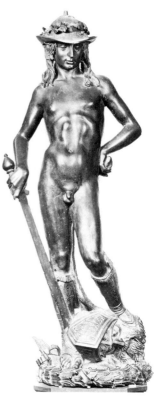

FIG. 11. *Apollo Belvedere*. Vatican Museum, Rome.　　FIG. 12. DONATELLO,
David. Bargello, Florence.

conception of Jesus, who became an Apollonian type in theology, art, and poetry—in the *Divine Comedy,* for example—so too was the light of both divinities gradually absorbed into the modern, secular notion of art. Although Rilke's Apollo seems to require a conversion of sorts on our part, such a transformation is free of explicit religious meaning.

In his emphasis on Apollo's virility, Rilke inspired Randall Jarrell's sexual musings in "The Bronze David of Donatello" (Fig. 12). Rilke had perceived the "slight turn of the loins" in the torso as a "smile." Jarrell similarly envisions "the rib-case, navel, nipples" of the *David* as "the features of a face." Focusing on the erotic play of Donatello's statue, Jarrell follows the part of Goliath's helmet, which "Grows like a swan's wing up inside the leg." Goliath "snores," says the poet, "in satisfaction."

Jarrell's poem, in turn, lies directly behind Richard Howard's "The Giant on Giant-Killing." Jarrell had insisted that while "the boy David dances, / Dances, and is exalted," Goliath is blessed: "Blessed are those brought low, /

Blessed is defeat, sleep blessed, blessed death." Drolly commenting on this state of beatitude and embellishing Jarrell's sensuous reveries, Howard's Goliath announces: "the triumph is mine." With amused pleasure, he asks us to "Notice the way my moustache turns / over his triumphant toe (a kind of caress, and not the only one)." When he admires David's "fertile torso," suggesting that "the body sees," Howard's Goliath addresses the triumphant youth in a manner reminiscent of Rilke overwhelmed by the torso of Apollo.

Howard's poem is written in a style derived from Browning's dramatic monologues. But whereas Browning's artist spoke, now it is the sculpture that speaks to us. What a bizarre variation on the myth of Pygmalion! The classical myth of a sculptor who creates a work of art that comes to life deeply informed Vasari's prototypical *Lives of the Artists*. Vasari tells us that Donatello's *Zuccone* seemed so real that the sculptor threatened it with a curse if it did not speak. "Favella, favella, che ti venga il cacasangue," he exclaimed— "speak, speak, or may you shit blood." In Richard Howard's poem Donatello's Goliath finally does speak. Paradoxically, it is the severed head, and not David, that speaks.

But it is not only poets who caressingly evoke the erotic powers of sculpture. Winckelmann's passionate lyric to the *Apollo Belvedere* (Fig. 11) in his eighteenth-century *History of Ancient Art* is one of the principal texts in the history of art criticism. Winckelmann's conceptions of art and of how to write about it depend on Vasari, and, like Vasari, Winckelmann relied on the earlier rhetorical and poetic traditions in his own vivid, rhapsodic prose. Gazing upon "the charms of youth, the graceful manliness of ripened years," he falls in love with what he tries to re-create in prose, and he compares his attempts to make a sculpture in words, then bringing it to life, to the efforts of Pygmalion. "My image," he says, "seems to receive life and motion, like the beautiful Pygmalion." In the manner of Renaissance poets, he offers his reader a catalogue of the charms of his beloved's "divine" head: his soft hair and proud forehead, his eyes "filled with sweetness," his nose and lips expressive of scorn. If Byron illuminated the stellar aspect of the *Apollo*, Winckelmann sees the statue instead as an earthly paradise. The *Apollo* is envisioned as "the happy fields of Elysium," his soft hair "agitated by a gentle breeze," conceived as if in Ovidian metamorphosis, as the "slender waving tendrils of the noble vine." Whereas the Renaissance poets beheld their beloved in a heavenly garden, Winckelmann now perceives his "Apollo" as "eternal spring" itself.

As in Winckelmann's art criticism, the pastoral theme is a dominant one in more recent poetry about art. It is central to Keats's "Ode on a Grecian Urn":

> Thou still unravished bride of quietness,
> Thou foster-child of silence and slow time,

> Sylvan historian, who canst thus express
> A flowery tale more sweetly than our rhyme:
> What leaf-fringed legend haunts about thy shape
> Of deities or mortals, or of both,
> In Tempe or the dales of Arcady?
> What men or gods are these? What maidens loth?
> What mad pursuit? What struggle to escape?
> What pipes and timbrels? What wild ecstasy?

Keats's rhetoric became fundamental to the nineteenth- and twentieth-century English and American poetry about art. Thus in the manner of Keats, Dante Gabriel Rossetti asks of Botticelli's *Primavera* (Fig. 13):

> WHAT masque of what old wind-withered New-Year
> Honours this Lady? . . .
>
> .
> What mystery here is read
> Of homage or of hope? But how command
> Dead springs to answer? And how question here
> These mummers of that wind-withered New Year?

Rossetti justly encourages us to see and hear the *Primavera* as a painted masque. His sense of the painting as a mystery is also apt, for the celestial quality of the image and Mercury's upward gaze toward the sun, which beams in his eyes, point to a meaning beyond what we can see.[32]

 In one of the major modern poems about art, "Seurat's Sunday Afternoon Along the Seine" (see Fig. 14), Delmore Schwartz still writes in the language of Keats:

> What are they looking at? Is it the river?
> The sunlight on the river, the summer, leisure,
> Or the luxury and nothingness of consciousness?

The subjects of Seurat's modern, urban pastoral are, as Schwartz says, "Icons of purified consciousness." Although the poem ends with great pathos, much of it is a celebration of the painting as a "permanent monument to Sunday's simple delight." "O happy, happy throng, / It is forever Sunday, summer, free," the poet hopefully exclaims, echoing Keats's celebration of eternal spring:

> Ah, happy, happy boughs that cannot shed
> Your leaves, nor ever bid the Spring adieu;
> And, happy melodist, unwearièd,
> For ever piping songs for ever new;

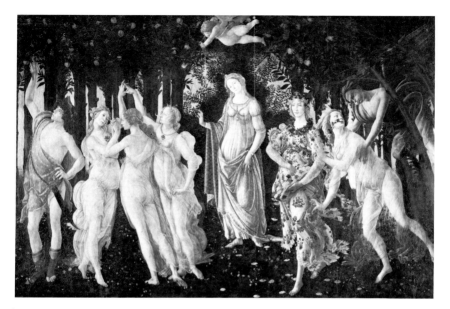

FIG. 13. BOTTICELLI, *Primavera*. Uffizi, Florence.

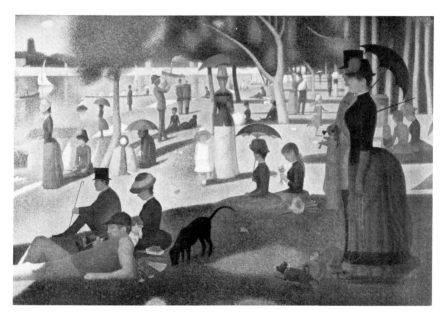

FIG. 14. GEORGES SEURAT, *La Grande Jatte*, 1884–86. Courtesy of The Art Institute of Chicago. Collection of Helen Birch Bartlett.

> More happy love! more happy, happy love!
> 　For ever warm and still to be enjoy'd,
> 　　For ever panting and for ever young;
> 　All breathing human passion far above,
> 　That leaves a heart high sorrowful and cloyed,
> 　　A burning forehead, and a parching tongue.

Keats's notion of the enduring joys of art is central to Gregory Corso's poem on Paolo Uccello's *Battle of San Romano*. Just as Keats's lovers "For ever panting" are "for ever young," Uccello's toy soldiers, engaged in a make-believe battle in the pastoral setting of an orange bower, "will never die." Wanting to enter the timeless realm of art, Corso dreams of joining "such a battle":

> a silver man on a black horse with red standard and striped
> 　　lance　　　never to die but to be endless
> 　　a golden prince of pictorial war

More than just a modern reverie on a fifteenth-century painting, Corso's poem brings alive the original spirit of romance and chivalry in Uccello's picture, which is indeed remote from the horrors of actual war.

As Keats's devices have become conventionalized, poets have played with them. In his poem on Pieter de Hooch, "A Dutch Courtyard," Richard Wilbur teasingly describes the Keatsian sense of the image enduring, just as it is, forever:

> This girl will never turn,
>
> 　Cry what you dare, but smiles
> Tirelessly toward the seated cavalier,
> Who will not proffer you his pot of beer;
> 　And your most lavish wiles
>
> Can never turn this chair
> To proper uses, nor your guile evict
> 　These tenants.

Wilbur goes on to joke about the irritating effect of the figures frozen still:

> 　What surprising strict
> Propriety! In despair,
>
> Consumed with greedy ire,
> Old Andrew Mellon glowered at this Dutch
> Courtyard, until it bothered him so much
> 　He bought the thing entire.

Like Wilbur and Corso, we all dream of passing through the looking glass of art, of entering the ideal paradisiacal world pictured before us, but the painting will never yield to our desires; the figures in it are "Immune to us." No matter, says Wilbur, for "What wholly blameless fun" it is "To stand and look at pictures."

Fun is precisely what Horace Gregory has in his poem about Titian, "Venus and the Lute-Player." Here the Keatsian theme becomes farcical as Titian's goddess comes to life and speaks to us:

> I am eternal
> Even beyond the sight of artful men.
> My presence wakes or sleeps, silent, unsought
> Within a darkened room; I need not rise or speak.
> I, the world's mistress, remain indifferent
> To strings that tremble, to reeds that blow.
>
> I am what you seek,
> And all you need to know.

By the time Gregory wrote his own poem, Keats's "Beauty is truth, truth beauty" had been repeated and interpreted so often that his words had become, like the infinite reproductions of the *Mona Lisa* or the classic themes used as pop tunes in movies, kitsch-gilded clichés, equivalent to the advertisement of a perfume as "a joy forever." This trivialization of art is exploited by Gregory, if in an ambiguous way. His little monologue of Venus, still with a touch of Browning in it, properly evokes Titian's goddess. Indifferent to her adoring madrigalist and to us, she appears with an air of hauteur—*superba,* as the Italian Renaissance poets might have said.

Several of the poems from which we have quoted are playful in spirit and seem to play with the very pictures they describe. Much of this writing is also very sensuous in character. We find a combination of such playfulness and sensuousness in another poem about a Renaissance Venus, Michael Field's "Botticelli's *Venus and Mars*," published in 1892 in the little book, *Sight and Song.* The authors, Katherine Bradley and Edith Cooper, who wrote under the pseudonym of Michael Field, were both friends and disciples of Walter Pater. They deftly describe the satyrs in Botticelli's *Mars and Venus* (Fig. 15) as "little powers on wooly hips" who "are gay as children round a nurse they love." This nurse is Venus, who "rears from off the ground / As if her body grew / Triumphant as a stem." Below her lies the vanquished god of war, Mars, "in perfect death / Of sleep that has no spasm." His "naked limbs" are "fallen in wearied curves," "their fury spent." Traditionally, or at least until recently, the erotic aspect of Botticelli's painting has not been much discussed. Art historians have preferred to dwell on the allegorical character of the painting, which is certainly part of its meaning. They have also not had

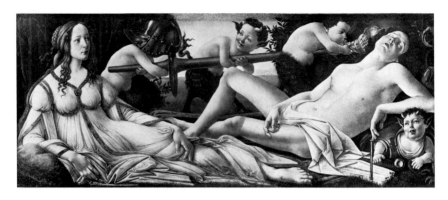

Fig. 15. Botticelli, *Mars and Venus*. National Gallery, London.

much to say about the ludic quality of the painter's art. How charming, then, to think that two Victorian spinsters should so justly and pointedly evoke the voluptuous subject and tone of Botticelli's painting and its facetious spirit. They bring out a playfulness that had already been alluded to by Vasari, who discussed Botticelli's jokes and jests. To the catalogue of such jests, Michael Field tells us, we should add the painter's *Mars and Venus*.

The language of the poets was assimilated by the English Romantic art critics. If William Hazlitt likened the experience of paintings to a "happy, noiseless dream," then these critics brought speech to such mute dream images. Hazlitt even began his famous essay on Poussin's *Orion* by quoting from Keats to help picture the blind giant who stalks: " 'And blind Orion hungry for the morn' . . . reels and falters in his gait, as if just awakened out of sleep." Other poets were similarly invoked by the Romantic critics. Describing Turner's *Jason*, John Ruskin uses Wordsworth's words to imagine its "intertwisted fibres serpentine." Picturing Turner's *Slave Ship*, Ruskin seems to be writing in the manner of Coleridge. Ruskin beholds the "lurid splendour which burns like gold and bathes like blood." Coleridge had similarly envisioned under the "bloody sun" a "painted ship" upon "a painted ocean," its "waves all aflame." Painter, poet, and critic alike embrace their subject with an imaginative fervor that is mirrored in their style.

Exactly in this romantic tradition of Hazlitt and Ruskin, of the critic as poet, as painter in words, we encounter Pater. It is not surprising that Yeats would later transpose Pater's hymn to the *Mona Lisa* into free verse, placing it as the first poem in his *Oxford Book of Modern Verse*:

> She is older than the rocks among which she sits;
> Like the Vampire,

She has been dead many times,
And learned the secrets of the grave;
And has been a diver in deep seas,
And keeps their fallen day about her;
And trafficked for strange webs with Eastern merchants;
And, as Leda,
Was the mother of Helen of Troy,
And, as St. Anne,
Was the mother of Mary;
And all this has been to her but as the sound of lyres
And flutes,
And lives
Only in the delicacy
With which it has moulded the changing lineaments,
And tinged the eyelids and the hands.

However remote Pater's re-creation of the *Mona Lisa* seems from the paint-
ing, it nevertheless expresses in a metaphorical way something fundamental
in Leonardo's work (see Fig. 5). The image of the Florentine lady is seen by
Pater in terms of his own Faustian quest for universal knowledge that else-
where he associates with Leonardo's studies. She embodies all of history, or
more specifically, all of historical knowledge and consciousness. For Pater she
sums up "all modes of thought." This is a correlative of Leonardo's own
curiosity, his own broad experience and learning, his own universality. Pater
is saying anew: "Every painter paints himself." Modern critics tend to think
of this special interest in the relation of the artist's life and personality to his
work as peculiar to biographical criticism of the nineteenth and twentieth
centuries. Pater's notion, however, has its roots in the Renaissance.

 Pater's intuitions are sometimes so subtly stated that his formulations are
often not recognized for what they are. Speaking of the "solemn effects" of
moving water in Leonardo's art, he observes that "the motion of great wa-
ters" is one of Leonardo's deepest themes. Pater's observation has become a
commonplace in the more conventional prose of recent art history, but art
historians, who have reacted fiercely to the so-called amateurism and appre-
ciationism of nineteenth-century criticism, seem unaware of the origins of
this theme in their own work. One suspects that their lack of awareness stems
from the fact that Pater's approach is poetic. They could not possibly be
dependent on such impressionist writing. Their point of view is epitomized
by the great art historian Erwin Panofsky, who once claimed, in a curious
lapse of understanding, that whereas the historian is objective in his view of
things the poet merely renders his impressions. Pater is too much the poet.[33]

 But the poet in the critic can often tell us so much more than the profes-
sional art historian. For Pater, as for Wordsworth, water is a symbol of both
time and consciousness. As he follows the course of the waters flowing

through Leonardo's work, he seems in pursuit of the motions of the artist's intellect. Commenting on the essence of the artist's mind, Pater implicitly connects the painter himself with the Mona Lisa, who "has been a diver in deep seas." But the motions of water are also for Pater a symbol of the "perpetual flight" that typifies our impressions in the modern world, the flux that he compares to a "whirlpool." Against this "stream" of impressions, he holds up the ideal of art, the moment "into which . . . all the motives, all the interests and effects of a long history have condensed themselves, and which seem to absorb past and future in an intense consciousness of the present."

A critic's words must be equal to the painterly language of the artist. Like the artist, the critic also must be able to render what Wallace Stevens spoke of under Pater's spell as "the fluctuation of the whole of appearance." Often our best critics are poets. Certainly, Stevens's "The Man with the Blue Guitar," a poem inspired by Picasso's painting from the artist's Blue Period, is not only one of the greatest poems about art of our century but is also exemplary art criticism (Fig. 16).

Picasso's figure, "merely a shadow hunched / Above the arrowy, still strings,"

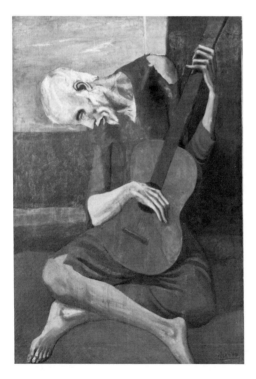

FIG. 16. PABLO PICASSO, *The Old Guitarist*, 1903. Courtesy of The Art Institute of Chicago. Helen Birch Bartlett Memorial Collection.

is recognizable in Stevens's meditation. But the painting also becomes the vehicle for the poet's own musings as he soars far beyond the image. Describing the guitarist, who plays "A tune beyond us," Stevens is speaking of his own poetry. If nineteenth-century poetry about art had expressed the "visionariness" of Romanticism, Stevens's poem epitomizes the interior world of twentieth-century consciousness—"The world washed in his imagination." Stevens quotes Picasso to suggest that his poem is like the painting—"a hoard of destructions"—the complex, rhythmic assemblage of the fluctuation of experience, transmogrified by the imagination. All art, Pater had said, speaking for his age, aspires to the condition of music, and his own music had been written in sinuous, honeyed melodies, the sound of "lyres and flutes." Now Stevens is "jangling the metal of the strings," making a "buzzing" melancholy music in tune with the doleful strains of Picasso's picture.

Two poems stand in direct line of descent from Stevens's. The first is Delmore Schwartz's "Seurat's Sunday Afternoon Along the Seine," which I briefly considered in regard to Keats. In its brooding on time and consciousness, Schwartz's poem recalls Stevens's work. Stevens had spoken of "A tune upon the blue guitar / Of things exactly as they are." Schwartz, comparing Seurat's painting to the music of Mozart, similarly refers to a "micro pattern" of the "imagined macrocosmos"—"all things big and small." Looking to Seurat's figures as symbols of "purified consciousness," Schwartz broods on the "wastes" of "so many days and years of consciousness"; and for all his ideals and hopes, he completes his meditation in "The voice of Kafka, forever sad." Having begun with a hopeful, Keatsian vision of a "happy, happy throng," Schwartz concludes in despair, his sorrow even more intense than Stevens's melancholy.

John Ashbery's *Self-Portrait in a Convex Mirror* (see Fig. 7) also echoes Stevens. In fact we can see that it is almost dependent on Stevens: "That is the tune but there are no words. / The words are only speculation. . . . They seek and cannot find the meaning of the music." Ashbery's reflections on Parmigianino's painting recall Schwartz's thoughts on Seurat as well. Just as Seurat's picture "has gone away / Has gone to Chicago," Parmigianino's portrait has gone from Rome to "Vienna where the painting is today, where / I saw it with Pierre in the summer of 1959." Ashbery's poem is written in "New York / Where, I am now, which is a logarithm / Of other cities." Like Schwartz, Ashbery follows the painting through time and space; but traveling further, drifting into finer, more nuanced memories, he still sees the "filiations" of the picture made in the distant past, beheld long ago, with the present. The clock of history seems to melt as the poet metamorphoses himself into the painter. Ashbery's artifice mirrors the mannered style of Parmigianino, whose self-portrait becomes the poet's own.

Published just over a decade ago, Ashbery's poem occupies a special place

in the history of writing about art. In a sense, his poem recapitulates the history of this tradition. Ashbery returns directly to Vasari's description of the painting, quoting and summarizing the earlier author's account of how the painting was made, of how it "stupefied" Pope Clement VII and his court. Interwoven through the poem are other incidents from Vasari's life of the artist. Ashbery reads Vasari as Browning did—to associate the artist's self with the self reflected in his work. But in place of Browning's dramatic monologue we now find a sort of interior monologue. Beholding "the enchantment of self with self" in Parmigianino's painting, Ashbery also echoes Stevens's self-consciousness, the "thinking of thoughts I call my own." He calls the painting a *bizarria,* borrowing the word from Sydney Freedberg's exquisite book on the painter. But Freedberg had already taken the word, which suggests the very capriciousness and pleasing oddity of the deformed image, from Vasari. Ashbery embellishes this bizarre effect, making his own "bizarria" when he speaks of Parmigianino's hand "like a dozing whale on the sea bottom." Enhanced by other allusions to swimming and water, this image is apt because it evokes the nearly subaqueous space of the picture, which, "englobed," is likened to a fishbowl.

Vasari, Browning, Pater, Stevens, Schwartz, Freedberg—all of these writers inform Ashbery's poem, which may be the longest and most ambitious poem about art ever written. More than 550 lines, it by far exceeds in length the monumental poems on art by Browning, Stevens, and Schwartz, or, for that matter, the long poems on Picasso by Rilke and Prévert. Given the high degree of self-consciousness reflected in Ashbery's work—"the enchantment of self with self"—we cannot doubt that he has sought to create a monument in the history of poetry about art.

For Ashbery, Parmigianino's painting englobes or encapsulates history and consciousness. If Pater's Mona Lisa "embodied" the "fancy of a perpetual life, sweeping together ten thousand experiences," and if Stevens's guitarist symbolized a "swarm of thoughts," "the swarm of dreams," Ashbery's self-portrait absorbs into itself "all time," for it is the "suspension" of "Today" with "Yesterday." The analogue to Ashbery's Proustian remembrance, his Paterian condensation of past and present, his Stevensesque hold on the fluctuation of experience, is found in his intricate network of historical references from the Renaissance to the present, which also includes allusions to Shakespeare and Mahler and, more generally, to modern philosophy and French poetry. Like Pater's Mona Lisa, who stands for "All the thoughts and experience of the world," Ashbery's portrait, his own Mona Lisa of sorts, personifies "all modes of thought and life." Whereas in the Renaissance painting had been perceived as a mirror of nature, now, in the modern era, pictures have become icons of consciousness—both of the history of thought in general and of the beholder's

self in particular. In the poet's vision of art criticism, these two histories, filtered through reverie, are self-consciously intertwined.

Our best writers—whether art historians and critics like Vasari and Pater or poets like Browning and Ashbery—have transformed paintings and sculptures into words, absorbing them into their own experiences and thus teaching us ways of seeing these works. The mysterious world of the image—the strange phantasm that belongs neither solely to the painters nor the poets—emerges from darkness into light when our best minds contemplate art. The image becomes speech that takes on shape and color, only to be re-uttered, then pictured anew, rephrased, envisioned again, gradually multiplying in its myriad forms into the inseparable histories of art and literature. There is no history of art without a history of literature, no history of literature apart from the history of art. Together painters, poets, and critics provide us with a picture of the world, ever changing, ever being transformed by the course of events, by consciousness itself, but ever valuable to the extent that this picture helps us to imagine ourselves, to dream, if for but a moment, of our place in the fleeting scheme of things.

8 Vasari and Imaginative Literature

His [Leonardo's] legend, as the French say, with the anecdotes which every one remembers, is one of the most brilliant chapters of Vasari.
—Walter Pater, "Leonardo da Vinci," The Renaissance

F irst published in Florence in 1550 and revised in amplified form in 1568, Vasari's *Lives of the Artists* is the foundation of all modern art history. All histories of art descend from Vasari's—from the numerous biographies of the seventeenth and eighteenth centuries down to the seemingly infinite specialized monographs of our own day. When Crowe and Cavalcaselle wrote their monumental history of Italian art in the mid-nineteenth century, they followed Vasari closely. And Pater, who facetiously referred to these authors as the "new Vasari," also followed Vasari, not only using anecdotes from the *Lives* but emphasizing the role of the Florentine school, which figures in four of his five essays on art.

Following the example of Pater's formalism, Bernard Berenson virtually rewrote Vasari's *Lives* in a compressed, even more strictly formal history of art when he published *The Florentine Painters.* In more recent scholarship, Vasari's aesthetics, some would say biases, remain alive in the prose of those scholars whose work descends from the nineteenth-century tradition of Pater and Berenson; for example, in Sydney Freedberg's *Painting in Italy: 1500–1600,* as well as in Frederick Hartt's *History of Italian Renaissance Art.* One of the reasons Hartt's book has been so popular with students is that, like Vasari's *Lives,* it reads like fiction. This is not to say that Vasari and his most recent follower, the "newest Vasari," write mere fiction; on the contrary, their work is indeed historically sound and informative. But like the finest fiction, their writing is especially absorbing because of its vibrant narrative structure. Vasari proudly tells the story of the rise of Florentine art, and Hartt, in a kind of political allegory, stresses the role of freedom in Florentine

republican art and of individual character that the Republic exalted: "Through two and a half centuries these qualities, in crisis and in triumph, in failure and success, had inspired and directed one of the great periods in the history of human artistic imagination."

The overwhelmingly vast scholarship on Vasari indicates his place in the history of art history. Insufficient attention has been paid, however, to the extent to which his book both belongs to the history of imaginative literature and has influenced this tradition in modern times. When Pater relied upon Vasari, responding to him imaginatively, he was reading Vasari as both historian and poet, for Pater found both poetry and history interwoven in the *Lives*. Such poets or poetical critics as Browning, Gautier, Baudelaire, and, most recently, Freedberg and Ashbery, all relied either explicitly or implicitly on Vasari in their poetry, history, or criticism. It is of particular interest that the first three of these writers all significantly influenced Pater and that the latter two wrote in his tradition.

To this group of imaginative writers who assimilated Vasari we can add Walter Savage Landor, whose "imaginary conversation" between Filippo Lippi and Pope Eugenius IV both echoes Vasari and is absorbed into Browning's poem about the artist. The twentieth-century poet Giovanni Pascoli also depends on Vasari for his long poem on Paolo Uccello in his *Poemi Italici*, as does Italo Calvino, whose more recent poetic reverie on Uccello in *Antaeus* (Summer 1985) echoes Pascoli. In fiction we find Vasari incorporated in Wilhelm Heinse's eighteenth-century novel about the Renaissance, entitled *Ardinghello*. And George Eliot, like Pater, a close reader of Vasari, relied heavily upon the *Lives* for her vivid depiction of the age of Savonarola in her novel *Romola*—a book read by Pater a short time before he wrote *The Renaissance*.

In particular, Eliot relied on Vasari's famous biography of the eccentric Piero di Cosimo. The following selection from chapter 18 of *Romola*, depicting Piero's house, gives an indication of how Eliot ornamented Vasari's original account of the artist:

> All about the walls hung pen and oil sketches of fantastic sea-monsters; dances of satyrs and maenads; Saint Margaret's resurrection out of the devouring dragon; Madonnas with the supernal light upon them; studies of plants and grotesque heads; and on irregular rough shelves a few books were scattered among great drooping bunches of corn, bullocks' horns, pieces of dried honeycomb, stones with patches of a rare-colored lichen, skulls and bones, peacocks' feathers, and large birds' wings. Rising from amongst the dirty litter of the floor were lay figures; one in the frock of a Vallombrosan monk, strangely surmounted by a helmet with barred visor, another smothered with brocade and skins hastily tossed over it. Amongst this heterogeneous still life, several speckled and white pigeons were perched or strutting, too tame to fly at the

entrance of men; three corpulent toads were crawling in an intimate friendly way near the doorstone; and a white rabbit, apparently the model for that which was frightening Cupid in the picture of Mars and Venus placed on the central easel, was twitching its nose with much content on a box full of bran.

Eliot alludes here to Vasari's description of the artist's strange behavior and its relation to his equally bizarre work. Not only does Vasari enrich Eliot's fiction, but, through it, he deepens our appreciation of the painter's delightfully capricious art.

A short time after Eliot wrote her book, the Blashfields, in their introduction to Vasari's work, illuminated the novelistic character of the *Lives:*

> What warmth and vitality this vivid local color imparts to the biographies! With Vasari and his people we visit every corner of Florence; we climb the stairs of the Palazzo Vecchio, we hobnob with Duke Cosimo in his study among his treasures, we chaffer for eggs and fruit in the old market, we watch the fight between Republicans and Mediceans in the square, we sup in the Piazza of the Nunziata with all the madcap artists in Florence, we walk in the funeral procession of Michelangelo to Santa Croce, we peep into Giotto's house in the Via de' Servi, and enter Donatello's *bottega* near the cathedral, we loiter in Ghirlandajo's shop in the Calzoleria, we pace the cloisters of San Marco with Fra Angelico; the convent doors open for us and we lean over Sister Plautilla Nelli's easel; the Medici palace has no secrets for us, and we see Duke Alexander in full armor and state-mantle posing for Vasari, or the young Catherine de' Medici, paint-brush in hand, chasing the good Giorgio down the long corridor; we can study Masaccio with the young painters in the quiet chapel of the Brancacci, and in the great hall of the old palace, while the factions are fighting outside we can watch the students dividing Michelangelo's cartoon for the battle of Pisa, into coveted fragments; the young Raphael, just come from Urbino with letters from his duchess to the *Gonfaloniere,* leads us to the palace of his hosts in the Via de' Ginori, and gorgeous in brocade and jewels Leonardo da Vinci rides by on one of his fiery horses.

It is as if the Blashfields were reading Vasari through Eliot or Dickens, seeing the rich variety of Vasari's characters and their social world in Florence in relation to the teeming vitality of Dickensian London.

The Blashfields' account is highly generalized, but it alludes to numerous novelistic anecdotes and dialogues in the pages of Vasari as he records the conversations, passions, jests, and social and political life of his subjects. The sweep of Vasari's book, which embraces the entire social world of the artist, is antecedent to those nineteenth-century cycles of novels that purport to record the overall history, the life and time, of a city. Just as Balzac saw himself as the "secretary" recording the totality of life in nineteenth-century Paris, Vasari was a sort of cinquecento Balzac reporting the rich pageant of Florentine history.

Particular nineteenth-century fictions seem to echo some of Vasari's tales. For example, Balzac's story "The Unknown Masterpiece," which deals with the obsessive perfectionism of the painter Frenhofer, is reminiscent of Vasari's famous account of Leonardo's quest for an unattainable perfection, his related incapacity to complete works on account of this self-defeating aspiration. Numerous novels, particularly about artists in Paris—for example, the Goncourts' *Manette Salomon* and Zola's *L'Oeuvre*—depend on the novelistic tradition of writing about artists perfected by Vasari. Zola's accounts of the *cénacles* and conversations of artists about art descend from Vasari's countless descriptions of similar gatherings, dinners, and banquets—tales of camaraderie, festivity, and conviviality in the spirit of art. Even the Bohemian life of nineteenth-century artists romanticized by Henry Mürger and others has roots in Vasari's stories of artists as eccentrics and hermetic recluses.

In the modern literature there are virtually hundreds of novels and stories about artists, from Hawthorne's *The Marble Faun* to John Berger's *A Painter of Our Time*. Such fictions are a distinctive literary genre, attesting that by the nineteenth century the artist had become a "hero" or "representative" man in Carlyle's or Emerson's senses of these words. Vasari's *Lives,* standing at the beginning of this tradition, are the foundations of the modern myth of the artist as hero. We should pause to recall that when Pater wrote at the end of the nineteenth century about Vasari's artists, endowing them with the attributes of fictional characters, he wrote as Vasari's heir.

If Vasari has enriched the modern fiction about art, he relied heavily upon earlier traditions of such writing. It is well known that he exploited the novelistic current of writing about painters, notably the tales of Calandrino, Bruno, and Buffalmacco told by Boccaccio, and the related trecento stories of Sacchetti, retold and varied by Vasari himself. Bernard Berenson, who often associated Vasari with Boccaccio, recognized that "Vasari was one of the great prose-writers of Italy, and the last important product of the novelistic tendency in Tuscan genius."

Vasari's *Lives* are generally read as the history of the technical and stylistic advancement of art from Cimabue and Giotto to Masaccio, Donatello, and Brunelleschi and, finally, to the perfection of art in the "new manner" of Leonardo, Raphael, Correggio, Andrea del Sarto, Giorgione, and Michelangelo—the greatest artist of them all. This view of Vasari's book is undoubtedly correct, but it is rather limited, for it fails to take into account the poetical structure of the *Lives* based on Dante's *Divine Comedy*. It is well known that in the first important biographies of his book, in the *vite* of Cimabue and Giotto, Vasari refers to a famous passage in *Purgatorio* in which these artists are mentioned by Dante. Building on this passage and the related tradition that developed in the trecento associating Dante and Giotto, Vasari ornaments the myth, suggesting that Giotto and Dante were very good

friends, that Giotto's frescoes were inspired by Dante. The great Florentine poet thus becomes for Vasari the model of all Florentine artists. Dante had written in the epic tradition of Virgil and, more distantly, of Homer, but whereas the ancient poets sang of the deeds of great men who were worthy because of their fortitude and heroic military prowess, Dante was now writing about himself—thus transforming the poet into an epic hero! This new ideal would be developed not only by Vasari throughout the *Lives* but would be the basis for the modern heroic concept of the artist and poet, epitomized in the romantic period, when Dante became a cult figure, and refined at the end of the romantic epoch, when Pater wrote of his aesthetic heroes, shaped by Dante.

Throughout the *Lives* Vasari associates artists and their works with Dante. Brunelleschi, whom he relates typologically to Giotto, friend of Dante, is seen as a Dantesque artist; his great dome of the cathedral described in Dante's words as rising *di giro in giro* is thus marked as a work of Dantesque epic ambition and scale. Like the painting of Giotto, the architecture of Brunelleschi foreshadows the most completely Dantesque work of Michelangelo, the dome of St. Peter's. "Ne'er walked the earth a greater man than he," wrote Michelangelo in a sonnet on his hero, and in his biography of Michelangelo, Vasari illustrates the great artist's identity as the new Dante by quoting Dante in relation to specific works by the artist, most notably *The Last Judgment*. Elaborating on this Dantesque theme, Vasari speaks often of artists as "pilgrims" who "journey" "upward" away from "vice" and "darkness" toward "splendor," "virtue," and "salvation." Their journey is like that of Dante himself in his poem, their lives, like Dante's, seen as a sort of "pilgrim's progress" toward "perfection." Following the allegory of Dante, Vasari poetically writes a kind of Dantesque Christian epic history. Like the deeply spiritual late poetry of the aged Michelangelo, written in the same period, Vasari's book is a powerful reflex of the Catholic Reform. It reminds us that the modern linear histories of art that trace the development of artistic style are grounded in Vasari's biblical view of history—of the pilgrimage of the soul toward spiritual perfection.

Vasari's book is—to borrow the language of one of Pater's heroes, Pico della Mirandola—a form of "poetic theology." Although the history of art after Vasari becomes increasingly secular, this poetically theological impulse endures. Thus Pater's contemporary and sometime follower John Addington Symonds, who relied heavily on Vasari, concludes his biography of Michelangelo with a hymn to the artist. Similarly, Pater adheres to the structure of the *Lives,* not only associating Florentine artists with Dante but speaking in the manner of Dante and, ultimately, of the Bible, about his subjects' lives as pilgrimages. An apocalyptic view of the history of art is no less fundamental to Pater's book than it is to the *Lives*. Just as Vasari's sense of the Renaissance

depends in part on the biblical notion of spiritual "rebirth," on the Dantesque idea of a "new style" in relation to this rebirth, so too does Pater's concept of the Renaissance, following Vasari's, have its roots in Dante and the Bible— although, admittedly, Pater's theology is more completely aestheticized than Vasari's.

Notwithstanding its conventional allegorical structure, the *Lives* is a work of striking modernity, especially in its sense of artistic personality. We tend to think of the concept of artistic temperament as a preoccupation of the nineteenth century. According to this view there is a close if elusive and hard-to-define relation between an artist's life and personality and his work. The belief that such a connection exists is the core of what is called "biographical criticism," the kind of criticism practiced by Pater and other nineteenth-century critics and biographers and much employed in modern scholarship. Strangely enough, although it has generally escaped the attention of scholars working in this tradition, Vasari was the first writer to develop and perfect biographical criticism on a large scale. It goes unnoticed that when Dr. Johnson wrote his *Lives of the Most Eminent Poets,* he wrote in the very tradition of biographical criticism mapped out by Vasari. Vasari's *Lives* was especially important in Johnson's circle and was the basis for the *Discourses,* delivered to the British Academy of Art by Johnson's friend Sir Joshua Reynolds. Not only the title of Johnson's book seems to echo Vasari's *Lives of the Most Eminent* [*più eccellenti*] *Painters, Sculptors, and Architects.* When Johnson tells us that Alexander Pope changed not a line of the poetry first criticized by a patron, who later praised him for supposedly following his critical advice, he suggestively tells the kind of story recounted by Vasari about Michelangelo, who, when told that the nose of his *David* was too large, feigned repairing the supposed defect and was then praised by his critic for the presumed improvement of his work. In both stories (and whether they report what "in fact" happened is beside the point), the artist's wit is associated with the excellence of his accomplishment, just as the lack of judgment is connected with the critic's deficiencies. Therein lies the "truth" of these tales.

The interpretive value of Vasari's anecdotes linking the artist's work and personality was greatly appreciated by the late Kenneth Clark, who justly viewed the author as one of the leading figures in the history of "art history and criticism as literature." With enthusiasm, he referred to the following story from Vasari:

> Vasari, sent by Julius III to Michelangelo's house for a design at the first hour of night, found him working at the Pietà in marble that he broke. Michelangelo, recognizing him by the knock of the door, left his work and took a lamp with his hand by the handle; Vasari explained what he wanted, whereupon Michelangelo sent Urbino upstairs for the design, and then they entered

into another conversation. Meanwhile Vasari turned his eyes to examine a leg of the Christ at which he was working, seeking to change it; and, in order to prevent Vasari from seeing it, he let the lamp fall from his hand, and they were left in darkness. He called to Urbino, to bring a light, and meanwhile came forth from the enclosure where the work was, and said: "I am so old that death often pulls me by the cloak, that I may go up with him, and one day this body of mine will fall like the lamp, and the light of my life will be spent."

Clark remarks on the literary quality of this tale that separates Vasari's writing from Condivi's rather mechanical biography of Michelangelo. He also suggests that one learns more about Michelangelo's sculpture from this anecdote than from the learned metaphysical exegeses of the artist's work.[34] Although rhetorically overstated, Clark's observation bears a grain of truth in it, for Vasari's story vividly brings out Michelangelo's preoccupation with his own death, expressed in the *Pietà* that he planned for his own tomb, as well as in his poetry from the same period. The anecdote also suggests Michelangelo's sense of humor, which is frequently evident in his art and writing, even when he is most serious.

The vivid sense we have today of Michelangelo and his forebears, of the relation of their art to their lives, depends primarily on Vasari's manner of interrelating his descriptions of their works with anecdotes, and with commentary on their personalities. Such characterizations or episodes are never gratuitously presented but are invariably pointed, and they contribute to our sense of the artist's personality and its reflection in his style. Masaccio, or "Hulking Tom," as Browning so aptly translated his name in his poem on Filippo Lippi, is described by Vasari as careless about his dress, indifferent to money or worldly things. The coarse-grained artist is thus implicitly interchangeable with the simple apostles and other saints painted by the artist in frescoes and altarpieces—*senza ornato*, "without ornament," as a fifteenth-century writer remarked. Vasari's copious description of Fra Angelico's saintly ways, his piety, humility, and fear of God, is seen in relation to the same virtues of the very saints he painted, who thus mirror the artist's own qualities. Filippo Lippi, his antitype, spends much of his time in pursuit of what Vasari ironically speaks of as *beati amori*, "blessed loves," and Vasari's account of how Lippi fled the Medici palace to pursue these amorous pleasures is implicitly a commentary on the fleshy and earthy character of his painting, as Browning understood so well.

Relying on the legend that Castagno murdered his friend Domenico Veneziano, Vasari brings out the ferocity, bestiality, and sheer aggressiveness of Castagno's pictorial style, and he tells us elsewhere of the painter's "fury," reflected in his bold style. Piero di Cosimo, as Vasari presents him, is singularly strange, reclusive, and eccentric in his habits. Emphasizing the fact

that the painter is "savage," he transforms him into the very type of the "Wild Man" so commonly painted in numerous works of Renaissance art. He is like the satyrs and rustics whom he pictured in his well-known mythologies, which in turn contribute to our image of the painter. Vasari also tells us that Piero was a master joke teller, a fact about the artist's personality directly related to its expression in his painting. Vasari speaks in another context of an artist's *burle infinite,* and we encounter some of these "infinite jests"—for example, in Piero's comical and voluptuous *Mars and Venus*—expressive of his sense of humor.

Piero's Venetian contemporary Giorgione is depicted in Vasari's literary art as an amorous sort, who in fact dies of a disease contracted from a lover. Giorgione was also an accomplished musician, who played the lute to accompany his own singing at various social gatherings where he entertained his friends. The amorous, musical, and sociable painter is thus the very companion of those courtiers who appear so often in such Giorgionesque pastorals as the *Fête Champêtre.* Giorgione, in turn, is the counterpart of the courtly Raphael, whose legendary pursuit of amorous pleasures Vasari also comments upon. He does so cunningly, just before describing Raphael's voluptuous frescoes of Cupid and Psyche painted for Agostino Chigi, as if these paintings were an expression of the artist's voluptuous temperament.

In the biography of Raphael we see just how shrewdly Vasari portrays the artist's life in relation to his art, especially in his treatment of Raphael's youth. Vasari relates that after his birth on Good Friday, 1483, Raphael was breast-fed by his mother because she "knew how important it is to raise children not with the milk of wet nurses but with that of their own mothers." He also observes that keeping the child with his mother, *la propria madre,* Raphael's good and loving father determined that his only child should be trained at home in family ways "rather than in the houses of peasants or common people of less gentle or rougher customs." After training Raphael as a painter, his father, knowing that Raphael could acquire but little from him, took the boy to Perugia to learn from Perugino, "at that time one of the painters of high rank" in Italy. It was, Vasari adds, "not without many tears of his mother who loved him so tenderly" that Raphael left for Perugia, where he learned much from an artist who was "courteous and kind," the personification of gentility. Most of this is fiction, since Raphael's mother died when he was only seven years old, and his father died three years later.[35]

The purpose of this fiction, however, is to comment on Raphael's art (Fig. 17). Vasari emphasizes the fact that Raphael painted the Madonna with special skill and feeling. He admired the Virgin in the *Madonna del Cardellino,* who "has an *aria* or air about her full of grace and divinity." He calls the figure of Mary in the *Madonna of Divine Love* "the summit of beauty, joy, and piety"; he says that the Virgin in the *Madonna di Foligno* exemplifies

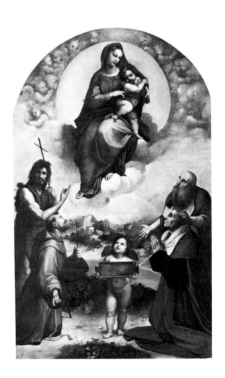

FIG. 17. RAPHAEL, *Madonna di Foligno.* Pinacoteca, Vatican.

"humility and modesty"; and he speaks of the "air" of Mary in the *Madonna dell'Impannata,* filled with honor, grace, and virtue. These descriptions are evocative of numerous other paintings by Raphael in which the Madonna appears with loving gentleness—*mansuetissimo,* as Vasari says of the Virgin's gaze in the *Madonna di Foligno.* Gradually, we come to see that in Vasari's biography life and art fuse, that Raphael's paintings implicitly express a maternal warmth and love like that which he himself is said to have experienced as a child. Vasari's brief account of Raphael's upbringing appears largely to have been invented, but this fiction serves as an extended metaphor to suggest the maternal feelings in Raphael's painting. When Goethe spoke of Raphael as the painter of the *Mutter Urbild,* or archetype of mothers, he echoed Vasari's sense of the painter. Vasari's critical fiction endures in part because today we are still attracted to the tender sentiments and sweet grace of Raphael's image of the Madonna that this fiction poetically illuminates.

The episode of Raphael's being breast-fed by his mother is keyed to a joke told by Michelangelo and reported by Vasari. First telling us that Michelangelo was sent to nurse with the wife of one of the stonecutters in Settignano, where he was raised, Vasari adds Michelangelo's joking remark that "with my mother's milk, I sucked in the hammer and chisels I use for my statues." Vasari frequently sets Michelangelo in a kind of harmonious *con-*

trapposto with Raphael. In fact, Michelangelo's joke may have partially inspired Vasari's fiction about Raphael. The joke and its variation bring out the differences between the austerity of Michelangelo, raised on stone, and the softness of Raphael, suckled by his mother. Following Vasari, Pater and other scholars would later emphasize the relation of Michelangelo's art to the primordial stone "from which it was hewn," just as in a Vasarian way they would extol the "noble tenderness" of Raphael's Madonnas.

Vasari's account of Raphael's childhood is elaborated into an appreciation of the artist's work in general. Vasari emphasizes the graciousness of Raphael's parents, then the courtesy of his teacher, Perugino, telling us that Raphael, "who was gentility itself," was not to be surpassed in courtesy by his friend Taddeo Taddei, for whom he made two paintings. Gradually, the courtly Raphael emerges as a "prince" among painters, and Vasari weaves into his biography of the painter an encomium on the grace of his manners and of his closely related manner of painting. Grace, or *grazia*, of style and behavior are inseparable in Vasari's depiction of Raphael, which more than a little reflects the social and aesthetic ideals of *The Book of the Courtier*, fittingly written by Raphael's friend Baldassare Castiglione.

Vasari associates Raphael's gentility, finally, with that of the supreme prince or lord—Jesus. With tact rather than with excessive elaboration, Vasari pregnantly observes that Raphael, born on Good Friday, also died on the same day, after completing *The Transfiguration* (Fig. 18). Describing the "immense light of Christ's splendor," Vasari shrewdly draws our attention only at the last to the luminous face of Christ, observing further that Raphael summoned all of his waning powers to finish this detail of the painting before succumbing to death. Vasari thus indissolubly unites the painter's death and subsequent immortality as an artist with Christ's death and ascent. In this hagiographical account Vasari exploits both the implicit association between Raphael's mother and Mary and the proximity of Raphael's age at the time of his death, thirty-seven, to that of Jesus when crucified. Writing of Raphael's life and art as a form of *imitatio Christi,* Vasari embellishes the image of the saintly artist by describing him as "so gentle and so charitable that even animals loved him." Such kindness to animals makes us think at once of St. Francis, another *secundus Christus.*

If Raphael's life was spent both "indulging his sexual appetites" and in imitation of Christ, it thus epitomizes the two types of lives led by the heavenly Angelico and the earthly Lippi. As the unity of these two types, Raphael is the embodiment of sacred and profane love.[36] Just as such cinquecento painters as Raphael synthesize divergent pictorial forms from the quattrocento, bringing them into conformity with a pictorial ideal, Vasari creates a similar harmony out of fifteenth-century sources, adapting the details of Raphael's life to the synthetically typological framework of literary portrai-

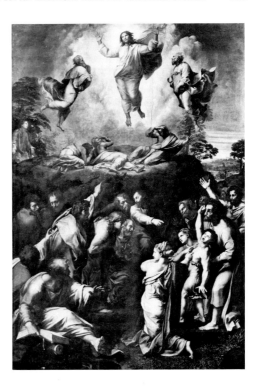

FIG. 18. RAPHAEL, *The Trans-figuration*. Pinacoteca, Vatican.

ture. By suggesting the unity of these types of personality, Vasari is not merely being literary and thus arbitrary, whatever the exact facts of Raphael's life may be, for he establishes a critical and interpretive framework with which to approach the artist, who was capable of making both the splendidly sensuous frescoes for the *stufetta* of Cardinal Bibbiena and the heavenly vision of *The Transfiguration*. The fusion of the devotional and sensuous aspects of Raphael's temper can be seen in the Loggie decorations, where the biblical narrative is sensuously adorned with grotesques and exquisite work in stucco.

Raphael is by no means the only artist compounded out of diverse types in Vasari's literary art. Leonardo is presented as a gracious courtly type of the sort we encounter in artists from Giotto to Raphael. At the same time, in his reclusive manner and secrecy, he belongs to a type defined by such strange and secretive figures as Uccello and Piero di Cosimo. The finest biographies in Vasari's *Lives* are informed by themes other than those strictly art-historical, and in the *vita* of Leonardo we find Vasari exploiting a grand rhetorical style to exalt the artist. As the initiator of the new style Leonardo surpasses his

precursors, and so Vasari exploits the artist's very name and its relation to the verb *vincere* to mark his artistic triumph. Quoting Giovanni Gaddi's epigram on Leonardo's *Neptune,* he tells us that, although Virgil and Homer "painted" Neptune, Leonardo triumphed over both: "Vincius . . . vincit eos." The theme of Leonardo's triumph is echoed in Vasari's remark that in his discourses he vanquished (*vincea*) every great genius. He sustains this theme in a discussion of *The Last Supper,* quoting Petrarch, who said "desire outran the performance." Although Vasari does not say so, his reader knows that the allusion is to Petrarch's *Trionfi.*

Vasari alludes to just such a "triumph," discussing Leonardo's cartoon of St. Anne, which "a crowd of men and women, young and old" flocked to see as "if they were attending a great festival." Recalling Vasari's allusion to Petrarchan *Trionfi* (which were re-created in public festivities), Pater teaches us how to read Vasari when he connects the Florentine response to Leonardo's cartoon with the earlier Florentine acclaim of a Madonna by Cimabue. "For two days," Pater says with poetic license, "a crowd of people of all qualities passed in naive excitement through the chamber where it hung, and gave Leonardo a taste of the 'triumph' of Cimabue."

Vasari also hints that Leonardo's painting is a sort of epiphany. When the Florentines gazed "in amazement" at the painting, Vasari says they were responding to the "marvels" of Leonardo's art (not just to its divine subject). That Vasari has the idea of epiphany in mind is evident from the related passage about Cimabue to which Pater so suggestively alludes. Not only was Cimabue's painting carried in "procession" to the sound of trumpets, but it was visited by the King of Naples and all the men and women of Florence, who rejoiced in the painting, seeing it for the first time. As a sort of word-picture, Vasari's description of the pre-Leonardesque "triumph" is suggestive of the processions and pageantry in Renaissance paintings depicting the arrival of the kings and their followers who come to behold their new Lord. In Vasari's account of Cimabue's and Leonardo's images of baby Jesus, the epiphany of the Messiah is displaced or transformed into the epiphany of art. Long before the modern aesthetic epiphanies of Pater, Joyce, and Proust, Vasari, as Pater recognized so clearly, had created such epiphanies in certain triumphant moments of art.

The victorious character of Leonardo's art is again reflected in what is in effect the climactic description of Vasari's biography—that is, Leonardo's depiction of the Florentine victory at Anghiari. Describing with epic grandeur the "fury" of the soldiers, Vasari is celebrating Leonardo's triumphant art, for in Vasari's mind the content and manner in which this subject is rendered, *con bravura,* cannot be separated. Vasari's celebration of Leonardo's victory is followed by a quotation from the poetry of Giovan Battista Strozzi, who, playing on Leonardo's name, proclaims that Leonardo triumphs over

Phidias and Apelles—"vince Fidia e vince Apelle." Phidias is seen in the Renaissance as the Homer of Greek art; thus Leonardo, by association with him, is linked with the epic tradition. If Leonardo's "triumph" over his antecedents, both ancient and modern, establishes the new style of Italian art, his victory also sets the stage for the greater victory of his younger rival, Michelangelo, who is the *vincitore* of all artists, including Leonardo da Vinci, as Vasari so pointedly suggests.

The poetical richness of the *Lives* depends on Vasari's way of molding his subjects into various types. Not only is Leonardo courtly and regal (*regio,* as Vasari says), triumphant in his art as is a prince in the sphere of arms and politics, but he is also a type of magician. Leonardo attends to "philosophical matters" (*cose filosofiche*) or, more specifically, alchemy. He aspires to render possible the impossible, as when he conceives of elevating the Florentine Baptistry without destroying the structure. Leonardo, Vasari also tells us, confesses his offenses against God upon his deathbed and is desirous of learning the ways of the Christian religion. Something of his strange un-orthodoxy is seen in the two terrifying images of the Medusa Leonardo is said to have made as a youth. It is as if the special transformative powers of the artist were implicitly linked with those of the magical Medusa itself. That Leonardo plays the lyre and sings so beautifully and charmingly also gives him in this context a certain Orphic and thus magical charm.

In Vasari's discussion of Leonardo's "natural philosophy," all the seeds are there for the nineteenth-century and especially Paterian view of Leonardo as sorcerer and for the more clinical, professional art-historical view of the artist as scientist. Speaking of Leonardo's schemes as a form of "natural magic," Pater says, too, that "Fascination is always the word descriptive of him." The very word *fascinum* means witchcraft. It is this power that is personified, as Pater sees it, in Leonardo's *Mona Lisa.* Although modern art historians reject what is supposedly a romantic view of the artist as a sort of bizarre magician, they might pause to reflect that they are casting aside the sixteenth-century view of the artist, that Vasari was likely employing earlier legends of the artist as a sort of magician. Virgil, for example, who was very important to Vasari and whom Leonardo was said to have surpassed, was thought during the Middle Ages to have been a magician, and it is conceivable that, long before Romanticism, such a tradition contributed to Vasari's "portrait" of the artist. We enter here into the realm of what Pater calls *legend,* but we are likely dealing not merely with a modern legend but with a legend that emerged in the Renaissance from earlier sources. To throw out or reject this legend is to discard a part of the past, to rewrite history.[37]

Vasari's portrayal of Leonardo is related to a passage in Castiglione's *The Book of the Courtier,* generally ignored by art historians. Castiglione seemingly has Leonardo in mind when in Book II, 40, he says: "Another, one of the

first painters of the world, scorns that art wherein he is most rare, and has set about studying philosophy; in which he comes up with such strange notions and new chimeras that, for all his art as a painter, he would never be able to paint them." Castiglione was in Rome at the time Leonardo visited the Vatican in the service of Giuliano de' Medici and, as Vasari would later say, indulged in alchemy and made a number of strange inventions, or *pazzie,* as Vasari calls them. Probably indebted to Castiglione, Vasari thus records the contemporary sense of Leonardo's problematic nature, and we can see that Pater's essay, with its sustained uses of Vasari, ornaments this historically grounded notion of the artist.

What Pater did probably more fully than any other nineteenth-century writer was to see Vasari's Leonardo as a type of Faust. Pater's is not just a romantic projection back upon a Renaissance artist, since the idea of Faust is itself a Renaissance invention, emerging, for example, as Marlowe's Dr. Faustus from earlier legends. Seeing Leonardo through Goethe, Pater thus encourages us to see the connections between Vasari's image of Leonardo as magician and this nascent Renaissance legend of Faustus. Pater helps us to recognize the role Vasari played in the development of Leonardo's image as the prototype of Faustus, who has played such an important role in modern myth and legend down through the writing of Thomas Mann, himself a fine scholar of Renaissance culture. Vasari's image of Leonardo has by no means vanished, for those modern art historians who have so scrupulously analyzed Leonardo's scientific methods have, like Pater, refined Vasari's portrayal of Leonardo. Although in different ways, Pater and the professional art historian both see Leonardo through Vasari's eyes as the natural philosopher or scientist who sought, in Faust's words, to know how nature's "secret elements cohere."

9 Renaissance Variations on a Theme by Keats

Thou, silent form, dost tease us out of thought.
—John Keats, "Ode on a Grecian Urn"

Ever since Plutarch reported the saying of Simonides that painting is mute poetry, writers have spoken of the haunting silences of such pictorial poetry, of what came to be called in the Renaissance *poesia mutola*. In the *Lives* Vasari will often evoke this effect, sometimes referring to the *poesia* of depicted music. Describing Fra Bartolommeo's *Pitti Pala* (Fig. 19), Vasari teasingly invites us to listen to the mute music of the two angels making music, "one on a lute, and the other on a lyre, one of whom he made with a leg drawn up and his instrument resting upon it, and with the hands touching the strings in the act of running over them, an ear intent on the harmony, the head upraised, and the mouth slightly open in such a way that whoever beholds him cannot persuade himself that he should not also hear the voice." "No less lifelike," Vasari continues, "is the other, who leaning on one side, and bending over with one ear to the lyre, appears to be listening to learn how far it is in accord with the sound of the lute and the voice, while with his eyes fixed on the ground, and his ear turned intently towards his companion, who is playing and singing, he seeks to follow in harmony with the air." Not only does one angel listen intently, but as Vasari says, we too seem to hear the voice of the angel who, with parted lips, sings.

Such music-making angels seemingly emerge in Florentine art from the tradition fully developed in Venice, the city Fra Bartolommeo had visited several years before he painted the *Pitti Pala*. There he would have seen the altarpieces by Bellini—the Frari, S. Giobbe, and S. Zaccaria altarpieces—in which such musical angels figure so prominently, and it is likely that his own angelic musicians owe more than a little to these Venetian exemplars.

Vasari associates the *armonia* or *accordamento* of music with pictorial harmony or *unione*. Such "unison" is based on the subtle harmony of smoky

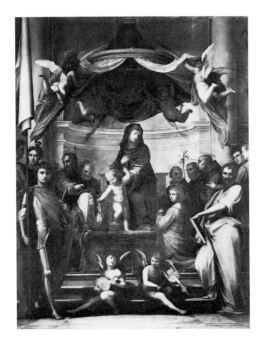

FIG. 19. FRA BARTOLOMMEO,
Pitti Pala. Palazzo Pitti, Florence.

shadow, *sfumato* or *fumeggiar,* what he speaks of in the magnificent but utterly untranslatable phrase as *ombra scura sfumatamente cacciata.* Vasari traces such *sfumato* or *cose unite* out of a Florentine tradition, and when he also praises the *cose . . . molto fumeggiate e cacciate* and *unione sfumato* in the art of Giorgione, he also relates this effect to the influence of Leonardo on the Venetian painter. Fra Bartolommeo worked in the tradition of Leonardo, but he also seems to have been responsive to the musical iconography of Venetian art and to its pictorial effects of harmony, created by Giorgione and his followers in a tradition independent of Florence.

When Walter Pater wrote about the music, color, and pictorial harmonies of Venetian painting three hundred years after Vasari, he spoke as heir to the Florentine historian and critic. Pater writes not of the musical angels of Bellinesque altarpieces, but of the related musical paintings that emerged from them: the pastorals by Giorgione and his followers, in which one beholds shepherds, nymphs, and courtiers playing lyres and flutes, tuning their instruments, and listening to the sounds of nature, as if these sonorities echoed the very harmony of the spheres. Pater sees this musical iconography and manner of painting as set against the "silence of Venice." Like Vasari, he

encourages us to listen to paintings, knowing all the while that, like Venice itself, they are hauntingly silent. Everywhere in Pater's essay on the school of Giorgione Pater also has in mind the pastoralism of Keats, in particular, the "silent form" of the urn the poet imagines in his "Ode on a Grecian Urn."

We have already had occasion to remark upon the pervasive influence of Keats's poem on nineteenth- and twentieth-century poetry about art, pointing out, if briefly, the validity of interpretations in this poetry. We have, however, scarcely plumbed the depths of Keats's influence. Beyond its intrinsic attraction to us as great poetry, his work has shaped modern art criticism itself. When, in his essay on Winckelmann, Pater describes the "abstracted gods" of the Parthenon frieze, "'ready to melt out their essence fine into the winds,'" his use of Keats's "Endymion" contributes to his interpretation of the nearly Platonic "abstraction" in the rendering of these divinities. They embody an "essence" like that which Pater had spoken of platonically in his essay on Della Robbia as "almost like pure thoughts or ideas."

More generally, Keats's poetry has served a neglected function as a lens through which we have come to perceive Italian Renaissance painting, especially its rendering of classical myths in what Pater called "painted idylls." Keats did not write explicitly about mythological pictures by Botticelli, Signorelli, Giorgione, and Titian, but, suggesting ways of looking at such paintings, his perceptions have worked their magic on subsequent writers, prefiguring and even influencing modern historical interpretations of Renaissance art.

When Keats pondered his imaginary Grecian urn—that "still unravished bride of quietness," that "foster-child of silence and slow time"—he fruitfully amplified our appreciation of pictorial silences and their relations with actual sounds:

> Heard melodies are sweet, but those unheard
> Are sweeter; therefore, ye soft pipes, play on;
> Not to the sensual ear, but, more endear'd
> Pipe to the spirit ditties of no tone . . .

Silence is not merely the absence of sound, for these unheard melodies allude to the eternal, heavenly harmonies of the spheres in a platonizing conceit that is also suggested by the description of the urn as a "silent form."

Keats can no longer identify the subject of the urn he envisions:

> What leaf-fringed legend haunts about thy shape
> Of deities or mortals, or of both,
> In Tempe or the dales of Arcady?
> What men or gods are these? What maidens loath?
> What mad pursuit? What struggle to escape?
> What pipes and timbrels? What wild ecstasy?

No matter that we cannot name these figures, for through the sculptor's enduring art they have become immortal. Like eternity itself, the silent form of the urn teases us "out of thought." The figures on it "cannot fade," the lovers about to kiss will endure, in just this way, in all their love and fairness, "for ever."

To see how Keats has shaped our way of seeing Renaissance paintings, we will need to take a broad view of the gradual and cumulative influences of his "Ode on a Grecian Urn" on such poets as Rossetti and Sturge Moore and on such highly poetical critics as Pater and Berenson. Doing so, we will see how Pater's appreciation of the school of Giorgione assimilates a Keatsian mode of description to the traditional Vasarian approach, transmitting this manner of writing to Berenson and, ultimately, to the mainstream of modern art history.

With Keats's poem clearly in mind, Dante Gabriel Rossetti wrote his sonnet "For a Venetian Pastoral by Giorgione (In the Louvre)":

> WATER, for anguish of the solstice:—nay,
> But dip the vessel slowly,—nay, but lean
> And hark how at its verge the wave sighs in
> Reluctant. Hush! Beyond all depth away
> The heat lies silent at the brink of day:
> Now the hand trails upon the viol-string
> That sobs, and the brown faces cease to sing,
> Sad with the whole of pleasure. Whither stray
> Her eyes now, from whose mouth the slim pipes creep
> And leave it pouting, while the shadowed grass
> Is cool against her naked side? Let be:—
> Say nothing now unto her lest she weep,
> Nor name this ever. Be it as it was,—
> Life touching lips with Immortality.

Although the painting (Fig. 20) is now generally ascribed to Titian, the new attribution does not modify our perception of its still Giorgionesque character, nor does it affect our appreciation of what Rossetti sees in it. He speaks of silence in an even more metaphorical way than Keats, observing that the heat "lies silent" in Titian's bucolic setting. Listening to its silent sounds, soft and subdued—the sighing wave of water in the well, the sob of the lute—Rossetti marks, finally, the cessation of music. "Happy, happy love" endures amidst the "happy, happy boughs" of Keats's vision, but the joy Rossetti finds in Titian's pastoral is tinged with sadness. Gazing into the painter's idyllic world of harmony among men and nymphs, courtier and shepherd, between city and countryside, man and nature—the harmony of love and music—we come to feel the fragility of a blessed moment. There are no

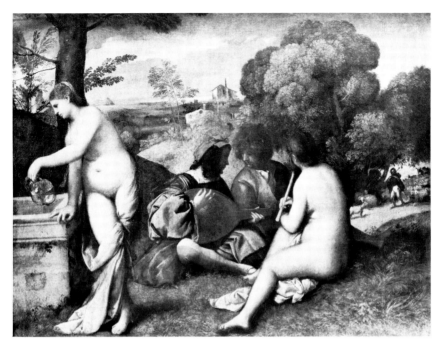

FIG. 20. TITIAN, *Fête Champêtre*. Louvre, Paris.

clocks in Titian's Arden, but for us, as for Rossetti and anciently for Titian's beholders looking into this timeless realm, time flees. We hear, in the words of Titian's poet-friend Pietro Bembo, the *note dolenti* of a perfect moment suspended in time, aware that such moments do not endure; and we savor the delight in the painter's re-creation in a minor key of a Golden Age sadly lost to us. Rossetti enjoins us to silence—"Hush . . . Say nothing," lest the illusion of life approaching immortality be shattered. Although Keats dreamed a pastoral secure from "waste" and "woe," Titian has depicted one that for Rossetti is more vulnerable. To describe it too explicitly, to "name this ever," is to destroy an illusion of perfect wholeness.

Sensitive to the poetry of Keats and Rossetti alike, Walter Pater dwelled on the precious sounds and silences of Venetian painting. Listening to the "music" of Venetian pictures, he elicits their most subtle tones: "In these then, the favourite incidents of Giorgione's school, music or the musical intervals in our existence, life itself is conceived as a sort of listening—listening to music, to the reading of Bandello's novels, to the sound of water, to time as it flies," to (we might add) the "other side of silence." Approaching the Platonic, as

did Keats, Pater remarks upon Giorgionesque subjects "with intent faces, as if listening, like those described by Plato in an ingenious passage of the *Republic,* to detect the smallest interval of musical sound, the smallest undulation of air." He alludes to Rossetti's "delightful" sonnet when he notes the woman pouring water in the *Fête Champêtre,* "listening, perhaps, to the cool sound as it falls, blent with the music of the pipes." Pater recalls the cool grass beheld by Rossetti, remembering also the chill of Keats's "Cold Pastoral." Like Rossetti, he finds a "blessedness" in such "perfect moments," those "exquisite pauses in time, in which, arrested thus, we seem to be spectators of all the fulness of existence, and which are like some consummate extract or quintessence of life." Although Pater shares Rossetti's sense of mortality, perceiving the bittersweetness of the pastoral world, he nonetheless still recalls Keats's vision, preferring to concentrate on the continuation of music, on music being played, not having ceased. Harking back to Keats, he speaks of Titian's idyll as a "happy one," and when he describes such moments as the "modulated unison of landscape and persons," he brings a Wordsworthian sentiment to his appreciation as well.

Whatever the iconography of the *Fête Champêtre* may be, whatever text or texts it may be supposed to elucidate or refer to, Pater and Rossetti, inspirited by Keats, invite us to see, to hear its silent music, to contemplate passionately the artist's illusion of immortal harmony. Their re-creation of a Venetian dreamland, their "performance" of it in musical words, heightens our sense of its vague and sensuous "visionariness." The wandering, melodious language they invent is a reminder that if we seek to fix the *Fête Champêtre*'s meaning too exactly, we distort it, failing to see the painting's essential vagueness, its fleeting loveliness or *vaghezza.*

In the last decade of the nineteenth century, the poet T. Sturge Moore, brother of the perhaps better-known philosopher G. E. Moore, wrote a series of poems about paintings, belonging to the tradition of Rossetti's poems "for pictures." Among these, Moore's "From Titian's 'Bacchanal,'" is a reverie on the sleeping nymph, called Ariadne by the poet, in Titian's *Bacchanal of the Andrians* (Fig. 21). Like Keats's urn, Titian's lively revel depicts a "wild ecstasy," for as "Ariadne" sleeps, "Brown satyrs, maenads, men, these sing; and hark! / Birds sing, the sea is sighing and the woods / Do sound as lovers love to hear them." Moore transports the exquisite silences of Keats, Rossetti, and Pater deeper into the world of the painting itself, for though the nymph's friends "laugh, carouse, and dance, she hears them not." The silence of these sounds of revelry is thus magnified by virtue of their being unheard deep within the Bacchic abandon. By contrast to the vibrant stillness of the sleeping nymph, "whose home is peace," within "unechoing halls," all of nature is languidly animated: "Slowly the tree-tops, in the wind's embrace, / Dance too; lush branches and gay vestures float, / Float, wave and rustle, sighing to

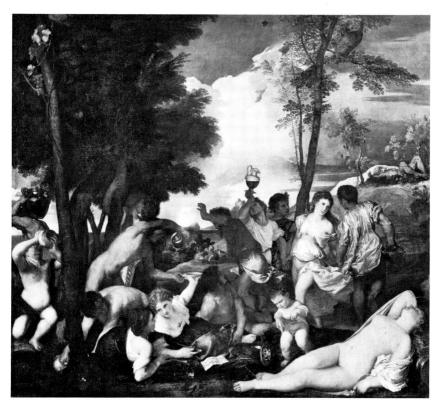

FIG. 21. TITIAN, *Bacchanal of the Andrians*. Prado, Madrid.

the wind." The nymph's "beauty is complete," her "joy is perfect," and her beauty will keep the bower quiet after the Bacchic troop is "afar with fainter riot and song." Nurtured by Keats, but tempered by Rossetti's and Pater's sense of the Giorgionesque, Moore's lyric heightens our consciousness as "spectators of all the fulness of existence." Re-creating the animated instant of Titian's dream of "sleep full of sweet dreams," Moore's "reflected vision" immortalizes it, renders it "for ever." While Moore's exalted appreciation seemingly does not interpret Titian's painting, that is, does not explicate it in the analytic manner of scholarship, it does intensify our perception of the nymph's pivotal role in the image—her deep sleep, sharpening, by antithesis, our appreciation of the bacchanal's rhythmical abandon.

Just as Keats's poetry has contributed to the growing consciousness of the Giorgionesque, it has also shaped our perception of Botticelli. Responding

once again to Keats's "Ode on a Grecian Urn," Rossetti pondered Botticelli's *Primavera* (see Fig. 13) in his poem "For Spring By Sandro Botticelli (In the Accademia of Florence)":

> WHAT masque of what old wind-withered New-Year
> Honours this Lady? Flora, wanton-eyed
> For birth, and with all flowrets prankt and pied:
> Aurora, Zephyrus, with mutual cheer
> Of clasp and kiss: the Graces circling near,
> 'Neath bower-linked arch of white arms glorified:
> And with those feathered feet which hovering glide
> O'er Spring's brief bloom, Hermes the harbinger.
>
> Birth-bare, not death-bare yet, the young stems stand,
> This Lady's temple-columns: o'er her head
> Love wings his shaft. What mystery here is read
> Of homage or of hope? But how command
> Dead Springs to answer? And how question here
> These mummers of that wind-withered New-Year?

Keats had asked what deities or men he beheld upon the urn, and in like manner Rossetti now asks, what masque does he behold? Observing the relation of the new year, of birth to death—"Birth-bare, not death-bare yet"—Rossetti again reflects with Keats on mortality, responding also to what Pater calls the painter's "minor tones": Botticelli "paints the story of the goddess of pleasure in other episodes besides that of her birth from the sea, but never without the same shadow of death in the grey flesh and wan flowers." The melancholy perceived by Pater and hinted at by Rossetti is no mere reflex of nineteenth-century sensibility, for this sadness is evident in the wistful faces of the painter's dancing Graces. It is implicit in the Renaissance conception of birth or rebirth, understood inseparably from the sense of mortality; expressed in the poetry of Dante and Petrarch and their followers, this sentiment informs the *Primavera*. When Rossetti asked what mystery is read in Botticelli's painting, he stimulated "much wordy debate" over its meaning. Quoting these final lines of Rossetti's poem as his point of departure, the great cultural historian Aby Warburg identified many of Botticelli's poetical sources in his dissertation of 1893—still the most complete and judicious study of the painting's literary context.

Rossetti offers a complex yet condensed insight into both the painting's content and form. Calling the painting a "mystery," he evokes the painting's relation with the tradition of "sacred mysteries" that was later explored by art historians. This mystery is expressed in the image of Mercury, who gazes toward the sun, which *we* cannot see; only its reflection is visible, shining in

the eyes of Mercury. Describing the *Primavera* as a masque, Rossetti intuits its relation with contemporary musical festivities—a historical connection that only recently has commanded the attention of Renaissance scholars. Speaking of Hermes as the "harbinger" of spring, Rossetti recalls the classical tradition linking the wind god to the new year, although one scholar has recently discussed this association in the painting as if it had been forgotten.[38]

Rossetti vividly touches on numerous details in the *Primavera*: the sensuousness of Zephyr's embrace, his "clasp and kiss" of Chloris (whom Rossetti mistakenly calls Aurora, seemingly in remembrance of Milton's "L'Allegro"); the ethereal form of Mercury, aptly described with a certain poetical license as "hovering"—a word that reinforces the figures' celestial connotations and sustains the painting's effect of continuing motion. As no one else has, Rossetti calls attention to the painter's architectural metaphors: the Graces' arms forming a "bower-linked arch," the trees of this bower as "temple-columns." Finally, when the poet repeats the breathy phrase "wind-withered," he suggests, in alliteration, the effect of breath or *spiritus* that has since come to be seen more as the *spiritus mundi* permeating this earthly paradise. Rossetti's perception of Botticelli is perhaps closer to Renaissance responses to the artist than our own. As he contemplates Botticelli's *locus amoenus* with wondering yet informed delight, Rossetti does not seek, as we often do today, to fix the painting's meaning exactly, stiffening its meaning too literally into iconographical formulas, but he allows the image to express its elusive richness of form and content as an indissoluble whole. He respects the very suggestiveness of a painted "mystery," in which the loveliness of its ethereal figures and the effect of heavenly music allude to a transcendent beauty beyond our apprehension.

The influence of Keats and his followers is also reflected in the writing at the end of the nineteenth century of the young art critic and historian Bernard Berenson, who had himself aspired to be a poet. Friend of Sturge Moore and an extremely close reader of Pater, Rossetti, and Keats, Berenson wrote evocatively in their tradition in his little book of 1897, *The Central Italian Painters,* alluding to the fugitive sounds in the Crucifixions and Entombments of Perugino: "The still air is soundless and the people wail no more; a sigh inaudible, a look of yearning, and that is all." If the soundlessness still distantly echoes Keats, the wistful tone or sentiment in Berenson's description is perhaps even closer to Rossetti and Pater.

When he writes about Signorelli, however, Berenson makes reference to Keats. Speaking of Signorelli's *Kingdom of Pan* (Fig. 22), he observes: "Primevally grand nude figures stand about him, while young Olympus is piping, and another youth lies at his feet playing on a reed. They are holding solemn discourse, and their theme is 'The Poetry of Earth is Never Dead.'" The

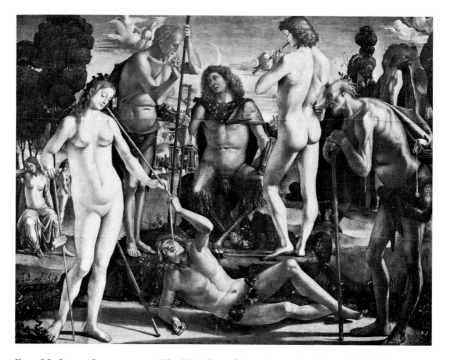

FIG. 22. LUCA SIGNORELLI, *The Kingdom of Pan*. Formerly Kaiser-Friedrich Museum (destroyed in 1945), Berlin.

quotation here is from Keats's poem "On the Grasshopper and Cricket." With Keats again in mind Berenson listens to the quiet piping of Signorelli's nostalgic reverie: "The sunset has begotten them upon the dew of the earth, and they are whispering the secrets of the Great Mother." His description of the "goat-footed Pan, with the majestic pathos of nature in his aspect," who "sits in the hushed solemnity of the sunset," evokes Keats's Pan in "Endymion," who "through whole solemn hours dost sit, and harken / The dreary melody of bedded reeds." Art historians, seeking to analyze in detail the painting's exact literary meaning, have often neglected the painting's very fugitiveness, the elusiveness of its melancholic tone. Berenson's brief words, poetical and poetically inspired, respect this vague sentiment. Pathos, nostalgia for a vanished Age of Gold, the sense of mystery in nature—these, then, contribute to the meaning that Signorelli's painting whispers dreamily to us.

Pan is the god of nature's regeneration, a theme that leads to thoughts on mortality and, in the case of Signorelli's picture, on the fragility of love. Pan had himself fallen in love with Syrinx, but before his passion could be ful-

filled, she was transformed into reeds—the very substance of Pan's plaintive pipes, now silently present in her memory.[39] Like Botticelli's *Primavera,* in which Venus appears to us in a sacred wood, Signorelli's picture renders the epiphany of a God associated with love and the rebirth of nature; and in these apparitions, thoughts of rebirth are tinged with sadness. In their tendency to touch the beholder's sense of the distance of the mythic past, they are also like the *Fête Champêtre,* although this pastoral evokes a Golden Age without presenting the epiphany of a deity. In Titian's *Bacchanal,* Bacchus is not prominent, but his force is ubiquitous, informing the revelry associated with spring and nature's rebirth. For all this painting's outward rhythm of dance, there is, however, a languor in the gestures of its actors, a wan wistfulness in their faces still Giorgionesque, still related to the quieter dreaming of the *Fête,* and more distantly to those bittersweet mythological reveries of the late quattrocento by Signorelli and Botticelli.

Each of these four paintings is distinctive in subject, pictorial style, and overtones. If the *Primavera* is permeated by a heavenly, nearly Platonic spirit, the *Bacchanal* is more earthly in temper. If the style of *The Kingdom of Pan* is still rooted in the early Renaissance, the *Fête Champêtre* exhibits the more ample forms of High Renaissance classicism. The marked emphasis on drawing and contours in Signorelli's and Botticelli's paintings is in contrast to the more vibrant coloristic devices of Titian's pastorals. Despite these differences of style commonly observed by art historians, there are associations of meaning and sensibility that unite these works. In their very community, these visionary images illustrate or illuminate each other: as re-creations of antiquity, they are meditations on time, the painted "sound of time fleeing," colored by the artist's pathetic sense of distance from the very past he himself revives. As I have tried to suggest, our sense of these reflections on mortality—heightened by Pater, Rossetti, Sturge Moore, and Berenson—is steeped in the poetical vision of Keats. Keats does not romantically falsify our perception of the Renaissance, for his own poetry, as scholars of English literature have always observed, is grounded in the literature of the period, especially the poetry of Shakespeare, which transports us back to the pastoral world of the Italian Renaissance, or nearly so. Listening, enamored, to the languid, loving strains of music made by nymph, shepherd, and courtier, to the wilder song of amorous bacchantes, to the sad tones of pipes fashioned of Pan's beloved, and to the heavenly melodies in the bower of the goddess of love, we discover, as perhaps did Keats, reading Shakespeare, that "To hear with eyes belongs to love's fine wit."

10 Walter Pater and Bernard Berenson

Art, in the fullest and most inclusive sense of the term, plans, builds, and furnishes this House of Life, and it is natural that this should be best understood by those who have been brought up on the classics, that is to say the works of art which manifest that purpose. To my knowledge it is none of us professional critics or historians who have written most comprehendingly about the painter's art, still less the painters themselves, but novelists like Balzac in his Chef d'Oeuvre Inconnu, *Gogol in his* Portrait, *and Ljeskow in his* Sealed Angel. *Among my own acquaintances it has nearly always been those brought up on Dante and Chaucer, Shakespeare and Milton, Tasso and Racine, Wordsworth, Keats and Shelley, Matthew Arnold, Goethe, Schiller and Hölderlin, on Pergolesi and Bach, Gluck and Mozart, Beethoven and Berlioz, Brahms and Bruckner, who have most enjoyed and best appreciated the architecture and sculpture of the centuries and the painting of the last eight hundred years.*

—*Bernard Berenson,* Aesthetics and History

When the aged connoisseur, art critic, historian, and man of letters Bernard Berenson took up Pater's *Marius the Epicurean* during World War II, it was, his first biographer tells us, to reread the novel for the eighth time. As Berenson said in his *Sketch for a Self-Portrait*, written in these years and published in 1949: "The genius who revealed to me what from childhood I had been instinctively tending toward was Walter Pater in his *Marius*, his *Imaginary Portraits*, his *Emerald Uthwart*, his *Demeter*. It is for that I have loved him since youth and shall be grateful to him even to the House of Hades, where, in the words of Nausicaa to Odysseus, 'I shall hail him as a god.'" As a young man Berenson had observed that "art teaches us not only what to see, but what to be," and from Pater's art Berenson learned to

become an Edwardian Marius. He shared with Marius a native "capacity of the eye," a "love of beauty"; and aspiring to Marius's "visionary idealism of the villa," he eventually re-created this ideal world at his Villa I Tatti.[40]

Berenson might well have added another book to the list of Pater's works that he mentions in his *Sketch for a Self-Portrait,* for as he wrote from Europe in 1888 to his patroness Mrs. Gardner, "Many a midnight, in coming home, I took up the *Renaissance* and read it from cover to cover." Pater's book was one of the principal texts to nurture the young Berenson, who, as a college student in the 1880s, published poetry, short stories, and criticism in *The Harvard Monthly* and hoped to pursue a career as an imaginative writer. Yet even after he abandoned these literary ambitions to become a connoisseur and historian of Italian Renaissance art, the lessons of Pater's prose, insights, and way of thinking were to penetrate deeply into Berenson's writings on art.

The last edition of *The Renaissance* to appear during Pater's lifetime was printed in 1893. By that time Berenson had become an expert in Italian Renaissance art, and in 1894, the year of Pater's death, Berenson, not yet thirty, published the first of his four little books on Italian painting, *The Venetian Painters.* This volume was followed by *The Florentine Painters* in 1896, *The Central Italian Painters* in 1897, and then, a decade later, by *The North Italian Painters.* These four slim volumes, the "Gospels" as Berenson later ironically called them, were subsequently collected in 1930 as *The Italian Painters of the Renaissance,* a book that has since come to be regarded as a classic in the study of Italian Renaissance art.

In recent years Berenson has been the topic of much discussion. Ernest Samuels's *Bernard Berenson: The Making of a Connoisseur,* which appeared in 1979, vividly documents Berenson's youth in Boston and education at Harvard, tracing his move to Italy and rapid ascent there as a prodigious scholar of Italian painting. The following year appeared Meryle Secrest's polemical *Being Bernard Berenson,* which focuses on the controversial aspects of Berenson's life—his financial ambitions, sexual relations, religious feelings. Since then, numerous reviews and essays on Berenson have been published. Although his books are referred to and sometimes summarized in these writings, emphasis has been placed on his alluring persona—the sage of I Tatti, himself his greatest creation, who presided over the extraordinary salon of his villa at Vincigliata in the hills outside Florence for more than half a century. The man has become more important than his work. His life is seen as his genius, and even his former protégé, Kenneth Clark, who dedicated a fine chapter of his *Moments of Vision* to "The Work of Bernard Berenson," writes only a few pages on *The Italian Painters.* The recent interest in Berenson coincides with the huge outpouring of books and essays on Pater. Although Pater's influence on Berenson has always been observed, the degree to which Berenson absorbed Pater's judgments has not been fully assessed. Kenneth

Clark, who has published an edition of *The Renaissance,* and who himself upholds the tradition of Berenson and Pater in modern scholarship, does not even mention Pater in his essay on Berenson.

There are of course fundamental differences between the respective books of Berenson and Pater. Whereas Pater is now generally regarded as one of the greatest prose stylists in the history of English literature, *The Renaissance* looked upon as a classic of prose, "the passages in Berenson's work which are likely to retain their value," as Clark observes, "are few and short." We continue to adhere to many of Berenson's critical judgments, but "they often seem to us," Clark adds, "imperfectly expressed." Pater's book is itself a highly sophisticated work of literary art, a sustained prose poem; Berenson's books are more conventional essays. Moreover, the subject of *The Renaissance* is different from that of *The Italian Painters;* Pater deals with both literature and art, whereas Berenson focuses more narrowly on painting. Finally, there is a basic difference of objectives that separates the two authors. For Pater one of the fundamental goals of criticism is to describe or re-create aesthetic experiences: "What is this song or picture to *me*? What effect does it really produce on me? Does it give me pleasure? and if so, what sort or degree of pleasure?" Berenson is still alive to these questions: ". . . what is it then that makes Sandro Botticelli so irresistible that nowadays we may have no alternative, but to worship or abhor him?" But Berenson does not merely seek to describe the impression upon him of art; rather, he attempts to identify exactly and precisely the formal properties of painting that account for our impression of it. Just as Berenson's connoisseurship, based as it was on the scientific principles of Giovanni Morelli, enabled him to attribute paintings to artists on the basis of their exact forms, so, too, his criticism of these works depended on a close analysis of the essential characteristics of form that exert their characteristic spell over us. Thus, whereas Berenson admired Pater's epithets for "their accuracy and rarity," he deplored his "lack of exact connoisseurship," the fact that Pater often discussed works that had been misattributed (the *Medusa* wrongly assigned to Leonardo da Vinci being a prime example). One still finds marginal notes in Berenson's copy of *The Renaissance* in the library at I Tatti, largely in the hand of his wife, Mary, but reflecting Berenson's own judgments, that object to the numerous erroneous attributions uncritically accepted by Pater.

Despite these basic distinctions between Berenson and Pater, it will be fruitful to examine the connections between *The Italian Painters* and *The Renaissance,* for they are deeper and more subtle than has generally been supposed. If Berenson's writing is not exactly "literature" as such, we should recognize its literary ambitions and the association of its critical accomplishment with Pater's writing; and if Pater's book is far more than "art history," we might well also pause to consider the value of his critical judgments of art

both for Berenson and for subsequent criticism. To examine their writings together is to see more clearly the extent to which their shared understanding of the Renaissance not only reflects the values of nineteenth-century art and literature but also came to shape our approach to Modernist art.

For both Pater and Berenson, Goethe is the hero of modern culture. In his essays on Winckelmann, Pater approves "the truth of Goethe's judgments on his [Winckelmann's] works; they are a life, a living thing designed for those who are alive—*ein Lebendiges für die Lebendigen geschrieben, ein Leben selbst.*" It is clear that, connecting Goethe with Winckelmann, Goethe's double, Pater appreciates this vitality in Goethe himself, whose own writings are for Pater "a life itself." When Berenson speaks of Renaissance art, especially Florentine painting, as "life-enhancing," his famous phrase echoes Pater's view of Goethe and Goethe's sense of the relation between art and life. For Berenson, Pollaiuolo's art has the power "to directly communicate life" to us. Under his spell "we feel as if the elixir of life, not our own sluggish blood, were coursing through our veins." Although Berenson speaks in the modern language of "hyperaesthesia," he follows Pater and Goethe back to a tradition of criticism rooted in antiquity and found in the Renaissance; for example, in Vasari, who extols art for its vitality or *vivezza*, for being *vivo* or *vivace*. Vasari's descriptions of the enlivened responses of beholders to paintings and sculpture—the response of the Florentines, for example, to the works of Leonardo and Cimabue—attest this *vivacità* or "life-enhancing" character of art.

Goethe's notion of culture is also fundamental for Pater and Berenson. In the nineteenth-century world, where the unity of culture was seemingly "a lost art," Goethe continued to uphold "the identity of European culture" against the multiple currents of modern thought. When Jacob Burckhardt published *The Civilization of the Renaissance in Italy* in 1860, he followed the example of Goethe, aspiring to the ideal of cultural unity and wholeness exemplified in Renaissance society, epitomized in the Renaissance city as a work of art, and embodied in the Renaissance man as *uomo universale*. Like Burckhardt, Pater and Berenson aspire to an ideal of cultural wholeness, what Pater called *Allgemeinheit*. Allusions to *Faust* abound in Pater's book, especially in the essay on Leonardo, whose "curiosity" and "larger vision" are Faustian. And Berenson similarly extols the Faustian ideal in Michelangelo's art, where we behold "the creation of the type of man best fitted to subdue and control the earth, and, who knows! perhaps more than the earth." It can be argued that the very emergence of the modern historical definition of Renaissance culture in the writings of Burckhardt, Pater, and Berenson is rooted in Goethe's quest for a universal culture.

In *The Renaissance* Pater outlines the "identity" of European culture, building in his "literary architecture" a *House Beautiful* from the classical and biblical

traditions and their utter fusion in the *Allgemeinheit* of modern French, English, Italian, and German culture. The subject of his book is ostensibly the art and literature of the Renaissance, but he in fact ranges over cultural history from Homer and Plato through Blake, Goethe, and Baudelaire. In like fashion Berenson, adhering to this Goethean or Paterian ideal, discusses the Italian Renaissance painters in relation to the classics, alluding to Homer, Aeschylus, Sophocles, Aristotle, Theocritus, Virgil, the *Niebelungen,* the *Eddas,* the *Roman de la Rose,* Boccaccio, Shakespeare, Calderón, Wordsworth, Shelley, Keats, and Tolstoy. In Pater there is a more unifying typology at work; for example, Plato is defined as a central type of Western culture, and Abelard, Pico, Botticelli, Della Robbia, Leonardo, Giorgione, Winckelmann, and Goethe are all discussed, either directly or indirectly, in relation to Platonism, which, as Pater later observed in *Plato and Platonism* (1893), "is not a formal theory or body of theories, but a tendency or group of tendencies." Pater's *Renaissance* is permeated by an abiding concern with this Platonic "tendency" of vision toward "pure form," and it is, along with Pater's other writings, one of the last sustained expressions of Platonism in the Western tradition, whereas Berenson's book, although dependent on Matthew Arnold's discussion of "Hebraism" and "Hellenism," is not so stringently organized in typological terms.

Just as Berenson follows Pater in his aspiration to a universal culture, he tends, like Pater, to write in an autobiographical way about his artistic heroes. It is a commonplace of literary scholarship that Pater assumes the identity of all his literary idols from Plato to Goethe. Like Botticelli, he is a "visionary"; with Della Robbia he attempts to etherealize form; like Michelangelo, he is "preoccupied with death." Pico's aspiration to a "spirit of order and beauty in knowledge" is Pater's, as is Leonardo's quest for "correspondences." The "music" of Giorgione and Du Bellay is that to which Pater himself aspires, and Winckelmann's and Goethe's ideal of "Hellenism" is also Pater's. Although not to the same degree or so consistently, Berenson too becomes his own subjects. The refinement of Pisanello's art and the "courtier's way of life" that it embodies reflect Berenson ideals, as do the noble figures of Mantegna, who appear "as if they had never been anything but marble, never other than statuesque in pose, processional in gait, and god-like in gesture." If we look at the famous photographic portrait of Berenson taken at I Tatti in 1903, picturing the elegant, courtly, and statuesque young Berenson suavely posed beneath his *Madonna* by Domenico Veneziano, we see how the critic has passed through the looking glass of Italian painting into a world of confident aristocratic elegance of his own. He has also entered into the world of Pater's fiction, appearing in the photograph as a modern Marius.[41]

The Renaissance is a highly poetical book, and students of literature have always recognized the extent of poetical influence on Pater's writings, the

reflections in it of Keats, Wordsworth, and Shelley, of Rossetti, Browning, and Swinburne, of Hugo, Gautier, and Baudelaire. Although less poetical than Pater's, Berenson's prose is similarly steeped in poetry and at times is poetical in its ambition to re-create the effects of paintings. The first lines of Gray's "Elegy" capture for Berenson the subduing effects of coolness and opalescent gray in Verrocchio's landscapes, and Ercole Roberti's Herod is described with a phrase from Shelley's "Ozymandias": "If ever man had 'wrinkled lip and sneer of cold command,' it is Herod." A line from Keats's "On the Grasshopper and Cricket" expresses the theme of Signorelli's *Pan,* and Berenson's own evocative description of Pan echoes the melancholic Keatsian god of "Endymion."

Berenson's uses of poetry are not always apparent. Discussing Andrea del Sarto, he teases the painter for depicting his figures like so many "clothes-horses" who dare not move "for fear of disturbing their too obviously arranged folds," who "have nothing better to do than show off draperies." Enjoying Berenson's pun on Sarto's "sartorial" obsession, we might fail to recognize that his facetious tone is a transposition from Browning's poem "Andrea del Sarto," of 1855, in which the pathos of the painter is brought out in combination with just such mockery—for example, when Browning has the pathetic artist offer his wife money for clothes: "Beside, What's better and what's all I care about, Get you the thirteen scudi for the ruff! Love does that please you?"

In *Moments of Vision* Kenneth Clark echoes Oscar Wilde, who described criticism as art, and Walter Pater, who rendered it. Clark observes that this kind of criticism is rare even in the prose of the finest critics. The most famous examples in Pater are his evocations of Giorgione's "idylls" and of Leonardo's *Mona Lisa.* Less familiar is Berenson's re-creation of the paintings by the gifted Ferrarese painter Cosimo Tura:

> His figures are of flint, as haughty and immobile as Pharaohs, or as convulsed with suppressed energy as the gnarled knots in the olive tree. Their faces are seldom lit up with tenderness, and their smiles are apt to turn into archaic grimaces. Their claw-like hands express the manner of their contact. Tura's architecture is piled up and baroque, not as architecture frequently is in painters of the earlier Renaissance, but almost as in the proud palaces built for the Medes and Persians. His landscapes are of a world which has these many ages seen no flower or green leaf, for there is no earth, no mould, no sod, only the inhospitable rock everywhere. He seldom finds place even for the dry cornel tree which other artists, trained at Padua, loved to paint.
>
> There is a perfect harmony in all this. His rockborn men could fitly inhabit a world less crystal hard, and would be out of place among architectural forms less burdensomely massive. Being of adamant, they must take such shapes as

that substance will permit, of things either petrified, or contorted with the effort at articulation. And where the effort at movement produces such results, expression must freeze into grimace before it has reached its conclusion.

Where there is harmony there is necessarily purpose, and Tura's purpose is clear. It is to realize substance with almost maniac ferocity. He will have nothing in his world which will not firmly resist his conquering embrace. Nothing soft, nothing yielding, nothing vague. His world is an anvil, his perception is a hammer, and nothing must muffle the sound of the stroke. Naught more tender than flint and adamant could furnish the material for such an artist.

We again find that Berenson's description depends on poetry, in this case a poem on Tura by Katherine Bradley and her niece, Edith Cooper, both friends of Berenson, who, as we have noted, wrote under the pseudonym Michael Field. In his copy of their *Sight and Song,* still at I Tatti, Berenson marked lines that contributed to his own poetical diction:

> A foot that rather seems to be
> The clawed base of pillar past all date
> Than prop of flesh and bone. . . .
>
> Grey are the hollowed rocks, grey is his head
> And grey his beard, that formal and as dread
> As some Assyrian's on a monument
> From the chin is sloping down.

Berenson does not literally imitate Michael Field, but the description of Saint Jerome's clawed foot, as if a fragment of statuary, and the picturing of his bleak rocky setting kindled the critic's poetical imaginings—appropriate to the exotic forms of that most fantastical of painters. Berenson's evocative, poetically inspired writing on Tura is clearly not of the same order as Pater's prose poetry, but it has exerted a powerful influence on twentieth-century interpretations of the Ferrarese school, shaping the appreciation of its strange, highly imaginative forms in Roberto Longhi's classic *Officina Ferrarese* of 1932.

In *The Renaissance* Walter Pater makes sustained references to Wordsworth, to the poet's idealization of childhood and feeling for nature, both of which underlie his appreciation of Renaissance art and literature, especially those "exquisite pauses" of Giorgione. Berenson similarly invokes the romantic poet, associating Piero della Francesca's heroic attitude toward landscape with Wordsworth's grand vision of nature. Nineteenth-century writers had not neglected Piero, but it was Berenson who first saw the extent of his accomplishment, characterizing him as one of the greatest artists of the quat-

trocento, and thus determined our appreciation of the painter, still reflected in the classic monographs by Roberto Longhi and Kenneth Clark. Although Berenson's own aesthetic theories are not so consistently developed as Pater's, his interpretation of Piero, influenced decisively by Pater, suggests a unified vision of art and is the core of his own critical position. The art that does not represent Piero's own feelings is an art of "impersonality"—an ideal epitomized in *The Flagellation of Christ,* where none of the dramatis personae responds to the horror, especially the foreground figures, who are "as unconcerned as the everlasting rocks." As Berenson observes, Piero loved impersonality, "the absence of expressed emotion, as a quality in things." In the art of the "impassive" Piero, "grand figures" are combined with landscapes of "severity and dignity"; and the "utmost power" of this work depends on the fact that in it "all special emotion is disregarded."

The roots of Berenson's theory of impersonality are to be found in the eighteenth-century neoclassicism of Winckelmann and Lessing, both of whom praised Hellenic art for its repose and harmony, for its lack of overt expression. Their point of view informs the thinking of Goethe, who once remarked to Herder that "the ancients represented existences, we usually represent the effect." Goethe's classical ideal subsequently influenced Burckhardt, who in *Der Cicerone* characterized Bellini's S. Giobbe altarpiece as an *Existenzbild,* a harmonious union of emotionless figures "in a blessed state of existence." In his book on Piero published in 1954, near the end of his life, Berenson invoked Burckhardt's formulation as one of the foundations of his own survey of the history of impersonality in art. We should also observe that the background to Berenson's notion of impersonality is extensive. In Hazlitt's "On Gusto" we find an appreciation of Greek art reminiscent of Goethe's: "It seems enough for them *to be* without acting or suffering," and in French Parnassian poetry of *l'impassivité* we recognize a similar ideal of impassive art prefiguring Berenson's—for example, Leconte de Lisle's "Vénus de Milo," in which the statue is prized in still Winckelmannian terms for its "impassive happiness," a "serenity" and "calm" like that of the sea.

The very fabric of neoclassicism woven from the threads of modern French, German, and English tradition into Berenson's work had already been artistically incorporated in the writings of Pater, and *The Renaissance* itself is a work of impersonal art in which Pater presents his own view of life impersonally through his Renaissance subjects. It is, however, only in Pater's essay "Style" in *Appreciations* (1889) and somewhat more fully in the last pages of his essay "Prosper Mérimée" (*Miscellaneous Studies,* 1895) that Berenson would have found the explicit formulation of the theory of impersonality. Speaking of *"impersonality"* in literary art, Pater describes an art of "self-effacement"—an art "impersonal in its beauty, the perfection of nobody's style." Pater quotes Flaubert's goal in art: " 'It has always been my rule to put nothing of myself

into my works,'" adding that Flaubert was "*disinterested* in his literary crea-
tions, so to speak." The word "disinterested" immediately brings to mind the
criticism of Matthew Arnold; but it also suggests Kant's concept of "disin-
terestedness," and in fact we find that at the beginning of his essay Pater
announces that "Kant's criticism of the mind" is the context in which he
intends to discuss Mérimée.

Using Pater's definition of impersonality, Berenson sketches the history of
impersonal art, referring to the Parthenon frieze, which Pater had called "the
highest expression of indifference," and invoking also the impersonal work of
Velázquez. In the art of the Renaissance he observes numerous examples of
impersonality. Perugino's figures are "impersonal as architecture," Raphael's
are "impassive"; Cossa's work is marked by "haughtiness," Roberti's by an
"absence of sensibility." He also identifies a "magical aloofness" in Melozzo
da Forli's painting that he associates with the poetry of Aeschylus and Keats
on the "fallen dynasties of gods." He observes that Melozzo's music-making
angels, although abandoned to feeling, are "unconscious of others, or even of
self" and are thus "impersonal," as is Calvé in *Carmen*; again we are made to
think of Pater, who pointed out that Mérimée's Carmen exemplifies imper-
sonality. Elaborating on Pater's brief remarks, Berenson thus outlines a his-
tory of impersonality from Phidias and Aeschylus through the Renaissance to
Wordsworth and Keats.

In his classic essay of 1919, "Tradition and the Individual Talent," T. S.
Eliot, who reacted against the biographical approach to literature of nine-
teenth-century criticism, observed: "for my meaning is, that the poet has, not
a 'personality' to express, but a particular medium, which is only a medium
and not a personality, in which impression and experience combine in pecu-
liar and unexpected ways. Impressions and experiences which are important
for the poetry may play quite a negligible part in the man, the personality."
We can now see what has been insufficiently appreciated by literary
scholars—that Eliot's "meaning" depends on the notion of "impersonality"
articulated in the 1880s and 1890s by Pater and Berenson. In more recent
criticism Clement Greenberg, who was deeply influenced by Eliot, has crit-
icized the theatrical or "literalist" tendency in modern art, and he was fol-
lowed by his former protégé, Michael Fried, also a close reader of Eliot, who
in the essay "Art and Objecthood" (*Artforum*, 1967) called for an art that is a
"presence," one not theatrically expressive or gestural. Such criticism harks
back indirectly through Eliot to the aesthetics of Winckelmann and Lessing.
But it can be also observed that just as Berenson's and Pater's writings imper-
sonally link twentieth-century art and literary criticism to the tradition of
nineteenth-century aesthetics, so too does their work occupy a pivotal inter-
mediary position linking recent "formalist" criticism to the aesthetics of eigh-
teenth-century neoclassicism.

If Berenson's criticism of Piero has had an impact on modern criticism, so too has his Paterian writing on Botticelli. Pater was the first critic to focus on the sadness or "ineffable melancholy" of Botticelli's works, but transcending Pater's impressionism, Berenson identifies the painter's "line" as the essential formal characteristic of his art, influencing our contemporary view of the painter: "This kind of line, then, being the quintessence of movement, has, like the essential elements in all the arts, a power of stimulating our imagination and of directly communicating life." Describing the "rhythm" of Botticelli's line, he calls his art a "linear symphony," in which "tactile values were translated into values of movement." Botticelli was, in short, "the greatest artist of linear design that Europe has ever known"; he "may have had rivals in Japan and elsewhere in the East, but in Europe never."

There are numerous aesthetic forces that shaped Berenson's criticism of Botticelli. His vision of line was determined, as he himself implies, by Japanese painting; and he was surely stimulated to appreciate the rhythmic effects of Botticelli's art by Pre-Raphaelite painting, especially the animated calligraphy of Edward Burne-Jones. The rhythms of both Japanese art and Pre-Raphaelite painting were felt in the Art Nouveau of the 1890s—for example, in the cursive drawings of Aubrey Beardsley, who made illustrations for *Salomé,* which was written by Berenson's friend Oscar Wilde. We could almost say that Berenson's "discovery" of the sheer buoyancy of Botticelli's draftsmanship, influenced by Art Nouveau, is itself a critical outgrowth of this style.

But, we might ask, how did Berenson come to write about Botticelli as he did? It is not unlikely that when he speaks of *The Birth of Venus,* in which he "feels the force and freshness of the wind in the life of the wave," he recalls once again the poetical imagery of his Paterian friends, the Michael Fields, who wrote about the painting in *Sight and Song*:

> Frills of brimming wavelets lap
> Round a shell that is a boat;
> Roses fly like birds and float
> Down the crisp air; garments flap:
> Midmost of the breeze, with locks
> In possession of the wind,
> Coiling hair in loosened shocks,
> Sways a girl who seeks to bind
> New-born beauty with a tress
> Gold about her nakedness.

Brimming, lap, fly, float, flap, coiling, sways—with this vocabulary the Fields had already brought out the movement of Botticelli that Berenson was to focus on a short time later. Berenson's description of Botticelli's "rhythm" or "mu-

sic" of line might also be based in John Addington Symonds's way of describing the "melodies of lines" in Mantegna's Hampton Court frieze or the music of Signorelli's *Kingdom of Pan,* in which all the figures are "drawn with subtle feeling for the melodies of line." But finally, it is in *The Renaissance* that Berenson found his point of departure, for when he speaks of the "abstract" idea in Botticelli, the "pure values of movement abstracted," the "*unembodied* values of touch and movement," he is using the vocabulary of Pater's book, which, throughout, is about the "way of etherealizing pure form." Pater speaks of the "abstract lines" of the faces in Botticelli's art, having already observed "the charm" in his art "of line and colour, the medium of abstract painting." Pater's repeated usages of "abstract" and "pure" are expressive of his own Platonism, as when he speaks of the "pure thoughts or ideas," the "pure form," and "system of abstraction" of the Hellenic art to which Renaissance art is related.

Pater's own Platonism and Platonic vocabulary were to pave the way to an understanding of the Platonism of Botticelli's art, although it was only later in the Warburgian exegeses of this century that such Platonic significance in Botticelli was made explicit, some would say too explicit. But just as Pater looked back to antiquity, he also announced a major concern of modernist criticism when he spoke of "abstract painting," perhaps the earliest such usage. Like Pater, Berenson speaks of Florentine art as "pure art," an art of "pure values"; but seeking to clarify Pater's perceptions, he puts far more emphasis on "tactile values" or "form" and stresses the "significance" of this form. "It was on form, and form alone," Berenson insists, "that the great Florentine masters concentrated their effects." Masaccio is "a great master of the significant"; Pollaiuolo "*extracts the significance of movements*"; whereas the paintings of Fra Angelico, Filippino Lippi, Domenico Ghirlandaio, and Andrea del Sarto are criticized for their lack of significance. Nowhere is it clearer that Berenson was writing in the language that twentieth-century critics would adopt than in his famous appreciation of Giotto:

> Now what is behind this power of raising us to a higher plane of reality, but a genius for grasping and communicating real *significance*? What is it to render the tactile values of an object but to communicate its material *significance*? A painter who, after generations of mere manufacturers of symbols, illustrations, and allegories, had the power to render the material *significance* of the objects he painted, must, as man, have a profound sense of the *significant*. No matter, then, what his theme, Giotto feels its real *significance*. (italics added)

We can now see that Berenson's modification of Pater's criticism was a major step toward the emerging doctrine of "significant form" codified by Clive Bell in 1914 in his widely read book *Art* and developed earlier in the essays collected in *Vision and Design* (1920) by Roger Fry, who speaks of "abstract

significance," "pure beauty," and the "purely aesthetic organization of form." Fry's "Essay on Aesthetics" in this volume is an adaptation of Berenson's aesthetics; for just as Berenson had spoken of form, movement, space-composition, and color as part of "decoration," Fry provides a similar scheme of "design," which includes line, mass, space, light, shadow, and color.[42]

Clement Greenberg observed in *Art and Culture* that "the notion of 'significant form' was very much in the English air around 1914, and I cannot help thinking that this attempt to isolate the essential factor in the experience of visual art had some effect on the young Eliot." We have already seen that the implicit doctrine of significant form was already developed by Berenson in the 1890s, and we find, too, that it was embellished by A. C. Bradley as early as his famous Oxford lecture of 1901, "Poetry for Poetry's Sake." Still writing in the tradition of Pater, Bradley discusses what he calls the "expressed meaning" or "significant form" of poetry, and when he also observes that "in poetry there is not a meaning *plus* paint, but a meaning *in* paint, or significant paint," he is speaking, perhaps not coincidentally, in the language of Berenson's book on the Florentines of five years before. Returning to Eliot's "Tradition and the Individual Talent," we find that his famous conclusion could have been written by Berenson himself: "But very few know when there is expression of *significant* emotion, emotion which has its life in the poem and not in the history of the poet. The emotion of art is impersonal. And the poet cannot reach this impersonality without surrendering himself to the work to be done." Eliot's famous formulation here is a rephrasing or paraphrasing of the twin doctrines of "impersonality" and "significant form" developed by Berenson from Pater's criticism.

So much has been made in recent years of Berenson's aversion to modern art that his role in the development of its criticism has been largely ignored, and insufficient attention has been paid to the fact that his own perceptions of Renaissance painting were determined by contemporary art. Although Pater scarcely alludes to the art of his times, noting only Ingres and Legros, Berenson's interpretations of Italian painting are made through his experience of nineteenth-century painting. He invokes Millet in his discussion of Roberti's "atmospheric effect," associates the "freedom of touch" in Signorelli's late work with Daumier's brushwork, and compares the "harmonies of tone" in Borgognone's work to those of "the exquisite American," Whistler. We sense that when Berenson admires Raphael's portrait of Castiglione, calling it "that exquisite study in grey," he is seeing the painting through Whistler's eyes. It is especially in his experience of the finest painting of the late nineteenth century that Berenson's sense of form is developed. With a prophetic tone he predicts that a real art of landscape "will come only when some artists modelling skies like Cézanne's, able to communicate light and heat as Monet does," also convey a feeling for space like that of the Umbrians. And his sense of

tactile values and movement in the work of Leonardo is heightened by his response to Degas. Berenson's notion of significant form is thus already concerned implicitly with the painting later championed by Fry in Berenson's idiom.

Because so much stress has been placed in the writing on Berenson on his celebration of the "life-enhancing" powers of "tactile values," an important and influential addition to his theory in *The North Italian Painters* has been overlooked. Whereas tactility is one of the essential characteristics of significant form, defined in *The Florentine Painters*, Berenson expanded his definition of form in the later book to embrace a "purely pictorial" art, or what he speaks of as "the plastic-pictorial" as opposed to the tactile or "plastic-linear" of the Florentines. He finds this kind of art in Bellini's painting, free of line and chiaroscuro, and even more so in the work of the Veronese masters, especially Brusasorci, who achieved a "mode of visualizing" that "still reigns in the world of painting." Just as Michelangelo was the greatest Renaissance master of tactile values and Degas was the leading modern exponent of tactility in art, so too Paolo Veronese was the finest cinquecento painter of the "purely pictorial," and Berenson probably thought of Matisse as among the most distinguished painters in this tradition. For in 1908, the year after the publication of *The North Italian Painters*, he wrote a defense of Matisse's work in *The Nation*. We have since come to see that the art of Matisse is the supreme example of the purely pictorial mode of visualizing in the first years of this century, thanks in part to the critical writings of Clement Greenberg, who, in *Art and Culture*, wrote in Berenson's language, stressing "the exclusively two-dimensional, optical, and altogether untactile definitions of experience" in Modernist painting.

Berenson's influences have led us forward in time to Fry, Eliot, and Greenberg, but let us return, finally, to his origins as a writer on art, to *The Venetian Painters*, in which he first articulated the views on color later elaborated upon in *The North Italian Painters*. His book on the Venetians brings us back once again to Walter Pater, that diaphanous veil through which shimmers all Anglo-American art criticism of the twentieth century. In his essay "The School of Giorgione," Pater speaks of "*colouring*" in Venetian art, associating it with the "abstract colour" of Japanese fan-painting. Reacting to Ruskin's overemphasis on what Berenson would call "illustration," but ever sensitive to Ruskin's own analyses of color, Pater observes, as Ruskin never would have, that "in its primary aspect, a great picture has no more definite message for us than an accidental play of sunlight and shadow for a few moments on the wall or floor." This passage was surely in Berenson's mind when he described Carpaccio's *Dream of St. Ursula* "as the picture of a room with the light playing softly upon its walls, upon the flower-pots in the window, and upon the writing-table and the cupboard." Although with attention to the

painter's artifice, Ruskin had focused instead on the subject of Carpaccio's painting: "It is very pretty of Carpaccio," he wrote in *Fors Clavigera,* "to make her dream out the angel's dream so particularly and notice the slackened sleeves; and to dream so little an angel—very nearly a doll angel—bringing her the branch of palm and message." Following Pater in his reaction to Ruskin's stress on subject matter, Berenson agrees with Pater's judgment that Venetian painters up to Carpaccio and Bellini make painting "a thing for the eye, a space of colour on the wall, only more dexterously blent than the marking of its precious stone or the chance interchange of sun and shade upon it"—although perhaps in his attention to the details of Ursula's chamber (the flowerpots, window, writing desk, and cupboard) Berenson retains just a little of Ruskin's love of particularity. Pater saw the epitome of this abstracting tendency in the art of Giorgione, calling him the "inventor of *genre*"; but Berenson, now modifying Pater and seeking some independence from him, insists that as a painter of genre Carpaccio "was the earliest master."

Berenson's criticism of Venetian art lies squarely in the French tradition that so informs Pater's *Renaissance.* His celebration of Bassano's sensuous "jewel-like" paintings, this "art for its own sake," echoes Gautier, and his description of Bassano's "modern versions of biblical stories filled with episodes from the life in the streets of Bassano" recalls Baudelaire's criticism of the painting of modern life. Berenson traces the evolution of modern art from the Venetians to the "best French painters" of his day, from Titian and Bassano to Cézanne: "Indeed, not the least attraction of the Venetian masters is their note of modernity." Bassano "beat out" the path to Velázquez, and the Venetians had an impact on the Spanish painters who had "an extraordinary influence on modern painting." The Venetian tradition was similarly absorbed by Rubens, then by Reynolds, and was sustained by Guardi, who developed "instantaneous effects" that prefigure Romantic and Impressionist painting. Similarly, Tiepolo's work in Spain contributed to the "revival" of painting there under Goya, who in turn influenced "many of the best French artists of our time."

Depending on Pater's sense of Giorgione's modernity, Berenson embellished it, outlining for the first time the evolution of modern art as we now construe it. His view has become commonplace in the texts of our day, but our familiarity with this historical outline should not diminish our recognition of his highly original formulation. When he later added to this scheme the definition of a "purely pictorial" tradition, Berenson provided a basis for extending this historical overview into the future to include Fauvism and even more recent forms of Modernism, notably Abstract Expressionism and Color Field painting.

Berenson's history of art is very much a formal history, and his influence on

Fry, Eliot, and Greenberg is reflected in their attitudes toward form. Today, however, we are witnessing a reaction against so-called formalism in the study of both art history and literature. Although the reaction to the New Criticism of literature is now already decades old, the hostility to formalism in the study of art is more recent, having emerged rather sharply in the 1970s—at the same time, curiously enough, that studies about Berenson and Pater have flourished. In any event, formalism is considered by many to be dead, to have been too narrow in its approach to art, which is informed by ideologies and symbolic structures, not susceptible to formal analysis alone. That art is more than its form is a proposition beyond dispute. To read Pater on Giorgione's pastoralism, Berenson on Mantegna's love of antiquity, Fry on Van Gogh's personality, and Greenberg on Paul Klee's fantasy and to recall the breadth of culture reflected in the writings of Pater and Berenson and their followers is to recognize that the formalists are not restricted in their interest only to form. But like the greatest critics before them and like those writing in their tradition, Pater and Berenson have justly insisted that the values of art, however we may define them and whatever our politics, philosophy, or method may be, reside in form, and that it is through form, and only through form, that a work of art mutely speaks to us.

11 Pater and the History of Art

But we must do more than merely refer to this exquisite work of art; it must be described, however inadequate may be the effort to express its magic peculiarity in words.
—*Nathaniel Hawthorne,* The Marble Faun

Kenneth Clark, who worked self-consciously in the great tradition of Anglo-American art criticism and history of Ruskin, Pater, Berenson, and Fry, wrote an important essay toward the end of his life, "Art History and Criticism as Literature," in which he defined the very tradition to which Walter Pater belongs as critic and historian of art. This tradition, which begins with Vasari, is poetic and imaginative in character and is found in the seventeenth century in Bellori, in the eighteenth century in Winckelmann, Reynolds, and Diderot, and in the nineteenth century in Hazlitt, the Goncourts, and Fromentin, to name but a few distinguished writers appreciated by those who have written of the history of art criticism. Clark's essay, characteristically urbane and gracious in tone, contains a somewhat polemical intention or implication, for without stressing the fact, Clark tells us that whereas the greatest art historians and critics belong to the history of literature, the professional writing of art history today—a booming industry indeed—is generally devoid of such literary quality and purpose. Clark misses in most contemporary scholarship the kind of vivid writing that he admires, for example, in Vasari and Pater and that inspires his own work.

This is not to say that professional art history is totally lacking in literary ambitions. The twentieth-century art-historical writing of Roberto Longhi in Italy, of Henri Focillon in France, and of Theodor Hetzer in Germany, for example, is informed by a powerful literary imagination. In fact, one can say that the excellence of this scholarship depends at least in part on its literary character, for the power to make the reader see and understand quite obviously depends on a writer's rhetorical and poetical skills. As writers, a

number of American and English art historians and critics can still be linked to the nineteenth-century tradition of which we have spoken. Sacheverell Sitwell, Richard Offner, John Beazley, Adrian Stokes, Robin Ironside, Millard Meiss, John Summerson, Lawrence Gowing, John Gere, Sydney Freedberg, and John Pope-Hennessy are but a few exemplary figures who have written in this grand manner. All of these scholars and critics are admired for their work, but it cannot be said that great attention has been paid to their gifts as writers or to their literary roots in Ruskin and Pater. On the contrary, art historians have sought to dissociate contemporary art history from the so-called impressionistic and aesthetic approach of earlier critics, who are seen as "romantics." The tendency to write poetically or evocatively about art is approached with suspicion, as if poetic writing were divorced from art-historical understanding.

Such poetic writing about art is found in the pages of Richard Offner's great *Corpus* of trecento painting. Offner, who like Clark writes in the tradition of Berenson and Pater, integrates formal analysis with iconography, pointing to the pictorial qualities and spiritual aura of Bernardo Daddi's Uffizi triptych:

> The Virgin dominates the composition. She rises, unseated and unthroned, high above the earthly horizon into a world of her own, without any object to differentiate the site. The rhythmic continuity of the contour maintains the group in a region of abstraction, as abstract as the enclosing geometric moulding to which we inevitably refer it. As she turns and looks downward, we realize that the iconographic focus is upon the Child, who emerges white against the Virgin's dark mantle, rigid as a stone image. The prevailing parallelism of His bent body, of the arms and legs turned towards His mother, and the erectness of His torso, immobilize Him, so that, divested of action and devoid of expression, He becomes a symbol of eternity. It is perhaps the less surprising, therefore, that the Virgin's thought is somewhat detached, and that her features barely betray a sense of precious possession, of maternal preoccupation or of tragic presentiment. Her thought ranges over an unseen region and her expression is an irradiation of an inner light, of a state of being, where life subsists at the peak of quiescence, in unshakable equilibrium. Her spiritual serenity subdues the body to passivity.

There is a hint of Pater in Offner's reference to the range of the Madonna's thoughts. This Paterian allusion is more explicit in his sweeping characterization of the historical context of Daddi's paintings:

> Derived possibly from northern Gothic, it descends ultimately from Hellenic antiquity. The kinship is unquestionable. In Florentine painting, we encounter it first in Giotto's classical phase, as, for instance, in the Virgin of his Adoration

in the Arena Chapel, where the same inner peace illuminates the face and relaxes the will. Half a century later it haunts some of the young women in Nardo's Paradise, and after three generations imbues Mr. Berenson's sublime Madonna by Domenico Veneziano, and later still Baldovinetti's Louvre Virgin. The supreme historical instance of this type, however, is Leonardo's Gioconda. And it is most likely Baldovinetti's example that dictated both Leonardo's design and the sitter's inner disposition. Seen against the broader background of such ancestry, Leonardo's portrait may be regarded the final flower of a native Florentine tendency, of which Daddi's Virgin is an earlier forerunner.

Using Pater's historicist scheme for the description of the *Mona Lisa,* Offner not only suggests Daddi's Hellenic and Gothic roots, but he also suggests the painter's place in the specifically Florentine tradition that culminates with Leonardo. He clarifies our sense of the relations between the trecento and the quattrocento, and, finally, he enhances our understanding of Leonardo by characterizing the type or convention employed by the great painter. By comparing the *Mona Lisa* to Daddi's Madonna he shows the way in which Leonardo's portrait assimilates the convention of religious painting. Perhaps this insight helps us to understand something behind the mystery of the *Mona Lisa,* for it is as if Leonardo's picture were a portrait of the Virgin disguised as a Florentine lady.

The Paterian tradition of writing on Leonardo is also contained in the prose of Kenneth Clark. More than simply seeking to acknowledge the tradition of poetical writing about art, Clark attempts to keep it alive, vivid in its old and radical sense. Evoking the central motive and energy of Leonardo's art, he re-creates its "flashes of magical perception":

> Leonardo da Vinci looked at swirling water with the same half-hypnotised intensity that Coleridge looked at the shrouded moon. His many drawings of cascades and currents, although done, as his notes tell us, with a practical intention, are certainly the record of heightened perception. But we can see from his studies of grasses and of plaited hair that their vital interlacings were all part of the pattern of his being and that the intensity with which he gazes at whirlpools was the result, rather than the cause, of this pattern.

Seeing Renaissance art through nineteenth-century poetry, Clark also follows the examples of Ruskin, Pater, and Berenson. Like Pater especially, he observes not merely that the artist was preoccupied with water in his drawings but that these studies echo his inner dynamics, "the pattern of his being." If Clark looks at Leonardo through Pater, he reads Pater through Freud.

What one admires in Clark's writing is the illumination that he brings to moments of pictorial vision, intensifying our own sense of these heightened

perceptions. Clark is equally skillful in conjuring up the "central truth of experience" in Dürer's art:

> He was brought up in a family and society of craftsmen; his earliest vivid memories must have been of strong, disciplined hands wielding a graver or knobbly hands grasping an adze; and all his life he saw humanity through the deeds of its hands, whether carving or arguing or praying.

No less than an insight into Dürer's art is this, Clark's own "éloge de la main."

Such writing is of a piece with Clark's finest prose. In his classic monograph, *Piero della Francesca*—unabashedly "a guide to the appreciation of Piero's art"—Clark demonstrated his rare gifts as a "writer on the visual arts," bringing to his description or "re-creation" of Piero's haunting *Resurrection of Christ* (Fig. 23) an incisiveness of historical understanding, combined with a critical language richly suggestive of the fresco's singular powers:

> But before Piero's risen Christ we are suddenly conscious of values for which no rational statement is adequate; we are struck with a feeling of awe, older and less reasonable than that inspired by the Blessed Angelico. This country god, who rises in the grey light while human beings are still asleep, has been worshipped ever since man first knew that seed is not dead in the winter earth, but will force its way upwards through an iron crust. Later He will become a god of rejoicing, but His first emergence is painful and involuntary. He seems to be part of the dream which lies so heavily on the sleeping soldiers, and has Himself the doomed and distant gaze of a somnambulist.

In Clark's description of Piero's fresco, "the great tradition" of art criticism is not only present but very much alive. His metaphorical suggestion that Christ is the subject of the soldier's dream is almost certainly an inventive variation of Ruskin's evocation in *Fors Clavigera* of Carpaccio's St. Ursula, who dreams of the angel "bringing her the branch of palm." The comparison of Piero's rustic Christ to a primitive "country god" recalls the theme of Heinrich Heine's exile of the pagan gods woven into and through Pater's *Renaissance*; but, above all, Clark's sense of "the solemnity, the importance of the moment," in Piero's image depends on Berenson's fundamental appreciation of Piero's art, especially of the "manliest and most robust" Christ rising "in the grey watered light of the morning, by the spreading cypresses and plane trees." Unlike those writers who suppose that they can "explain" the meaning of a work of art by mere reference to the proper texts, iconographical or theoretical, to the facts of historical context, Clark realizes that we can only hint at the mysterious powers of art and that a poetical language is the best means of such evocation. Clark does not follow his literary forebears

FIG. 23. PIERO DELLA FRAN-
CESCA, *The Resurrection of Christ.*
Pinacoteca, Sansepolcro.

slavishly but uses words vividly to suggest the wondrous sensation of rebirth
so awesomely rendered by Piero, and the slow, careful cadences of his own
prose embody some of the gravity and grandeur in Piero's great fresco. Clark
reminds us that there is no such thing as mere description of a work of art.
The kind of poetical prose that the best writers about art employ is interpre-
tive and is based on analysis—an analysis that is the very texture, the warp
and woof, of interpretation.

Rather than examining here the full range of various writings in the great
tradition of art criticism, particularly of Pater, I will focus on the writings of a
single figure who currently upholds this tradition in his work, Sydney J.
Freedberg. With droll, teasing wit Kenneth Clark remarked that Freedberg's
writing reads like the prose of Henry James translated back into English from
the German. No wonder an uncomprehending critic of Freedberg once
claimed in unwittingly comic desperation that Freedberg does not even write
in the English language! Whereas Clark himself tried to make his prose, for all
its studied rhetoric, accessible to the "common reader," Freedberg's writing, as
Clark's remark about him suggests, is rather more complex and difficult.
Indeed, like the prose of James, it is highly mannered, but this mannerism
contributes to Freedberg's illumination of the complexities of sixteenth-cen-
tury art.

To many it will seem peculiar to celebrate Freedberg's achievement, since
he is regarded not only by his proponents but by his grudging admirers and
detractors as a formalist; and formalism, as one art historian recently claimed,

is *passé*, "dead." Freedberg would not accept this characterization of himself as formalist without a certain irony, given the negative connotations of the word as it is currently and too carelessly used, for the purpose and extent of his scholarship, of formalism, are far richer than the term would imply.

Nowhere are Freedberg's literary, critical, and historical gifts more evident than in his description of Bronzino's *Venus, Cupid, Folly, and Time* (Fig. 24)—an unrivaled description and analysis of the picture that belongs in any anthology dedicated to the finest English prose on painting:

> Based upon a complex verbal allegory of the Passions of Love, it pretends a moral demonstration of which its actual content is the reverse; the exposition of a sexuality so knowing as to be perverse, and so refined as to be at once explicit and oblique. Inverting Pygmalion's role, Bronzino has altered human presences into an improbably pure statuary, but he has retained in transmuted form, a vibrance that those presences contained, distilling what conveyed their sexuality and quick-freezing their subtlest sensations. Glacé surfaces of flesh emanate a contrary excitation; the postures of the protagonists are frank and yet evade; cold grace is manipulated into attitudes that convey, by the effect of pattern, the fine-drawn tension of the actors' states of mind. The whole pictorial patterning, a crystalline, eccentrically kinetic skein, is an elaboration upon this last effect. The colour, basically that of the enmarbled flesh and the ice-blue background, has the dual quality, by now characteristic for Bronzino, of intensity, and abstracting cold. The extreme refinement of the execution defines the image in consonant terms, but it also conveys the sense that whatever else it may be, the picture is a surpassingly wrought object of art: fiction, ornament, and jewel, and this is an index of the attitude with which, from the beginning, the artist has approached its essentially erotic content. Even this aspect of human experience must be aestheticized, its values transposed into those of art.[43]

Freedberg has here wrought out from within a complex verbal image, approximating as has no one else the meaning of Bronzino's image (as it resides in form), employing a richly poetical language evocative of the irony, artifice, and perverse eroticism that Bronzino's painting radiates. He achieves in his prose a refinement yet intensity that mirrors Bronzino's highly wrought art. Speaking of the painting as explicit and oblique, frank and evasive, he suggests its paradoxical character. He enters into the very spirit of refined play in Bronzino's painting, so understandingly observing its perversion of the moral meaning that it feigns. He does not have to identify explicitly the figure of Jest, who scatters roses next to Venus, in order to bring to the fore the ironic play of Bronzino's work. When Freedberg speaks of human experience as "aestheticized, its values transposed into those of art," he reminds us of his roots in the aestheticism of Pater, who brought his own aestheticism to bear in the rediscovery of sixteenth-century Mannerism. Freedberg thus be-

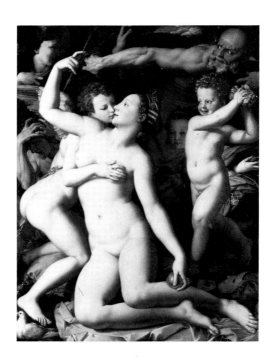

FIG. 24. BRONZINO, *Venus, Cupid, Folly, and Time.* National Gallery, London.

longs to the literary current of such writers as Gautier, Pater, Swinburne, and James that has contributed so much to the modern appreciation of Mannerism.

Just as we spoke of Pater as not merely a critic of Mannerism but also a latter-day Mannerist, so too can we speak of a mannered grace, preciosity of diction, and refinement in Freedberg's prose that makes of him a Mannerist, a Bronzinesque writer.[44] In the greatest criticism, the art of the past is reborn—coming alive in the art or re-creative act of the critic, poet, or novelist. In Nabokov's allusions to the Mannerist art of Parmigianino and in Ashbery's Paterian references to the same painter, we find a comparable verbal complexity appropriate to the intricacy of Mannerist art. Not surprisingly, as we saw earlier, Freedberg's prose and insights into Parmigianino are integrated into Ashbery's poem about the painter.

Freedberg's description of Bronzino's picture is built upon analysis and is not merely impressionistic, although it surely depends on his impression of the work. It is grounded in a close reading of Mannerist iconography. Indeed, Freedberg has read the entire iconographical scholarship on Bronzino's painting, assimilating those aspects of meaning that are seen in the image, testing the consonance between literary meaning and form—their very "interpenetration," as Pater might have said. He rejects the Panofskian notion that the painting is a moral allegory, precisely because the form of the picture

and its tone, as he says, subvert this pretended meaning. By analogy, he adds in a footnote that Bronzino's painting subverts the authoritative work of Michelangelo, whose Madonna in the *Doni Tondo* is parodied in the posture of Venus. In the spirit of Freedberg's observation, we might further note that the transposition of Mary into Venus augments the subversive irony of the picture.

Freedberg finds a similar perversity in the sphere of religious art, in particular in the work of Rosso Fiorentino, whose complex *Descent from the Cross* is notable for its "evasive irony, as if there were some ambivalence in Rosso towards the human and religious meaning." He sees in the "brilliant irony" of Rosso's *Dead Christ* "a sensuality that contradicts a value more essentially Christian than the specific dogma." And in a similar vein, he finds a "derisive irony" in Caravaggio's *St. John the Baptist,* which is a "blasphemy," intending an aesthetic sacrilege, for it is a shockingly realistic "reaction to Michelangelo's veiling and sublimation" through the idealization of art.

Freedberg thus writes in a general way about irony in moral, religious, and aesthetic terms. More than perhaps any modern art historian, he has dwelt on the paradoxical and ironical in Renaissance art—aspects of this art too often neglected or overlooked by scholars. Doing so, he writes in the manner of Pater, who so skillfully underscored the ironic disparity between the religious content and eroticism of Leonardo's *St. John.* Just as Freedberg writes in the fashion of Pater, Freedberg's subjects—Rosso, Bronzino, and Caravaggio—all worked in the tradition of Leonardo interpreted by Pater. For Pater, Leonardo's art epitomizes the emergence of consciousness or self-consciousness, the precondition for pictorial irony, and following Pater's aperçu, Freedberg outlines the history of such consciousness in sixteenth-century painting.

Freedberg's description of Bronzino's *Venus, Cupid, Folly, and Time* presents by implication his very method. This method is still that of Paterian "aesthetic criticism," which combines knowledge of one's "impression" of the work with an understanding of the object " 'as in itself it really is.' " To know the work in itself Freedberg relies on all historical data available to him, assimilating them to his description. He relies, for instance, on the criticism and theory of Vasari, who was Bronzino's friend. (Often Freedberg will even emulate or parody the cadences and archaic Latinisms of sixteenth-century English to approximate the qualities of grace, variety, and gravity of cinquecento art.) Although he does not explicitly quote from Vasari's writing on Bronzino, Freedberg describes Bronzino's picture in such a way that we have a sense of Vasari's appreciation of artistic *sottigliezza* and *bella maniera,* or perhaps *maniera ricercata.*

Over the years a vast and rich scholarship has emerged on Renaissance art theory—from the writings of Kallab and Schlosser to those, more recently, of Baxandall and Summers. The study of this art theory is valuable for its own

sake, and for what it might suggest about Renaissance art itself. But we should note that the bulk of this writing deals with theory disjunctively from art, whereas Freedberg, assimilating its language, uses it to express concretely the qualities of particular works of art. By analogy, the study of iconography is valuable for what it teaches us about the symbolic conventions of art, but whereas much of the iconographical scholarship deals with the texts that paintings are said to illustrate but not much with the paintings themselves, Freedberg assimilates the findings of other scholars to his descriptions of paintings. As Freedberg reminds us, the text becomes valuable to our understanding of art only when it is judiciously applied to the description, and thus to the interpretation, of the image itself.

In Freedberg's evocation of Bronzino's painting, as in Pater's descriptions of works of art, a vast amount of historical data is contained within and in a sense is masked by description. Reading his description in relation to Vasari's *Lives*, Cellini's *Vita* or theoretical *scritti*, in relation to Bronzino's poetry or Firenzuola's discourses on beauty, or in relation to countless other primary sources that comment on the social, literary, artistic, and even political milieu of Duke Cosimo de' Medici, for whom Bronzino's picture was made, we come to appreciate that Freedberg's interpretation of the painter's artifice and irony justly bespeaks these aspects of the Medici circle in the middle years of the sixteenth century, that his sense of the painting, his "sense of fact" or "impression" of Bronzino, is corroborated by the historical facts.

Following Pater's emphasis on "pure form" and building on Berenson's related distinction between "form" and "illustration"—a "necessary fiction" as Berenson called it—Freedberg also insists that the value of art resides in form. This view, as we have seen, does not by any means preclude a historical interest in works of art, including works of lesser quality, which are important for what they tell us about the culture in which they were made or, as Pater said, for what they teach us about the relation of "secondary" figures to "great" artists. Freedberg upholds the conviction in a notion of quality that many art historians, who would want to free art history of aesthetics for reasons that defy analysis and outrage moral sensibility, find objectionable. The current tendency to debunk the study of form and the characterization of its beauty and qualities is an analogue to the tendency of art-historical discourse to be plain in manner, unliterary, if not antiliterary, and even brutal in its antiseptic tone and careless use of jargon. Just as this writing is for the most part no longer literature, the works that it treats are no longer art but de-aestheticized historical data. Surprisingly, or not surprisingly at all, however, for all the talk of freeing art history of aestheticism and formalism, of an elitist canon, the history of Renaissance art now being written still presents essentially the same historical configuration introduced by Vasari and refined by such critics as Pater, Berenson, and Freedberg.

Like Pater and other literary scholars of art, Freedberg responds to the poetical aspects of Vasari's interpretations, creatively absorbing them into his own descriptions of paintings. Describing Michelangelo's *Creation of Adam* (see Fig. 2), Vasari had said that Adam is "a figure of such a kind in its beauty, in the attitude, and in the outlines, that it appears as if newly fashioned by the first and supreme Creator rather than by the brush and design of a mortal man." In Vasari's rhetoric or poetic theology, the "divine" Michelangelo is associated with God the Creator, and this connection is consistent with the overall allegorical structure of his hagiographical biography. Rather more subtly, but still in the tradition of Vasari, Pater associates the act of creation in *The Creation of Adam* with the general theme of the "creation of life" as "the motive" of all Michelangelo's works. It is as if all Michelangelo's works were meditations on creation, linking his own to those of "the Creator." Pursuing this vision of Michelangelo's fresco, Berenson described, as we have seen, the Faustian "type of man best fitted to subdue and control the earth, and, who knows! perhaps more than the earth." Berenson retains Vasari's notion of the artist's divinity, echoing his sense of Nietzsche's *Übermensch* as well. When, finally, Freedberg writes about this fresco, he writes in the manner of Pater and Berenson, returning rather more directly to his Renaissance forebear when he observes that "for the moment Michelangelo's and God's roles merge: God acts the classical sculptor." This is a variation on Vasari's theme connecting artist and Creator, a different way of putting Vasari's point that Michelangelo's Adam seems not to have been painted but to have been created by God himself!

The Vasarian interpretation of *The Creation of Adam* can be traced back to its intellectual roots in the writings of the Florentine Neoplatonists, who spoke so insistently of man's "divinity." Pater, we will recall, suggestively juxtaposes Michelangelo and Pico in *The Renaissance*, interweaving Michelangelo into his essay on Pico, Neoplatonism into his essay on Michelangelo. In the "Oration on the Dignity of Man," Pico celebrates man's capacity to fashion himself, as if he were shaping himself into an angelic or heroic being. Such an idea, linking spiritual and artistic perfection, is found conspicuously in Michelangelo's poetry, in which the poet relates his quest for spiritual "perfection" or completion with the making of a statue; it is implicit in Vasari's description of Michelangelo's *Creation of Adam* and is still alive in Freedberg's iconographical reprise of Vasari's Neoplatonic theme.

Keeping in mind the historicism of Pater's description of works of art—for example, his depiction of the *Mona Lisa,* who embodies all of history prior to and after her, all modes of thought—we can see that our sense of Michelangelo's *Creation of Adam* is similarly determined by the history of theology, from the Bible to Pico, just as it is further defined by the transformations of this tradition from Vasari to Freedberg. If our impression of the fresco is

colored by the intermediary writings of Goethe, Pater, Nietzsche, and Berenson, Freedberg reminds us that, through them, we can still approach Michelangelo's creative intentions.

A survey of the broad history of interpretations of Michelangelo's *Creation of Adam* from Vasari through contemporary scholarship also points to an important connection between the Renaissance and the modern period. For Pater, the heroes of his book are aesthetic heroes; like the Greeks, they are "ideal artists of themselves, cast each in one flawless mould." Defining the modern aesthetic hero, Pater relies on the diction of Pico, Vasari, Michelangelo. This hero is not identical with the saint as hero or with the artist as saintly hero. But the modern Paterian hero does have his roots in theology, for, as we see in reading Pater, the ideal of aesthetic perfection emerges from the ideal of spiritual perfection. Pater betrays this relation in his description of the "pure form" of art. When he calls it "purged form," he is still alluding to the purgation necessary to spiritual perfection. Pater, Berenson, and Freedberg do not write with the religious conviction of Pico, Michelangelo, and Vasari, but they make us see that, just as aesthetics is said to have emerged in a general way from theology, the modern aesthetic hero has his antecedents in a spiritual or saintly type. Pater's ideal artist who molds himself descends from Pico's notion of man fashioning or perfecting himself spiritually.

When Freedberg describes "the interpenetration of the physical and spiritual being" in Michelangelo's Adam, he alludes to "the essence of the classical idea." Nor is this ideal of "interpenetration," which recalls the diction of Pater, unrelated to the Paterian ideal of the "unity of culture," the unity of being. In an age when most scholars reject an ideal of synthesis or claim that it is no longer possible, Freedberg aspires to achieve a richly balanced account of the cinquecento that is itself a critical and literary analogue to the very ideal of classical harmony that he extols. With Vasari, Goethe, Pater, and Berenson, Freedberg focuses on the "vitality" of the classical style, its "life-enhancing" energies. Yet like Pater, he also recognizes the fragility of this dynamic synthesis, beheld in a nearly Keatsian way in the *Mona Lisa,* the "synthesis of a rare perfection between art and reality: an image in which a breathing instant and a composure for all time are held in suspension." Such harmony is destroyed in the postclassical art of the Mannerists, and one senses in Freedberg's writing, as in other modern interpretations of this art, that the concept of dissolution is analyzed in light of the modern predicament that Pater spoke of as the "unweaving of ourselves."

Like Pater, master of the analogical method, Freedberg aspires to a classical synthesis by weaving artists of diverse situations, geographical and temporal, into a unified, harmonious historical tapestry. Thus Fra Bartolommeo's *Salvator Mundi* is an "analogue" of Raphael's tapestries; a *Holy Family* of Andrea del Sarto is similarly an "analogue" of Leonardo's art; the Castelfranco altar-

piece is analogous to Raphael's early work; the unity of the *Tempesta* is akin to the harmonies of central Italian art; and Giorgione's *Venus* is a "counterpart" of Michelangelo's Adam. Sometimes these analogies are presented with the subtlety of *sfumato*. Parmigianino's Fontanellato frescoes, for example, "fall in temper between Perino's Roman decorations and Pontormo's of Poggio a Caiano." Such relations are multiplied seemingly *ad infinitum* in order to achieve a close-textured, complex, yet unreductive historical picture, for Freedberg (again reminding us of Pater and other great nineteenth-century critics) insists vigorously on the individual "temper" or "temperament" of each artist whose work he discusses.

Freedberg sees the harmonies of art in Paterian terms of the interwoven threads of a tapestry. The relation of color and light in Leonardo's *St. Anne* is like a "tissue that is woven," and Michelangelo's *Madonna of the Steps* is characterized by its "slow-weaving, rounding continuity." The "complexities of colour" are "threaded" in a "tapestry-like" way into the works of Parmigianino, and "fine-spun patterning of drapery and silhouette and complex modellings" mark the work of Palma Vecchio. For Freedberg, as for Pater, the seamless fabric of art approaches the harmony of music. The "weaving" of "strands" of Mannerist painting is likened to "polyphonic music." The "strong, slow curving rhythm" of Andrea del Sarto's *Madonna del Sacco* transforms "geometry into music." Raphael's *Parnassus* is notable for its "melodiousness," Leonardo's work for its "smooth melodious effect." The "*largo*" of Giorgione's *Judith* is a "cadence slower and purer than any in Leonardo." This last description brings us back to Pater's sense of the Giorgionesque.

Freedberg's writing on Giorgione belongs to the great tradition of English literature on Venetian art from Hazlitt and Ruskin to Pater and Stokes. His description of the *Sleeping Venus* is exemplary: "The shape of being is the visual demonstration of a being in which idealized existence is suspended in immutable slow-breathing harmony. All the sensuality has been distilled off from this sensuous presence, all incitement; Venus denotes not the act of love but the recollection of it. The perfect embodiment of Giorgione's dream, she dreams his dream herself." Freedberg's implicitly iconographical appreciation of *sogno* or dream in Venetian art is seemingly reminiscent of Ruskin's description of Carpaccio's St. Ursula, who dreams the angel's dream, but perhaps even more it echoes the kind of dreamy *voluptas* in French nineteenth-century poetry— especially in Mallarmé's "L'Après-midi d'un faune," in which the poet dreams of the flesh of nymphs that "hovers in the air drowsy with tufted slumbers." Freedberg's affinities with Mallarmé recall Mallarmé's indebtedness to Pater. It is thus not surprising that Freedberg's sense of Giorgione's voluptuousness, from which all sensuousness has been distilled, is especially Paterian, recalling Pater's approach to Giorgionesque works in which color is perceived "sensuously" but in a kind of abstraction. Also like Taine, whose often un-

acknowledged concern with artistic *milieu* stands behind much contemporary study of art in context, Freedberg relates Giorgionesque art to its environment—to the "kaleidoscopic visual enchantment" of Venice, where "the sea-selected light" makes "complicating interactions among colours." Freedberg's appreciation of art is partially determined by study of the particular historical circumstances in which this art was made; for instance, he relates the opulence of Venetian art to the Venetian economy, as described by the distinguished historian Ferdinand Braudel. This opulence is expressed in the chromatic richness of *Giorgionismo*, which Freedberg also observes "may often be a thematic matter more than one of formal style." Freedberg's point had been intimated by Kenneth Clark when he remarked that the title of Pater's essay, "The School of Giorgione," suggests that "the Giorgionesque" is a "subject"— understood as well through its "reflections" as through a study of the "fluctuating outline of its central luminary."[45]

Freedberg moves effortlessly through the history of Venetian art, from the tranquil silence of Giorgione to the "awesomeness" of Titian, which he likens to the *terribilità* of Michelangelo. Still in the manner of Vasari, he appreciates the vivacity of Titian's "stupendous" style, recognizing that the world in which the painter's figures act takes on the semblance of a dream, that this is "a new, dynamic, and aggrandized recrudescence of Giorgionesque *sogno*." It is a dream of unsurpassed "emotion generating vibrance," beheld, for example, in Titian's most complex late work:

> In the *Marsyas* the surfaces of bodies make a silver incandescence, and the atmosphere, almost unbreathably dense, is like dulled fire. The image seems both palpable and limitless, depicting existences in landscape space but denoting that what we see is a function of the cosmos. In this intensely present yet immeasurable world the enactment and the actors seem to make time as well as space coalesce, and it is uncertain whether they are beings conjured into now from mythical antiquity or persons from the present, almost caricatures, in antiquarian disguise. There is a wry comedy within the cruelty, ugliness and strangeness within the magisterial beauty, and terror accompanies the sense of the sublime. The daemon who inhabits Titian, making union between him and the cosmos, is Old Pan.

By analogy, the daemon who possesses Titian's critic is Old Pan. Like Pater, who seemingly exhibits a kind of Negative Capability, becoming Giorgione, Freedberg inhabits Titian and renders in words the painter's impassioned incandescence. "There is something Faustian," Freedberg remarks of Titian's last works, in his ultimate "possession of the world of the painter's knowledge; it has the element of the daemonic." There is something similarly almost Faustian about Freedberg's writing on art, for he commands his subject in prose with an all-consuming passion and clarity of vision. In an age

when professional art history (in many respects a deviation from the tradition founded by Vasari) has often descended to pedantry, treating art as commodity, Freedberg's monumental work serves as a beacon to those amateurs still committed to the beauty, dignity, and moral force of art, and it also serves as a bridge between Walter Pater and the future course of art history.[46]

12 Form and Meaning in Giorgione

"The importance of Pater's essay" on the school of Giorgione, Kenneth Clark observed in his introduction to *The Renaissance*, "does not lie in his descriptions of Giorgionesque painting, but in the four or five pages of criticism with which it opens." And yet, if Clark is correct in claiming such importance in these first few pages of the essay, it is also the case that Pater's descriptions of Giorgionesque paintings are culturally significant. Their lyricism informs modern poetry, for example, the writing of James Joyce, whose "soft sweet music" on "invisible harps" in "Chamber Music" is Giorgionesque:

> All softly playing,
> 　　With head to music bent,
> And fingers straying
> 　　Upon an instrument.

And perhaps, too, Yeats, whose relations to Pater have often been remarked upon, writes in a Giorgionesque manner in "The Lake Isle of Innisfree," in which we hear "lake water lapping with low sounds . . . in the deep heart's core."

If Pater brings Giorgione to Joyce and Yeats, he finds qualities akin to those of the painter in Wordsworth. The "exquisite pauses" of time that Pater finds in Giorgione are the "select moments of vivid sensation" that he discovers in Wordsworth. The theme of love in Giorgione's Venetian pastorals is linked implicitly with Wordsworth's "passionate pastorals," the *fuoco giorgionesco* with Wordsworth's "imaginative flame." Just as Wordsworth is the heir of the Venetian painter, so is Giorgione the precursor of the romantic poet.[47]

Ever since Pater wrote about Venetian pastorals, art historians have investigated Giorgione's paintings in relation to Venetian pastoral literature. Pater gave shape to the general character of modern art-historical discourse on Giorgione. Literary scholars have carefully glossed Pater's essay on Giorgione, tracing its uses of such eighteenth- and nineteenth-century writers as Lessing, Schiller, Hegel, Rossetti, and Browning, among others, but they have by no means exhausted his sources—antecedents that helped him to define the essence of the Giorgionesque.

At least a word should be said about the debt Pater's essay owes to the writing of Ruskin, for though he is not mentioned by name in the Giorgione essay, Ruskin is present by implication. Indeed, Pater's celebration of Renaissance culture should be seen in relation to Ruskin's condemnation of the Renaissance Grotesque. Moreover, when Pater writes specifically about Venetian painting, he writes in the shadow of Ruskin, the principal critic and historian of Venetian art in Victorian England, and what he says about Venetian painting is often a revision of Ruskin. For example, Ruskin praises the cataclysmic spirituality of Tintoretto's vast, agitated religious works, especially the San Rocco pictures. When Pater mentions Tintoretto, however, he notes with cool detachment, if not pointed coyness and restraint, "the arabesques traced in the air" by the painter's "flying figures." He transforms the expressively mannered, incipiently baroque painter into a refined rococo designer. Disdainful of Ruskin's overly expressive manner, Pater seeks a more "elusive," exquisite prose, and he finds its analogue not in the trumpet blasts of anatomical agitation and gyration of Tintoretto's art but in the refined grace, restraint, and stillness of Giorgionesque art.

Just as Ruskin is present in Pater's writing by implication, so too is Hazlitt. More than any other piece of nineteenth-century art criticism, Hazlitt's "On a Landscape of Nicolas Poussin" is likely to have been a source of inspiration to Pater.[48] Hazlitt's essay is similarly about pastoral paintings, and like Pater's it is delicately crafted. In contrast to the torrential intensity of Ruskin's criticism, Hazlitt's is measured, seemingly classical in its stateliness. This restrained grandiloquence would have served Pater well. There is something almost Giorgionesque or incipiently Paterian about Hazlitt's appreciation of Poussin's moist, color-saturated, twilight landscape:

> Mists rise around him, and veil the sides of the green forests; earth is dank and fresh with dews, the "grey dawn and the Pleiades before him dance," and in the distance are seen the blue hills and sullen ocean. Nothing was ever more finely conceived or done. It breathes the spirit of the morning; its moisture, its repose, its obscurity, waiting the miracle of light to kindle it into smiles: the whole is, like the principal figure in it, "a forerunner of the dawn." The same atmosphere tinges and imbues every object, the same dull light "shadowy sets

off" the face of nature; one feeling of vastness, strangeness, and of primeval forms pervades the painter's canvas, and we are thrown back upon the first integrity of things.

Both the subject and the general shape of Hazlitt's essay would have been of particular interest to Pater. Hazlitt begins with a meditation on a single painting, *Orion*, described above, and from this interpretation he proceeds to define the general character of the painter's art, likening it to poetry, before concluding with general remarks on the pleasures of pictures. Hazlitt quotes the inscription—*Et ego in Arcadia vixi*—in Poussin's picture of shepherds in the Vale of Tempe, a painting about the passing of time and death that is especially Giorgionesque in its stillness and Venetian landscape. Describing pictures in a nearly Paterian way as "a stream of pleasant thoughts passing through the mind," calling a life passed among such pictures a "happy, noise-less dream," Hazlitt sets this life of artistic dream against death. It is as if Hazlitt were already talking about such paintings as *Orion* as "profoundly significant" instances, "exquisite pauses in time."

Another work likely to have shaped Pater's appreciation of the Giorgio-nesque is the Goncourts' *L'Art au Dix-huitième Siècle*, particularly the first essay on Watteau. Whereas the general design of Hazlitt's essay was the likely model for Pater's essay on Giorgione, the Goncourts provided Pater with a special diction and imagery. Into a primordial world *à la* Hazlitt, Pater projects the Goncourts' sense of a sort of salon al fresco. Their description of Watteau's *fêtes* could almost be from Pater's description of the school of Giorgione: "throughout his *fêtes galantes* there penetrates an indefinable sadness; and, like the enchantment of Venice, there is audible an indefinable poetry, veiled and sighing, whose soft converse captivates our spirits." Speaking of the "poetry," "elegance," "grace," and "languor" of Watteau, all matched by Pater's Gior-gione, the Goncourts believe that Watteau "drew magical visions, an ideal world, from his imagination and raised up, beyond the frontier of his epoch, one of those Shakespearian kingdoms, one of those passionate and luminous countries, such a paradise as Polyphile raised upon the clouds of his dreams for the contemporary delectation of all poetic natures."

The reference to Polifilo brings us back to the dream world of Giorgione's Venice, for the *Hypnerotomachia Polifili* is a romantic Venetian work close in spirit to Giorgionesque painting; its woodcut illustrations, especially of pas-toral scenes, are linked to Giorgione's pictures, just as Watteau's are associ-ated with Giorgione's. As the Goncourts speak of the musical instruments in Watteau's art—"the delightful air of a profile bowed over a lute"—or of "that flashing harmony as of golden locks wreathed with red violets," they reinvent the Giorgionesque world: "Sight and thought languish into a vague, vanishing distance, like the deep floating backgrounds that are the frontiers

of Titian's pictorial world." Watteau's is like a Giorgionesque dream of a "Lethean stream" that "spreads silence through this land of forgetfulness." Whereas the Goncourts emphasize the sheer voluptuousness of Watteau's neo-Giorgionesque world, Pater finds a more chastened *voluptas* in the Venetian painter's bittersweet painted dreams.

Much has been made of the fact that the Goncourts touched upon the melancholy in Watteau's work, but it has quite escaped notice that, doing so, they followed Gautier, who brings out this quality of Watteau's works in his poem about the painter, "Watteau."[49] We have already noted that Pater's taste for mannered refinement in art, like Swinburne's, is closely related to Gautier's. In his guidebook to the Louvre, Gautier said that the Giorgionesque *Fête Champêtre*—which he undoubtedly saw through the eyes of Watteau—"tells no story." His characterization foreshadows that of Pater, who saw such paintings as *genre*, as "painted idylls," and of those art historians who have agreed that no precise story is rendered in them.

When an art historian published a learned interpretation of the *Fête Champêtre* as an allegory of poetry in *The Art Bulletin* in 1959—a study widely followed in modern scholarship—she wrote not merely an iconographical study but an appreciation in the tradition of Pater and of the poets and poetical critics who inspired him.[50] To put it differently, our understanding of Giorgione's "poetry" depends upon the poetry of Wordsworth and Gautier, of Rossetti and Keats, and upon the prose poetry of Hazlitt, the Goncourts, and Pater. We have seen that painters themselves, Poussin and Watteau, as Hazlitt and the Goncourts imply, have taught us how to look at Venetian art. Poets and poetical critics do not belong merely to the history of taste, as art historians sometimes suggest, but to the history of the interpretation of art, for even if these poetical writers do not offer exact elucidations, they suggest such interpretations and often determine the direction of iconographical illumination.

In Phase 14 of *A Vision* Yeats, following Pater, links Giorgione with Keats, reminding us that our understanding of the painter is not purely an art-historical phenomenon, since the art historian's perception is shaped by the forces of poetry and poetical criticism. The tradition that Pater epitomizes, linking the history of art to poetry, calls our attention again to the place of art history in our general cultural life. Poetry, *belles lettres,* and scholarship are interwoven in this cultural fabric, and they cannot be unwoven without deforming it. The historical understanding of a work of art is bound up with a critical sense of the work and, as Baudelaire suggested, poetry may be the most effective way of rendering in words the sense of a painting or, as we might put it, of approaching pictorial meaning.

Repudiating this fundamental relation between criticism and history, E. H. Gombrich recently concluded his book *The Sense of Order* with the following

proposition: "The art historian is not a critic and should not aspire to be one." It would seem that Gombrich's remark, despite its grammatical form, is less an injunction as to what art history should be than a description of what it is at present: all art history aspires to the condition of futility. Yet there is, *au fond*, no necessary incompatibility between the quest to understand the meaning of a work of art and the critical sense brought to it by its interpreter.

One way in which art historians have sought to separate historical analysis from criticism is through the study of texts to which works of art are thought to be related. Discussing these texts, scholars often seem to believe they are reading the works of art themselves. But until these texts are assimilated to the description and thus to the interpretation of the work of art, they serve only as a kind of prolegomenon to the understanding of art. Even when the text is discussed in relation to the artistic image, we should observe that the image is never an exact equivalent of the text it illustrates, for it transforms the words it depicts into something other than what they were. The written word will help us to approximate the meaning of a work of art, but we cannot claim that it explains *the* meaning. This meaning is inseparable from the form in which it is rendered. To ignore this form, as many antiformalists do, is thus to ignore a part of this meaning—the intelligence that resides in form, the intentions of form, which are part of the work's total meaning.

This meaning, like the imagination that conceived it, is often mobile, not to be fixed or "nailed down," to use the unfortunate phrase of a distinguished iconographer. The very fluency of Renaissance *fantasia*, for instance, is justly described by Pater's friend and follower Vernon Lee. Speaking somewhat ironically of Giorgionesque paintings in *Fancies and Studies,* she observes: "Of such pictures it is best, perhaps, not to speak. The suggestive imagination is wandering vaguely, dreaming, fumbling at random sweet, strange chords out of its viol, like those of young men and maidens. The charm of such works is that they are never explicit; they tell us, like music, deep secrets, which we feel, but cannot translate into words."

As an illustration of the very suggestiveness and elusiveness of Giorgionesque art, let us examine Giorgione's enigmatic little canvas, the *Tempesta* (Fig. 25). Some scholars have identified the figures in this canvas as classical gods or biblical heroes and saints. Others have suggested that it represents a moral or cosmological allegory.[51] None of these interpretations, however, has gained wide acceptance, probably in part because they depend, in modern iconographical fashion, on interpretations of literature and not on an understanding of the painting as such. We have come to believe that the meaning, if not the value, of the *Tempesta* resides in the matter of its illustration. The painting is treated as if it were a literary work, and we are expected to "read" it as if it were a text or an approximation of a text. The distinguished Viennese scholar Johannes Wilde best summed up contemporary thinking when

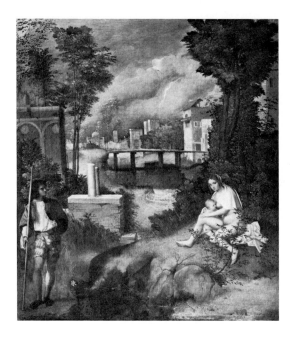

FIG. 25. GIORGIONE, *Tempesta*. Accademia, Venice.

he observed of the *Tempesta*: "Not until the actual text on which a picture such as this was based has been found can we claim that we understand its subject."

Some scholars, however, have spoken of the painting as a "non-subject" or even "anti-subject," in reaction to the excessive *literalism* of iconographical exegesis, and this has been a helpful corrective to a fundamental fallacy of interpretation.[52] But doing so, they have overreacted, for pictures still have subjects even if they cannot be associated with texts. Giorgione's subject, briefly stated, is a man and a nude woman with a child in a stormy landscape; the question of what this subject intends or expresses is another matter.

If we trace the great tradition of creative writing about art back to the times of Giorgione himself, we find that, while acknowledging the relations of art to literature, this writing has treated painting as painting, not misleadingly as literature, and has had much to say about the "subject" of art (not necessarily its literary content). The respect for the meaning of art as it resides in form is everywhere evident in the writings of Vasari, exemplified in his brief description of a lost work by Giorgione:

> He painted a man in the nude with his back turned and at his feet, a limpid stream of water bearing his reflection. To one side was a burnished cuirass that the man had taken off, and this reflected his left profile (since the polished surface of the armour revealed everything clearly); on the other side was a mirror reflecting the other profile of the nude figure.

As Vasari tells us further, the painting was made to demonstrate the virtuosity of painting, which surpasses sculpture in its capacity to show in one scene "more aspects of nature than is the case with sculpture." But the painting by Giorgione was more than the mere illustration of a theory of art, for on the basis of Giorgione's extant works we can imagine both the mimetic power and sensuous beauty of light reflecting from the water, armor, and mirror to which Vasari alludes. As Boschini remarked in the seventeenth century, Giorgione's forms "reflect like mirrors," and this luminosity, in all its dazzling magnificence, is part of the subject of Giorgione's *Tempesta*. In the modern literature, Vasari's follower, Walter Pater, above all remarks upon the significance of form to painting, especially in the work of Giorgione and his school:

> . . . that the mere matter of a picture, the actual circumstances of an event, the actual topography of a landscape—should be nothing without the form, the spirit of the handling, that this form, this mode of handling, should become an end in itself, should penetrate every part of the matter; this is what all art constantly strives after, and achieves in different degrees.

The ostensible subject of the *Tempesta* is a landscape with three figures, whether personifications of gods, saints, or mere mortals. A description or explication of its purported symbolism does not give a full sense of the painting's meaning and value, for it does not comment upon the indissoluble relation of form to content. The "essence of the pictorial," to use Pater's term, resides in the obliteration of the distinction between form and matter, and the interpenetration of form and matter, which gives the *Tempesta* its value, should be studied, not overlooked, by the scholar as he searches for Giorgione's "reading list."

Writing in the manner of Pater of "the system of responsive balances woven into a connected unity" of structure in the *Tempesta*, Sydney Freedberg also comments on the role of light and color, which infuse the painting with the "vibrance of the seer's feeling." Doing so, he points to an iconological implication of the painting—the painter's seerlike capacity to see profoundly, to look deeply into nature. In a related fashion, Adrian Stokes had spoken in *Venice: An Aspect of Art* of the *Tempesta* as "a moment of utmost revelation," connecting the "outward world" to "a deep-set wordless dream," adding that Giorgione's "calm poetry" "induces a contemplative mood." We follow Stokes and Freedberg back to Pater's sense of Giorgione's art, which is likened to Wordsworth's "impassioned contemplation" of nature. The words "seer," "revelation," and "contemplation" are all theological in their origins and connotations, clues to the modern aesthetic critics' sense of the still-sacred implications of Giorgione's art.

Let us now look more carefully at the painting in order to understand better

how the painter has achieved his effect. We gaze upon a lush, green landscape, permeated by a moist, dark, blue-green atmosphere. In the distance we see a city, its tower and dome rising above the horizon; in the middle ground looms a pool of water spanned by a bridge; closer still are trees and bushes on either side; part of a ruin and a wall with broken columns are to the left, and in the foreground a courtier, who holds a staff, stands on one side of a stream, which extends forward from the distant pool toward a nude woman suckling a child. As we look at the painting we become aware of two slow-moving rhythmic undulations of form intersecting toward the lower center of the canvas. We follow the descent from the ruin on the left, to the wall with columns, to the earthy patch below the woman, and as we do so we notice that the forms of the ruin are softened by its arches and by the gently bending trees and bushes. This movement is interwoven with the flow of form from the tree above the woman through the bushes adjacent to her, across the rocky mound of earth upon which she is seated, to the other side of the stream. The cadences of the two descending curves are soothing in their easy, graceful, turning descent.

The painting may be said to be informed by the grace of circularity. The trunks and branches of the trees on either side of the pool bend centerward, implying a circular form at the upper center of the picture, harmoniously and gently embracing the distant city and the pool of water. This small pool, seemingly deep and still, reflects the rock above, which in its gradually sloping form blends with the shape of both the foreground pool and the watery body in the center. At the left of this little pool the courtier is gracefully posed; bending fluidly, his body is echoed by the shoreline at his feet and re-echoed by the shapes of bushes behind, as by the arches of the buildings. All of these arcing forms are subsumed by the large semicircular flow of form from the lower right corner to the upper left of the painting, and as we dwell in this region of Giorgione's landscape fantasy, we recognize further circular resonances. At the tops of the broken columns, little discs unite with the decorative circles of the ruins, and these columns, which circle in depth, imply a relationship to the male figure, who, leaning forward and holding his arm behind him, suggests an imaginary cylinder in space. Beyond the columns the shoreline curves alluringly into the distance, reaching the dome, its shape consonant with the architectural details in the middle ground. Even straight lines approximate curves; hence the ruin behind the male figure is ever so slightly at an oblique angle to him, combining with the figure not to sustain a purely vertical flow but to suggest the upward sweeping curve of the painting. The verticality of the pictorial design is diminished by the inflection of the courtier's staff set at a slight, inward angle, approximating that of the analogous slender, bending tree behind. Imagine the figure without his staff; it would be less unified with the landscape, for in the distance the sloping roofs and ultimately the lightning sustain its form.

Some of the pleasure we take in Giorgione's painting resides in our recognition that we can return to it often and discover on each occasion further secrets of its harmony. The next time we see the painting we might focus more sharply on the complexities of the trees, which are united not only to the figures before them but are no less integrated with the figure on the side of the canvas opposite them. We will recognize in the bend and sway of the grass and trees, previously overlooked, rhythms that further harmonize this vision, and we will find that the bridge in the middle of the painting—one of its primary actors—is tilted slightly, contributing to the subtle upward movement previously observed.

The harmony of the painting depends fundamentally on Giorgione's rendering of light and color. Lights and darks are subtly harmonized to create a unified, almost palpable atmosphere. These gradations of light and shadow are so subtle that we cannot fully compass their nuance, but we respond to their effect—the harmonious atmosphere to which figures and forms are ineluctably fused. Almost as in a canvas by Velázquez, the atmosphere seems a living presence, and although we do not discern each gradation of light and shade in Giorgione's painting, we immediately perceive the overall pattern of lights and darks shot through it. The pale, pebble-filled sand is played against the dark foreground pool; this shadowed area is answered by the blackened blue-green mass of the bridge's watery shadow and by the darker areas of the tree to either side. Yet in these plants, as in the sky above or in the grass below, golden light plays upon surfaces, brightly animating this subdued vision of lush blue-green.

A single passage illuminates the refinement of Giorgione's handling of light and color. Dressed in red and white, the courtier commands our attention. Red and white are interwoven throughout his costume, harmonized by the pink of his leggings and subdued by their gold, which is related also to the golden threads of light scattered brightly through the obscurities of landscape. Although enshadowed, the courtier's left leg emerges luminous at the calf, a subdued variant of the white blouse, brilliant against the bright red and coal-black shadow of the courtier's cape. Few painters have matched Giorgione's uses of black and white (or whitened, luminous color). The bright white of the blouse is wed to the even brighter white of the nymph's drapery. These two brightened areas are linked to the bright flash of lightning above, and touches of white—flecks upon the water or upon the façades of the buildings—serve to integrate these bright areas. The building at the right, beyond the woman, is a luminous yet partially shaded variant upon her whiteness. The columns behind the courtier are similarly analogues to the courtier's leg in both their subdued blacks and whites and their rounding forms. Here we witness the effortless, modulated unison of light, color, and form, whose "tints," as Byron said, "are truth and beauty at their best."

These pleasingly intricate harmonies, affecting us like an anodyne, are inseparable from the painting's ostensible subject, for they are intimately wed to its meaning. We have been gazing upon the harmonious relations of man, woman, and child in nature, made alluring by virtue of the richness of the very form rendering and uniting them. The courtier's dress implies the harmony of court dweller with nature, and the wholeness of nature with which he and the woman and child are united is elementally expressed by the appearance of the four elements—earth, air, water, and the fire of the lightning—all interpenetrating in Giorgione's vision. Despite this flash and impending storm, the figures are reassuringly aloof and calm, and perhaps we especially respond to the soothing image of the child at the woman's breast, an illustrative metaphor for the formal epiphany of ease, comfort, and oneness that Giorgione has rendered, "love in life," as Byron describes it. For in effect our relation to the painting and to the world it represents is analogous to the child's relation to its mother; we gain sustenance from Giorgione's vision, embraced by the encircling arms of his art. The flash of lightning and the broken columns evoke the idea of the passage of time, but at the same moment Giorgione presents us with the image of an eternal order, gentle yet vital, to which we happily return. And the pleasure we take in this nurturing harmony does not reside merely in the idea of harmony, which is only a cliché, but in the subtle and complex realization of that idea as form.

Let us turn our attention finally to some of the numerous, specific interpretations of the painting. Scholars have associated the painting with the texts of Ovid, Statius, Petrarch, Boccaccio, and Francesco Colonna; they have identified the picture as the illustration of Adam and Eve, the discovery of Moses, a profane *Rest on the Flight*, or the legends of San Rocco and San Teodoro. Jupiter, Bacchus, Paris, and Danaë have all been identified as protagonists of the picture, and it has further been supposed that Giorgione painted the origins of the Vendramin family, a lament on the death of Matteo Costanzo, and a portrait of his own family. In more general terms, the painting is said to be an illustration of the union between sky and earth, an allegory of the four elements, an allegory of charity and strength overcoming fortune, and a visualization of the dictum "Harmonia est Discordia Concors." As we have observed, none of these interpretations has received wide acceptance, and most have been generally discarded. And yet, if we reflect upon them, although too literal, many of these are both interrelated and, more important, responsive to the painting.

The classical, biblical, and allegorical interpretations all hark back to the mythic or primordial, to the sense of something momentous and extraordinary—the very origins of things—as if in many interpretations Giorgione is thought to have re-created the origins or early history of man and nature as a harmonious ideal. Whether seen as Adam and Eve, the Holy Family, the

origins of the Vendramin, or Giorgione's family, the painting, as scholars have repeated over and over in different forms, expresses an ideal of familial harmony, as if capturing a prelapsarian wholeness, biblical, pagan, or both. These interpretations are of a piece with those allegorical readings that stress unity and concordance, and although we cannot claim that all of these interpretations fit together, we do recognize a certain family relation or correspondence among them. For all their literalizing distortion, they may be retained as metaphors, not only for what they tell us about art-historical taste and attitude during the last 130 years, but for what they point or allude to in the painting itself. As we look at the picture, we see no clear distinction between the modern sense of the picture's significance and Giorgione's intention. Yes, the narrowly conceived goal of explaining pictures with texts results in the apparent falsification of these pictures, or, we should say, the fictionalizing of them, but, as we perhaps also come to see, there is a certain "truth" in these unwitting art-historical fictions—a truth rooted in the scholar's original apperception of Giorgione's splendid harmonious vision. "True" to the painting, his false iconographical interpretation is a metaphorical analogue of the painting.

This recognition goes against the grain of accepted art-historical dogma, as reflected, for example, in the writings of Erwin Panofsky, who has been widely followed in his belief that "since the inward experience of the art historian is not a free and subjective one, but has been outlined for him by the purposeful activities of an artist, he must not limit himself to describing his personal impressions of the work of art as a poet might describe his personal impressions of a landscape or of the song of a nightingale."[53] The distinction drawn here between poetry and supposedly scientific scholarship is misleading, and the recent intense criticism of Panofsky's own brilliant hypotheses would suggest, in the negative sense of his distinction, that in his various Neoplatonic interpretations he himself lapsed into "poetry." Some of his "poetry," in a more positive sense, is sound and helpful, and although his Neoplatonic interpretation of the Medici Chapel, for example, has been harshly dealt with in recent years, its concern with certain aspects of the chapel still calls our attention to significant features of the building (such as the vertical movement in the architecture heavenward, toward the dome)—even if, strictly speaking, the chapel does not illustrate Neoplatonic doctrine. His interpretation, like many readings of Giorgione's painting, is still rooted in a perception of the work of art, despite itself and despite what the work becomes or is made into in iconographical exegesis.

Art historians interpret art implicitly as critics, rendering not an interpretation of the object unto itself, apart from the impression they have of it, but rather their impression of it. The distinction between intention and critical response exists only in theory, never in practice, as the history of art teaches

us. Modern scholarship has been generally hostile to the kind of "impressionism" advocated by Pater, described by him as part of the course of interpretation, and followed here in our scrutiny of the *Tempesta*. But, like the poets and poetical critics, scholars express their critical impression of the *Tempesta*, rendering it through their interpretation of its meaning. We have seen that Giorgione's painting epitomizes for both poetical critics and scholars an ideal harmony, not merely of form, but of man's relation to nature. Does this ideal not account in the end for the deep art-historical and critical fascination with the picture? Perhaps Adrian Stokes put it best when he said: "Giorgione's man belongs to the landscape, not in the sense of one of Hardy's peasants, on the contrary, in the sense of being at home in the world." Giorgione's beings—man, woman, and child—in nature, afford us an ideal vision of harmony to which we, like Pater, exiles in the modern world, aspire. Only for a brief moment, through works of Giorgionesque art, can we, Pater suggests, participate in the "fulness of existence"—achieving what Virginia Woolf and Kenneth Clark after her called, in a Paterian way, "moments of being." Poets, critics, and historians are all drawn to the magical image of the *Tempesta* on account of its deep ontological significance, as if the painting embodied an original Golden Age where man was "at home in the world," in the very fullness of existence. Our recent sense of estrangement is not incompatible with the painting's own nostalgia, for just as we look back to the Renaissance as a Golden Age, typified by such pictures as the *Tempesta*, its painter, at an earlier stage of modernity, looked back to a former ideal in antiquity—dreaming it into being anew.

13 Botticelli and the Eternal Vision of Art

But how command Dead Springs to answer?
—Dante Gabriel Rossetti, "For Spring
By Sandro Botticelli"

S cholars of art and literature have often written of the Victorian rediscovery of Botticelli, who had been largely forgotten after Vasari wrote his biography of the artist in the *Lives*. It is said that currents of romantic and Pre-Raphaelite taste drew artists, writers, and critics back to the fifteenth-century painter, and this is certainly so. What escapes notice, however, is that this writing is not merely a reflection of changing taste but is often interpretive, and this interpretation can be historically valid. Rossetti's sonnet on the *Primavera*, we have noted, offers historical insight, appropriately likening the painting to a masque, calling Mercury, one of the gods of spring, "harbinger of spring" (see Fig. 13).

We often become so steeped in interpretation itself that we lose sight of its significance, of those secret, invisible forces that draw us to works of art whose mysteries we would fathom. Does the modern spell of the *Primavera*, for instance, not lie, as Pater hinted, in its "shadow of death," the sense of what Rossetti spoke of as spring's "brief bloom"? Berenson perhaps put it best when he said in *Aesthetics and History*, speaking more generally of Botticelli's picture and other works discussed here: "The precariousness and fragility of existence are brought home to us with almost the same stab in Botticelli's 'Spring', as in his 'Birth of Venus', in Signorelli's 'Pan', in Giorgione's 'Soldier and Gipsy' as well as in his 'Fête Champêtre', in Watteau's 'Embarquement pour Cythère', but with a sharpness that has no sting, a reminder that in painting, as in music and poetry, 'our sweetest songs are those that tell of saddest thought.'" It is as if Berenson summarized the bittersweet sense of art that Pater defines as fragile moments of bliss, reflecting in different degrees the musings of Gautier, the Goncourts, Keats, Haz-

litt, and Rossetti. The modern melancholic sense of the *Primavera* is not, however, incompatible with the painting itself, for the wistful faces in it, especially of the Graces, remind us that here, as in the Tuscan poetry that informs it, the joy or *letizia* of love is mingled with sorrow and tears: *piange Amore*.

The rediscovery of the *Primavera* in the nineteenth century coincides with and is bound up with the modern definition of the Renaissance as a historical period. This definition is derived from Vasari, but in the *Lives,* although Vasari speaks of the revival of antiquity, he uses the words *rinascita* and *rinascimento* in the biblical sense of Dante, who associated the "sweet new art" of Tuscan poetry with spiritual rebirth—a concept clearly stated in the *Vita Nuova* and assimilated in the *Lives,* which celebrates the sweet new plastic arts of Tuscany. Botticelli's painting has been absorbed into the historical definition of the Renaissance and is seen as an allegory of Renaissance Florence, Flora personifying the city of flowers. Just as Botticelli lived in the Golden Age of Lorenzo de' Medici, as Vasari said, he re-created it in the *Primavera,* where the golden fruit, alluding to the Medici *palle,* are emblematic of the association of the Medici and the Age of Gold. We look at the painting today and, without reflection, see in it the epitome of the Renaissance—its paganism, its spirituality, its association with Florence and the Medici. We thus embellish the Vasarian myth through our historical interpretation of the image, seeing not just its subject but the painting itself as the spring or rebirth of art. If our sense of Botticelli's work is aesthetic, so too is our historical definition of the epoch in which he worked, for the very poetic and fictive devices of the literature of Dante, Poliziano, and Lorenzo de' Medici, who spoke of a new Golden Age, give shape to our perception of the period. The poets furnish us with a mythic scheme in which we place the historical data.

As time has passed, we have come to see the painting as itself a Golden Age distant from the modern world, just as scholars in the Renaissance saw ancient art and letters as part of an even remoter past. The *Primavera* is today an icon of the Renaissance, a sort of Edenic Golden Age from which we have been banished, although it still beckons us and we would enter it if we could.

If Renaissance artists and writers saw themselves self-consciously as standing apart from the antiquity they sought to restore, important continuities of classicism link their historical epoch to the ancient world. Similarly, there are such links between us and Botticelli, and Pater gives us an insight into these. In *The Renaissance* he adheres to the Vasarian, Dantesque, and ultimately biblical sense of life as a spiritual pilgrimage, for he moves through history as a historical pilgrim, who is like his subjects—Botticelli, Michelangelo, and Winckelmann—all of whom, as pilgrims, are compared to Dante. Pater writes like Vasari, connecting the lives of artists to the spiritual pilgrimage of Dante.

But whereas Dante and Vasari saw spiritual "rebirth" in *Paradiso,* Pater seeks such redemption in art, transforming heaven itself into a kind of aesthetic paradise. Seen in the "shadow of death," the *Primavera* is one of those "exquisite pauses" that offers an ideal of timeless harmony in opposition to the flux of time that leads toward death. The subject of the *Primavera* is the epiphany of an ancient goddess, Venus, who is informed by a Christian spirituality, and similarly for Pater such pictures become in the modern sense epiphanies of art, the spirituality of religion being transformed in these aesthetic epiphanies into the spirit of art. Although Pater's sense of art is highly aestheticized, we should recall that Dante and the Tuscan poets and painters among his followers brought theology into the realm of poetry, equating aesthetic and spiritual grace. They had thus already begun to aestheticize religion, establishing a relation between religion and art made even more explicit when Vasari chose to see Michelangelo as the Messiah of art. Michelangelo's repudiation of the idolatry of his youthful art and poetry can be seen, at least in part, as a rejection of his own Renaissance aestheticism.

Modern art historians will perhaps find these reflections beside the point, for it is their task to know the painting in itself, not to dwell on their impression of it, what we sometimes call their subjective response. But interpretation is inevitably conditioned by the aspirations of the historian, which determine his impression of the work he interprets. Those scholars who, following Aby Warburg, analyze the philosophical and poetical contexts of the *Primavera* aspire to the universal culture of the Renaissance. In this respect they follow Goethe, Burckhardt, Pater, and Warburg, who all aspired to this ideal. It is as if the great Warburgians, weaving texts together and around the *Primavera,* seeking a kind of aesthetic synthesis of ideas, were themselves latter-day Ficinos, Picos, or, in some cases, even Polizianos. Although the debates between scholars over interpretation have sometimes drawn them far afield from Botticelli's picture, one senses nevertheless that they were drawn to the painting in the first place not simply because it is an iconographical puzzle (and this is part of its charm), but because, like Pater and his poetical followers among scholars of Botticelli (Horne, Binyon, Yashiro), they were captivated by the beauty of the painting and the complexity of this aesthetic force. One also suspects that the painting remains alive in scholarship, as in modern poetry, because it typifies the ideal of rebirth—no longer in the explicit religious sense of its Dantesque intention, but in the sense of cultural or artistic renewal.[54] It is thus the renaissance *par excellence,* as Pater's own book is the best possible exemplification of his title.

Walter Pater's essay on Botticelli in *The Renaissance* is generally recognized as the first extensive appreciation of the artist written in English. Pater set the stage for subsequent iconographical interpretations of the *Primavera* and other pictorial mythologies by stressing that "before all things" Botticelli is "a

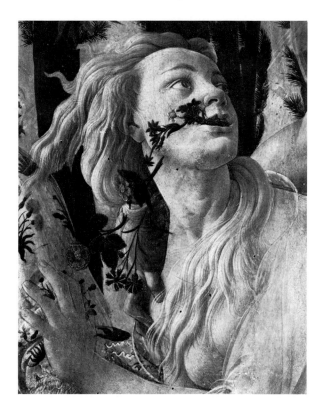

FIG. 26. BOT-
TICELLI, detail of
Chloris from *Pri-
mavera*.

poetical painter." Shortly after Pater wrote, scholars began to link the *Prima-
vera* to classical and Renaissance poetry, ranging from Lucretius and Ovid to
Petrarch and Poliziano, and Aby Warburg wrote his learned treatise on the
countless associations between Botticelli's mythological paintings and their
poetical context.

The subsequent scholarship on Botticelli's mythologies is filled with dis-
putes over exactly which texts Botticelli illustrated in them. Scholars have
argued that Ficino or Poliziano was the painter's principal source, sometimes
losing sight of the community of meaning linking the poetical philosophy of
the former to the philosophical poetry of the latter. As time went by Pater was
remembered merely for his quaint Victorian appreciation of the painter—as if
he had nothing more to tell us about Botticelli.

Pater's essay is nevertheless rich in implications that have not been fully
explored. Emphasizing Botticelli's connections with Dante, Pater returns to a
theme of Vasari's biography of the artist. But more than this, he tells us that

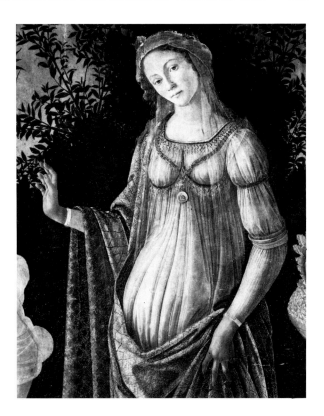

FIG. 27. BOT-
TICELLI, detail of
Venus from *Pri-
mavera*.

as a "visionary painter" Botticelli resembles Dante. Pater thus invites us not
only to contemplate Botticelli's illustrations of the *Divine Comedy* but to
reflect upon the relation of his "visionariness" to that of the great Florentine
poet. Doing so, we come to see that Botticelli's *Primavera* is indeed grounded
in the poetry and poetical tradition of Dante. What follows now is an icono-
graphical and stylistic interpretation of the *Primavera*—one that takes into
account the interpenetration of form and content—based on Pater's insight
into the Dantesque character of Botticelli's art. Before turning to this inter-
pretation, let us look once again at Botticelli's enchanting pictorial vision and
consider in summary fashion its relations to the Florentine cultural life it so
luminously reflects.

Still silvery blue with the chill of winter, Zephyr bursts through the fruitful
wood in pursuit of fair Chloris, goddess of the earth. Cheeks puffed, he
breathes inseminating rays into the fleeting goddess, whose lips blossom in
flower (Fig. 26). As he clasps her full body, visible through a gossamer of

drapery, she returns his glance in fright. Her body recoils gracefully, echoing as it bends away the bowed trees, arched by the force of Zephyr's gust. Faint evanescent silhouettes of flower forms appear between her legs, and at once they flow from her lips, rushing past her long, waving golden locks, merging with the variegated bouquet bursting forth from the fair dress of Flora. Chloris's outstretched, imploring limbs are answered by the giving gesture of the radiant, heavenly yet wanton flower goddess, who, stepping gently forward, bedecks the green carpet of her garden with countless flowers, tossed and also abundantly spilling from her lap—in time with the undulations of her breeze-filled draperies.

At the center of this bower, demure Venus (Fig. 27) beckons us with uplifted hand into her enchanted garden. Like the smiling goddess of flowers, so benign and pure, she inspires us with love, calming spirits troubled by quotidian concerns. Blind Cupid above, the keystone to this bower's arch, aims his flaming dart at Venus's handmaidens, the Graces, who dance in time to the Love goddess' beat. The love inspired here is a tempered one, expressed through suave and ethereal rhythms, as of a celestial and spiritual harmony. The long stately limbs and fingers of the Graces are interwoven into tendril knots; hands join in a gentle heavenward-reaching clasp. Voluptuous yet chaste, these faintly melancholic sisters dance behind their leader, Mercury, harbinger of spring, lover divine. This courtly scion of Praxiteles' Hermes, arm resting softly on hip, lightly touches staff to sky, dispelling faint clouds, and as the flames of his draperies, like those on Venus's dress, radiate downward, the rays of Apollo shine through the clouds, beaming in his eyes.[55]

As Frederick Hartt has observed: "In the universally beloved *Primavera* we cross the portals of sleep and enter the very dream." In like manner, the poet-art historian Laurence Binyon had earlier remarked so well: "It is as if we were transported to some secret place at the heart of the vernal earth and saw in vision the powers that bundle and send forth into the wintry world the riches of springtime." Botticelli's large panel hung long ago in Florence in the palace of Lorenzo di Pierfrancesco de' Medici, younger cousin of the illustrious statesman and poet, Lorenzo il Magnifico. Probably painted to celebrate the patron's marriage in May of 1482, it can be seen as a sort of pictorial epithalamium or poem celebrating marriage, in which the goddess of love is beheld in an epiphany amid the very flowers of the Tuscan spring, in the city of flowers, to greet and bless the patron and his bride. As if an evocation of the Golden Age, re-created by the Medici, the *Primavera* is a *paradiso* like the garden in which Lorenzo il Magnifico had beheld his beloved, a pleasant garden or *giardino amenissimo*, as he tells us in his poetry, "abounding in all the things that please, . . . all the amenities the human heart may desire": a *locus amoenus* like that in which the Tuscan poets of the Middle

Ages and the Renaissance first saw their *donne angelicate*. Like the celestial Venus of Lorenzo de' Medici's "Song of the Seven Planets," Botticelli's "graceful, luminous, and beautiful Venus inspires love and kindness in the heart," elevating the beholder into a celestial sphere, its inaudible music to which the Graces dance turning his thoughts heavenward toward cosmic harmony.

Botticelli's invention is the fruit of the rich interpenetration of pictorial and literary cultures in fifteenth-century Florence. Inspired by such contemporary poets as Lorenzo de' Medici and Poliziano, Botticelli made visible ideals similar to theirs, never merely imitating these poets but expressing like sentiments, transformed into the distinctive imagery of his own pictorial vision. His goddesses express a sweetness or *dolcezza* like that of Dante's Beatrice or Petrarch's Laura, embodied still in Botticelli's own times in Poliziano's Simonetta. Flora's eyes emit a sweet serenity, a *dolce sereno* reminiscent of Simonetta's; her smiling face, a celestial joy or *celeste letizia*, also recalls that of Poliziano's idealized, inspiring lady, who, stepping forward in the poet's garden, exerts a power to enthrall, making everything pleasant: *si fa tutto ameno*.

Envisioning the bower of Venus, Botticelli relies on Florentine pictorial and sculptural traditions, thus appropriating the orange grove where Paolo Uccello's toy soldiers had entered into mock warfare in *The Battle of San Romano*. Now arranged with greater order, with stately, almost templelike formality, the trees flower and bear fruit simultaneously, expressing the eternity, the perpetual fecundity of this mythic paradise. The dainty flowers at Venus's feet recall the art of Botticelli's teacher, Lippi, as do the faces of his goddesses, so like the Madonnas by Filippo, but even more exquisite in their linear finesse. The supporting actors are graceful refinements of Florentine sculptures now set in a garden—the dancing Graces recalling Ghiberti's more rhythmic figures on the Gate of Paradise, perhaps with an added touch of delicacy inspired by Beato Angelico, the winged, ethereal Mercury being a free invention on Verrocchio's nearly glowing bronze *David*.

Perhaps the most inventive aspect of the painting is the inaugural passage of Zephyr in flying-embrace of Chloris. Not even the analogous angel soaring into the Virgin's bedchamber in Botticelli's *Annunciation* for the hospital of San Martino alla Scala (which Botticelli may have recalled here) quite explains the enchanting effect of this miraculous aerial apparition. Long ago, Aby Warburg recognized that Botticelli's image alludes to a passage in Ovid's *Fasti* in which Flora mentions her abduction, alluding to her transformation from her previous earthly status as Chloris into her present floral form. Ovid says that "while she spoke her lips breathed vernal roses," and it has been further recognized that Botticelli freely transformed Ovid's words to make visible, to make seemingly actual, the metamorphosis of Chloris into Flora—

alluded to but *not* described by Ovid. In an observation that has largely been forgotten, Warburg also suggested that Botticelli's Chloris is also like Ovid's Daphne, described in flight from Apollo in the *Metamorphoses*: "and she was lovely even in flight, her limbs bare in the wind, her garments fluttering and soft hair streaming"; like Zephyr, Apollo "borne on the wings of love, gave her no rest, shadowed her shoulder, breathed on her streaming hair." It is as if Botticelli not only freely transformed Ovid's *Fasti* but reformed it in the imagery of *Metamorphoses,* conflating the two texts with both literary and visual wit to make visible to us what we could only imagine reading Ovid's *Fasti.* This wit has its very counterpart in Botticelli's rendering of flowers, for we cannot distinguish the actual flowers spilling forth from Flora from those painted on her dress—"of roses and other flowers painted," as Poliziano says of Simonetta's dress in his famous *Stanze.*

The literary context of Botticelli's art is extensive and complex, as this brief summary only partially indicates. The foundation of this context, Pater's writing suggests, is the poetry of Dante and those who wrote in his tradition. No matter that Botticelli painted well over a century after the poet's death, for the spirit of Dante lived on in Florence and was alive in the writings of Botticelli's contemporaries. The Dantesque character of the *Primavera* has occasionally been briefly commented upon, and of late there has been a revived interest in Botticelli's drawings for Dante's text. But surprisingly little has been written about the relation of the *Primavera* to the Earthly Paradise of the *Divine Comedy* and Botticelli's own illustration of it.

Botticelli first made some drawings for the *Divine Comedy* from which engravings were made to illustrate Cristoforo Landino's famous edition of Dante's great poem published in 1481. And again, some years after he painted the *Primavera* for Lorenzo di Pierfrancesco de' Medici, he returned to the *Divine Comedy,* depicting the Earthly Paradise described in Purgatorio XXVIII as part of the illustrations made for the same patron. Rereading this canto with Botticelli's *Primavera* in mind, we might well suspect that the painter was already thinking about Dante's description of the Earthly Paradise when he painted his own paradise. Describing his inspiring vision of Matilda in the Earthly Paradise, Dante evokes a gentle breeze or *soave vento* like the breeze blowing caressingly through the *Primavera*: "A sweet air that was without change was striking on my brow with the force of a gentle breeze, by which the fluttering boughs all bent freely to the part where the holy mountain throws its first shadow." Comparing Matilda to Persephone, Dante alludes to the very myth underlying that of Zephyr and Flora, the myth of Pluto, who abducted Persephone, allowing her to return to earth annually, bringing spring with her. In her delicate, luminous, and rhythmically graceful aspect Matilda suggests Botticelli's Venus, Flora, and Graces:

As a lady turns in the dance with feet close together on the ground and hardly puts one foot before the other, she turned towards me on the red and yellow flowerets like a virgin that veils her modest eyes and gave satisfaction to my prayer, approaching so that the sweet sound came to me with its meaning. As soon as she was where the grass was just bathed with the waves of the beautiful river she did me the grace to lift her eyes; and I do not believe such light shone from beneath the lids of Venus when, through strange mischance, she was pierced by her son. Erect, she smiled from the other bank, arranging in her hands many colours which the high land puts forth without seed.

When the Venus- and Persephone-like Matilda addresses Dante, she expresses an idea similar to that made visible by Botticelli's Mercury, who dispels the clouds above and gazes at the heavenly or divine light: "'You are new here' she began 'and, perhaps because I smile in this place set apart to the human kind for its nest, some doubt keeps you wondering, but the psalm *Delectasi* gives the light that may dispel the cloud from your mind . . .' She said therefore: 'I will tell how that which makes thee marvel proceeds from its cause and I will rid thee of the cloud that has fallen on thee. The Supreme Good who does not only His own pleasure made man good and for good and gave him this place for earnest of eternal peace.'" Matilda goes on to speak of her wooded garden as the eternal spring (*primavera sempre*), further suggesting an imagery like that in the *Primavera*: "'Those who in old times sang of the age of gold and of its happy state perhaps dreamed on Parnassus of this place; here the human root was innocent, here was lasting spring and every fruit, this is the nectar of which each tells.'" Dante's garden, wooded and beflowered, is rooted in the Garden of Eden, but it is interpreted allegorically in classical terms of the Age of Gold and the myths of Venus and Persephone. Conversely, Botticelli's *Primavera* is a classical mythology, but in its allusion to a Golden Age it is permeated by a spirituality that is distinctly Christian in tone, Dantesque in spirit; whereas Dante's virginal Matilda is Venerean, Botticelli's Venus is Marian. That Botticelli conceived of Dante's Earthly Paradise and his own in the *Primavera* in a similar way is further attested by the community of imagery and tone linking his drawing of Purgatorio XXVIII with *Primavera* (Fig. 28). In this drawing Botticelli represents an ethereal sacred wood like that of the mythological painting, and the representation of the graceful and delicate Matilda is a counterpart of the depiction of ethereal goddesses in the *Primavera*; her gesture heavenward, toward the heavenly light, is also suggestively identical with that of Mercury.

Botticelli's imagery is no less profoundly bound up with that in Dante's poetry of the *Vita Nuova*. Dante reveals the power of his spiritual love for Beatrice, whose eternal beauty contributes to his own rebirth or *vita nuova*, and we are similarly intended to be transfixed or transported by the haunting

Fig. 28. Botticelli, drawing from *The Divine Comedy, Purgatorio*, XXVIII. Staatliche Museen, Berlin.

Flora, the delicate modest Venus, and the tender, wistful, and melancholic Graces in the *Primavera* (Figs. 29 and 30). Like Beatrice, they captivate us and move us to love:

> My lady looks so gentle and so pure
> When yielding salutation by the way,
> That the tongue trembles and has nought to say,
> And the eyes, which fain would see, may not endure.
> And still, amid the praise she hears secure,
> She walks with humbleness for her array;
> Seeming a creature sent from Heaven to stay
> On earth, and show a miracle made sure.
> She is so pleasant in the eyes of men
> That through the sight the inmost heart doth gain
> A sweetness which needs no proof to know it by:
> And from between her lips there seems to move
> A soothing essence that is full of love,
> Saying for ever to the spirit, "Sigh!"[56]

Botticelli's Venus and attending figures are "clothed in humility" (*d'umiltà vestuta*), and they seem to have come upon earth from heaven "to show forth a miracle" (*per miracol mostrare*). Their power to inspire love in us, like that of

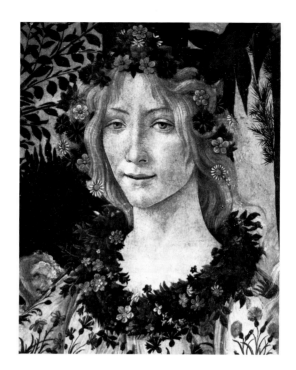

FIG. 29. BOTTICELLI, detail
of Flora from *Primavera*.

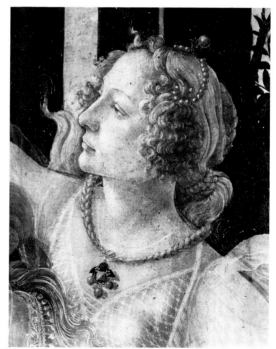

FIG. 30. BOTTICELLI, detail
of a Grace from *Primavera*.

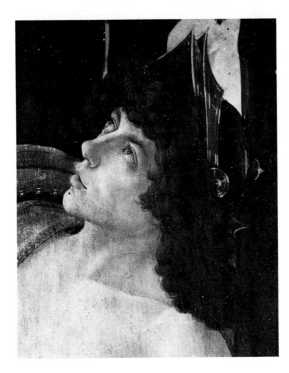

FIG. 31. BOTTICELLI, detail
of Mercury from *Primavera*.

Beatrice, resides in their eyes and mouths; and, especially through the slightly parted lips of Flora, a *spirito soave* seems to issue forth.

In the very period when the *Primavera* was painted, Botticelli's younger contemporary, Leonardo da Vinci, commented on this poetical tradition, observing: "And if the poet says he can kindle love in men, which is the main motive of the species in the whole animal world, the painter has the power to do the same, the more so as he can place the true image of the beloved before the lover, who often kisses it and speaks to it, a thing he would not do to the description of the same beauties by the writer."[57] Although the *Primavera* is not a portrait, it vividly reveals the power of Renaissance painting spoken of by Leonardo to enthrall the beholder, suffusing him with love.

In the end, we witness a form of creation or re-creation in the *Primavera*, which contributes, in the root sense of the word, to our own re-creation or *vita nuova*. Beginning with an Ovidian metamorphosis, this transformation becomes Platonic ascent, that is, a final metamorphosis in which the soul of Mercury rises toward the Sun or the Idea of the Beautiful—the very ideal toward which we ourselves are drawn by the ethereal beauty of Botticelli's

mythic, celestial actors, although finally we see only the reflection of this transcendent, divine beauty in them and in the beam of light shining in Mercury's eyes (Fig. 31). Like the poetry that inspired Botticelli, so informed by Platonic sentiments, Botticelli's entrancing image expresses the unity of sacred and profane love, permeated by the visible harmonies of unheard cosmic music; and inspired, filled with spirit, we behold in vision the magical reenactment of the origins of spring, as if for ever.

Conclusion:
The Thread of Continuity

*For him the problem came to be:—Can the blitheness
and universality of the antique ideal be communicated to
artistic productions, which shall contain the fulness of
experience of the modern world?*
 —*Walter Pater, "Winckelmann,"* The Renaissance

As we have seen, the modern definition of the epoch known as the
Renaissance is a highly poetical and aesthetic concept of the period as a
kind of Golden Age—"when they would still live with acorns," to use Pater's
words. Pater, like Goethe, Burckhardt, Taine, Browning, Rossetti, Eliot,
Vernon Lee, Symonds, and Berenson, among those who wrote of the period
in their fiction, poetry, history, and criticism, treated it with a kind of nostal-
gia, as of something lost. Vitality, passion, liberty, and wholeness are some of
the Renaissance virtues celebrated by its nineteenth-century, one might say
romantic, admirers.

We have considered Pater's and the general nineteenth-century sense of
estrangement from the ideals embodied in Renaissance culture, but this per-
ception does not diminish our sense of the relations of the modern period to
the Renaissance. Like Burckhardt, Pater stresses the fact that the Renaissance
is the beginning of the modern period. In this way, he encourages us to see
the thread of continuity between the two periods, or, perhaps we might say,
taking the long Paterian view of history, that we are dealing with two phases
of the same period. Tracing the romantic and lyric tradition from twelfth-
century France to Giorgione and Du Bellay, Pater finds the roots of the
lyricism and romanticism of Hugo, Gautier, and Baudelaire, who are always
present in *The Renaissance*, visible even when silent. Following Pater's lead,
we can pursue this thread to what we have spoken about as the Giorgion-
esque poetry of Joyce and Yeats. Pater also helps us to see the continuity
between Vasari's sixteenth-century conception of Leonardo as a magus and

the nineteenth-century view of him as a kind of Faust. Following the implications of Pater's writing, we recognize that the recent scholarly interest in Leonardo's scientific thought reflects this Faustian ideal and the emergent nineteenth-century view of the scientist as hero. Echoing a Hegelian theme, Pater finds a developing consciousness in Renaissance culture, epitomized by Leonardo, a consciousness Freud would later investigate under the influence of Pater.

Studying the artfully systematic philosophy of Pico, Pater comments on the Hegelian philosophy of his own day, providing Yeats with a vehicle for the subsequent ideal of cultural synthesis in *A Vision*. The aspiration to cultural unity that Pater finds in Pico, then in Goethe and Arnold, is related to the subsequent quests of Berenson, of Warburg and his followers. Pater encourages us to see that, like himself, Panofsky and Gombrich, for example, are not merely students of Florentine Neoplatonism but are, in a sense, followers of the Neoplatonists. (The Kantian idealism of Panofsky is especially linked to the earlier platonizing idealism of the Renaissance philosophers he studied.) Returning himself to the artful periodicity and archaisms of Renaissance prose, Pater writes in a kind of Euphuistic or Mannerist style. Like Gautier and Swinburne, he participates in the historical and critical reevaluation of Mannerism, helping us to see that nineteenth-century aestheticism is a late reflex. In the wake of Pater, we can trace its new life into the twentieth century in the difficult, late fiction of Henry James, in the complex early writing of Sydney Freedberg, in the contrived fiction of Nabokov, and in the intricate poetry of John Ashbery. Pater guides us to an understanding that, if to a lesser degree than Pater himself, Vasari had already aestheticized religion in his hagiographical biographies of artists. Pater's own transformations of theology into art, his rendering of aesthetic epiphanies, are echoed in Joyce, whose Stephen Dedalus is a kind of modern Pico. To be sure, sharp contrasts can be made where these and other continuities have been suggested, but the differences between the nineteenth and twentieth centuries, on the one hand, and the fifteenth and sixteenth centuries, on the other, do not obliterate our perception of how Renaissance values remain alive or have been revived at a later stage in the modern period. For what is culture—Pater's understanding of culture and our own—if not a vision of such historical continuity?

Toward the end of the nineteenth century there emerged a rhetoric that focused on the decline and decadence of art and culture. The very fatality of Pater's *Renaissance,* its singular morbidity, contributed in no small measure to this language of decline in Victorian England. Yet, paradoxically, Pater also held up toward the turn of the new century the ideal of a new art and culture, for the Renaissance, as he defined it in his book, symbolized cultural renewal. By seeing its afterlife, or a later phase, in the age in Goethe at the turn of the

nineteenth century, he held up an ideal to those writing at the turn of the twentieth century. Suspended between being and nothingness, he posed, like Matthew Arnold but more sharply, the fundamental question that so many modernists would confront in their own poetry and fiction: How is it possible to maintain universality and historical continuity, built out of the Hellenic and Hebraic traditions, in the modern world, where such wholeness seems to be dissolving within the flux of experience?

Pater provided a model for such typical *fin de siècle* writers as Havelock Ellis, who, in *The New Spirit* (1890), emulated Pater's philosophy of history, invoking Heraclitus to observe: "There is never a moment when the new dawn is not breaking over the earth, and never a moment when the sunset ceases to die." Ellis imitates the structure of Pater's *Renaissance,* presenting essays on central figures of European culture, preceded by a preface and introduction, followed by a conclusion. Emulating Pater, Ellis touches on the twelfth-century renaissance, speaks of the Renaissance proper, and then of "the evolution of the modern spirit" from it, reflected in representative figures ranging from Diderot to Huysmans. Just as Pater sees Blake, Winckelmann, Wordsworth, Hugo, Goethe, and Browning participating in this new spirit born of the Renaissance, so does Ellis recognize this modern spirit in Heine, Whitman, Ibsen, Tolstoy, and his other subjects, whose origins are also to be found in the Renaissance. Among his heroes we find Pater, whose *Marius* is called "one of the most exquisite and significant books of the century." Whereas a highly aestheticized theological structure underlies Pater's *Renaissance,* the related religious impulse of Ellis's book is more boldly expressed, for in his conclusion Ellis bluntly observes that "play" and "art" are to be understood "in one word, religion." His conclusion is very nearly a commentary on the famous conclusion to Pater's book, in which religion was transformed into play and art.

Ellis's book is a reminder of the fact that in Pater, as in Burckhardt before and Berenson after, the historical definition of the Renaissance is inseparable from the concept of the modern. To put it differently, the historical definition of the Renaissance is one of the fruits of Modernism. It is no accident that the great biographies of the Renaissance (including those of Vasari) were to become so important in the modern period, when the Romantics seized upon biographies of great men as a means of expressing the heroism of modern life. It is similarly no accident that Burckhardt defined the Renaissance in the period of Baudelaire and that Pater assimilated Baudelairean Modernism to his definition of the Renaissance just a short time later. Pater's book is both an imitation of an earlier phase of modernity, called the Renaissance, and a new or more recent reflex of its spirit. At the same time it is a major foundation for subsequent definitions of the modern.

Yeats, we have observed, attempted to create a new mythology—a type of

theological system of myth, dependent on the ideals of Paterian synthesis. The poet found in Pater, truly his father, an aspiration toward cultural regeneration that Pater found earlier in the Renaissance itself and in the Romantic period, and he defined it indirectly in biblical terms of spiritual rebirth. In his similarly cyclical or recursive scheme, Yeats linked Socrates and Pascal, Giorgione and Keats, Beardsley and Masaccio, reminding us of Pater's way of doubling such historical figures as Plato and Pico, Leonardo and Goethe, Dante and Winckelmann. Like Pater, Yeats sees a Unity of Being within antithetical forces, and as he weaves his own cultural tapestry, he acknowledges, in the very language of Pater, that "each age unwinds the thread another age had wound."

It is the sense of the unwinding of the fabric of culture that Pound confronts in his *Cantos*. The threads of culture are rewoven upon the "loom" of his monumental poem. The fragmentary sense of Pound's poetry results from his acknowledgment that the threads of culture with which he weaves an artistic fabric had become unwoven. Like Yeats, and like him responsive to Pater, Pound weaves into his own poetic tapestry the threads of Renaissance art, from Lombardo, Bellini, and Piero della Francesca. The sense of culture "vanishing away"—as if breaking into the fallen idols from Pater's *House Beautiful*—similarly informs Eliot's *The Waste Land*. Among the "fragments" of these "ruins" is Pater himself and his "Lady Lisa," who epitomizes "all modes of thought." In Eliot's poem she becomes Madame Sosostris, "famous clairvoyante," "the wisest woman in Europe." Her treacherous Tarot cards, a "wicked pack of cards," include Belladonna, the Paterian "Lady of the Rocks."

Like Yeats, Eliot, and Pound, Joyce confronts the Paterian problem of modern art in his epic novel *Ulysses*. The peculiarly modern problems of time, history, culture, consciousness, and memory are all at the heart of his great novel set in the "Unreal City" (to borrow words from Eliot) of the modern world. Joyce's Stephen Dedalus, a new type of aesthetic hero who, as we have seen, descends from Pater's Pico as from Pater himself, speaks Pater's language when he says: "As we . . . weave and unweave our bodies . . . from day to day . . . their molecules shuttled to and fro, so does the artist weave and unweave the image." In *Ulysses* Joyce weaves, unweaves, and reweaves the threads of Hellenic and Hebraic tradition, artistically meditating on the relations of art to culture, pondering, in Arnold's words, the "strange disease of modern life." Like Pater, and for that matter Nietzsche, he finds the ideals of cultural renewal and rebirth in art itself, and, like Pater, he parodies the great writers of the past, bringing them to life anew.

Unlike Baudelaire before him or Joyce and Eliot afterward, Pater never uses the language of modern realism. He seems to hover above it, as if in a reverie. He feels "how much need" there is of "castigation," of "softening" this "rougher element," but we always have a sense of the reality beneath his

fastidiousness. Traveling into the past in his historical time-machine, Pater always brings with him the acute consciousness of the modern world, which he never leaves behind. Although his book is written in a "dead" language—a language purged of the colloquialisms of the modernists—he is incipiently the narrator of his own "waste land," himself a nascent Joycean aesthetic pilgrim and exile.

Perhaps of all work in the tradition of Pater none is so close to his writing as Virginia Woolf's *Orlando*. Here Woolf revels in the reverie of Paterian romance, parodying, as we saw, Pater's journey through history in sympathy with Pater's parodies of his own subjects. The very name Orlando is of course resonant of Renaissance romance, but as Woolf's romance unfolds, her hero-heroine moves in a Baudelairean or Paterian flux from the Renaissance court to modern London, recapitulating the motion of Pater's book. As she journeys through history, we receive a quickened sense of time. Woolf participates in the very history she describes. Doing so, she underscores Pater's view of the continuity between the Renaissance and the modern world. The Renaissance is said to have not only developed a new self-conscious concept of history but to have discovered time. Pater, we saw, construed Leonardo's meditations on the motion of water, by way of Baudelaire, as a meditation on the flux of time. The consciousness of this flux was to become a dominant theme in Modernist literature. Long before Proust and Woolf became connoisseurs of time, before Woolf's unnoticed reader Nabokov penned his imaginary treatise, "The Texture of Time," in *Ada*, Pater had become (in Nabokov's language) "an amateur of time, an epicure of duration." If he sought to arrest its flow in the timeless pauses of art, he nevertheless delighted, paradoxically, in its sensuality, "in its stuff and spread, in the fall of its folds, in the very palpability of its grayish gauze, in the coolness of its continuum."

Even more than Pater could have imagined, he was, like his Mona Lisa before and Madame Sosostris afterward, clairvoyant, dreaming, if you will, the future implications of the Renaissance. Looking at the cultural rebirth of the past, he spoke of "renaissance" in such a way that his sense of artistic regeneration took on new and broader significance for those who followed him. Born too late to be of the Renaissance and too early to participate in the cultural rebirth of twentieth-century Modernism that he helped to mold, he in a sense belongs to neither yet to both. This, then, is perhaps the final paradox of his hauntingly elusive, suggestive, and highly influential little book—a paradox that arises from the weaving, unweaving, and reweaving of art and history, and through them, of our very selves.

Notes

1. Published subsequently as *Walter Pater: An Imaginative Sense of Fact,* ed. Philip Dodd (London, 1981). In this volume, see especially R. M. Seiler's "Walter Pater Studies: 1970–1980," 84–95.

2. For the earlier writing on Pater, see *Walter Pater: An Annotated Bibliography,* ed. Franklin E. Court (Victoria, B.C., 1980).

3. The best general sketch of Pater and Modernism is chapter 6, "Pater and the Modern Temper," in Gerald Monsman, *Walter Pater* (Boston, 1977). Monsman hints at the relevance of Pater to more recent literature in his *Walter Pater's Art of Autobiography* (New Haven and London, 1980). See also Harold Bloom, *Selected Writings of Walter Pater* (New York, 1974), vii–xxxi. Bloom prophesies that Pater "will prove to be the valued precursor of a Post-Modernism still fated to be another Last Romanticism."

4. This is the first in a series of allusions to the relations of Eliot to Pater. My view partially intersects that of John J. Conlon, "Eliot and Pater: Criticism in Transition," *English Literature in Transition* 25, no. 3 (1982): 169–77. Conlon includes a full bibliography on the subject.

5. Erwin Panofsky, "The Neoplatonic Movement in Florence and North Italy (Bandinelli and Titian)," *Studies in Iconology: Humanistic Themes in the Art of the Renaissance* (New York, 1962), 171–230; Edgar Wind, *Pagan Mysteries: An Exploration of Philosophical and Mystical Sources of Iconography in Renaissance Art,* revised edition (New York, 1968); and E. H. Gombrich, *Symbolic Images: Studies in the Art of the Renaissance* (London, 1975), especially "Botticelli's Mythologies."

6. J. J. Pollitt, *Art and Experience in Classical Greece* (Cambridge, 1972), 96 and 140–41, hints at this connection but hesitates to discuss it.

7. Patricia Egan, "*Poesia* and the *Fête Champêtre,*" *The Art Bulletin* 41 (1959): 303–13.

8. Marcia Hall, "Michelangelo's *Last Judgment*: Resurrection of the Body and Predestination," *The Art Bulletin* 58 (1976): 85–92.

9. E. H. Gombrich, "The Form of Movement in Water and Air," *Leonardo's Legacy,* ed. C. D. O'Malley (Berkeley and Los Angeles, 1969), 131–204, and Martin Kemp, *Leonardo da Vinci: The Marvellous Works of Nature and Man* (Cambridge, Mass., 1981), 307–10.

10. André Chastel, *Art et Humanisme à Florence au Temps de Laurent le Magnifique* (Paris, 1959), 106–28.

11. "Platonic Justice designed by Raphael," *Journal of the Warburg Institute* 1 (1937): 69–70.

12. Gerald Monsman, *Pater's Portraits: Mythic Pattern in the Fiction of Walter Pater* (Baltimore, 1967), and the same author's *Walter Pater's Art of Autobiography* (New Haven and London, 1980).

13. I am here embellishing a point made by Ian Fletcher, who observes that Pater's work lies "between" a multiplicity of genres; see *Walter Pater* (London, 1959), 5.

14. The influence of Baudelaire's imagery on Pater has often been discussed; see, for example, the relations suggested by Donald L. Hill in his edition of *The Renaissance,* and most recently and definitively by Patricia Clements, *Baudelaire and the English Tradition* (Princeton, 1985), 77–139.

15. Monsman, *Walter Pater,* 53–54.

16. For Pater's uses of French sources (many of which are also identified by Hill), I have happily plundered from A. Richard Turner's unpublished lecture entitled "Who Invented Leonardo?"

17. Frank Kermode, *The Romantic Image* (London, 1957), 61.

18. Pater's influences on Yeats have often been discussed; other aspects of this relation are considered by Harold Bloom, *Selected Writings of Walter Pater,* vii–xxxi.

19. Probably more than any other critic, Bloom has stressed the poetic character of Pater's work.

20. Noted by Arthur Symons in the Introduction to *The Renaissance* (New York, 1919), xi–xxiv.

21. I am responding to Robert M. Adams's highly suggestive *Nil: Episodes in the Literary Conquest of Void during the Nineteenth Century* (Oxford, 1970).

22. See especially chapter 10, "Play-Forms of Art," in *Humo Ludens: A Study of the Play-Element in Culture* (Boston, 1964), 158–72.

23. This guidebook, an extremely valuable document of nineteenth-century taste, is generally ignored by students of art and literature; it is found in Théophile Gautier, *The Complete Works,* trans. F. C. De Sumichrast, vol. 5 (New York, 1910).

24. Although he has not focused on the ludic aspect of Pater's work, Gerald Monsman has hinted at the playful character of Pater, speaking of the "play" of pattern and structure in his works.

25. In his three books on Pater, Gerald Monsman has emphasized the fictional character and implications of Pater's work.

26. The fullest discussion of Pater and Woolf is found in Perry Meisel, *The Absent Father: Virginia Woolf and Walter Pater* (New York and London, 1980).

27. See Billie Andrew Inman's very useful essay, "The Intellectual Context of Walter Pater's 'Conclusion,'" in *Walter Pater: An Imaginative Sense of Fact,* 12–30.

28. For example, Holmes and his creator are not mentioned in William Gaunt's fundamental *The Aesthetic Adventure* (London, 1967).

29. In a letter to William Michael Rossetti; see *The Swinburne Letters,* ed. Cecil Y. Lang, vol. 3 (New York, 1969), 73.

30. Kenneth Clark, *Moments of Vision & Other Essays* (New York, 1981), 1–17.

31. The standard edition of Vasari's *Lives* is still that of Gaetano Milanesi, reprinted in *Le Opere di Giorgio Vasari,* 9 vols. (Florence, 1981). The best translation is *The Lives of the Most Eminent Painters, Sculptors, and Architects,* trans. G. Du C. de Vere, 3 vols.

(New York, 1979). Also of use, because available in paperback, is *Lives of the Artists,* trans. George Bull (Harmondsworth, 1980). In the following chapters I have used translations from both, sometimes slightly edited, and some of my own translations as well.

32. An interpretation of the *Primavera* in the spirit of Rossetti, Keats, and Pater is presented in chapter 13.

33. Panofsky, Introduction, *Studies in Iconology,* 3–31; see chapter 12 below for further consideration of Panofsky's point of view.

34. Clark, *Moments of Vision,* 83, and his introduction to the Du C. de Vere translation of the *Lives,* vol. 1, xxii.

35. Brief comments on Vasari's "romanticized" account of Raphael's "early days in Urbino" are made by T. S. R. Boase, *Giorgio Vasari: The Man and the Book* (Princeton, 1979), 236–37.

36. The typology of Vasari's book has yet to be fully explored; however, for some helpful preliminary remarks on the subject, see Laura Riccò, *Vasari Scrittore: La prima edizione del libro delle "Vite"* (Rome, 1979).

37. I owe to Penelope Smith the hypothesis that Vasari's image of Leonardo as magician might be linked to the earlier legend of Virgil as magician; see Domenico Comparetti, *Virgil in the Middle Ages,* trans. E. F. M. Benecke (New York, 1929).

38. Charles Dempsey, "'*Mercurius Ver*': The Source of Botticelli's *Primavera*," *Journal of the Warburg and Courtauld Institutes* 23 (1960): 251–73.

39. Strangely enough, this aspect of the painting—the origins of *poesia* or art from unrequited love—has not been discussed by art historians.

40. Berenson's indebtedness to Pater has always been observed. For a recent, more generalized treatment of this topic, see Franklin E. Court, "The Matter of Pater's Influence on Bernard Berenson: Setting the Record Straight," *English Literature in Transition* 26, no. 1 (1983): 16–22.

41. See Ernest Samuels, *Bernard Berenson: The Making of a Connoisseur* (Cambridge, Mass., 1980), both for the photograph and the association of Berenson with Marius.

42. Fry's uses of Berenson's theory were hinted at by Francis Spalding, *Roger Fry: Art and Life* (London, 1980), 68.

43. This and all the following passages are from *Painting in Italy: 1500–1600* (Harmondsworth, 1971), with the exception of the reference to Caravaggio, in *Circa 1600* (Cambridge, Mass., and London, 1983).

44. The mannered quality of Freedberg's prose is even more apparent in his earlier writing; for example, *Parmigianino* (Cambridge, Mass., 1950) and *Painting of the High Renaissance in Rome and Florence,* 2 vols. (Cambridge, Mass., 1961).

45. Clark's introduction to his edition of *The Renaissance* (Glasgow, 1975).

46. An indication of how this tradition is being upheld by younger scholars is given in Andrew Ladis's evocative introduction to *Taddeo Gaddi: A Catalogue Raisonné* (Columbia, Mo., and London, 1982).

47. My references are to "Wordsworth," in *Appreciations* (London, 1907).

48. Hazlitt's essay has been noted only in passing by art historians, even though it is arguably the finest appreciation of Poussin ever written. In his note on Poussin's *Orion,* for example, Gombrich says that when Hazlitt remarked of Poussin that "at his

touch, words start up into images, thoughts become things," he wrote "with strange intuition"; see *Symbolic Images,* 122.

49. For example, the last stanza of Gautier's poem:

> Je m'en allai l'ame triste et ravie
> En regardant j'avais compris cela:
> Que j'étais près du rêve de ma vie,
> Que mon bonheur était enfermé là.

50. See note 7.

51. A full review of the vast body of literature on the *Tempesta* is given by Salvatore Settis, *"La Tempesta" interpretata: Giorgione, i committenti, il soggetto* (Turin, 1978), 46–81.

52. Especially Creighton Gilbert in his important and by now classic essay of a cautionary kind on the limits of iconography, "On Subject and Non-Subject in Italian Renaissance Pictures," *The Art Bulletin* 34 (1952): 202–16.

53. See Panofsky's introduction to *Studies in Iconology,* 20.

54. A number of contemporary poets have written on the *Primavera,* including Elizabeth Jennings and Robert Hass. For a general discussion of Botticelli and the poets, see Robert Clements, "Botticelli's *Primavera* and *Venere*: Eighteen Literary Readings," *Forum Italicum* 14, no. 4 (1979): 439–53.

55. My description, a summary interpretation, adopts a number of perceptions current in the scholarship; for this bibliography, see R. W. Lightbown, *Sandro Botticelli,* 2 vols. (London, 1978).

56. This poem (given in Rossetti's translation) and other lines of poetry cited above are representative of the Tuscan tradition and can equally well be replaced by other, similar poems and phrases.

57. *The Literary Works of Leonardo,* ed. Jean Paul Richter (London, 1970), vol. 1, 64. Leonardo's remark belongs to a poetic tradition; for example, Giacomo da Lentini's "Meravillosamente," in which the poet describes the painting of his beloved in his heart. See *The Penguin Book of Italian Verse,* ed. George Kay (Harmondsworth, 1960), 21.

Selected Bibliography

Adams, Robert M. *Nil: Episodes in the Literary Conquest of Void during the Nineteenth Century.* Oxford, 1970.

Ashbery, John. *Self-Portrait in a Convex Mirror.* New York, 1975.

Baudelaire, Charles. *Les Fleurs du Mal,* trans. Richard Howard. Boston, 1982.

———. *Selected Writings on Art and Artists,* ed. P. E. Charvet. Harmondsworth, 1972.

Berenson, Bernard. *Aesthetics and History.* Garden City, N.Y., 1954.

———. *The Italian Painters of the Renaissance,* 2 vols. New York, 1968.

———. *Piero della Francesca: or The Ineloquent in Art.* London, 1954.

———. *Sketch for a Self-Portrait.* New York, 1949.

———. *The Study and Criticism of Italian Art.* London, 1903.

Binyon, Laurence. *The Art of Botticelli: An Essay in Pictorial Criticism.* London, 1913.

Bishop, Elizabeth. *Geography III.* New York, 1976.

Boase, T. S. R. *Giorgio Vasari: The Man and the Book.* Princeton, 1979.

Bradley, A. C. *Oxford Lectures on Poetry.* London, 1909.

Browning, Robert. *The Poems and Plays.* New York, 1934.

Byron, Lord. *The Poetical Works.* Boston, 1975.

Castiglione, Baldassare. *The Book of the Courtier,* trans. Charles S. Singleton. Garden City, N.Y., 1959.

Chandler, Raymond. *The High Window.* New York, 1942.

———. *The Simple Art of Murder.* New York, 1980.

Chastel, André. *Art et Humanisme à Florence au Temps de Laurent de Magnifique.* Paris, 1959.

Clark, Kenneth. *Moments of Vision & Other Essays.* New York, 1981.

———. *Piero della Francesca.* London, 1969.

———. *Ruskin Today.* Harmondsworth, 1982.

Clements, Patricia. *Baudelaire and the English Tradition.* Princeton, 1985.

Clements, Robert. "Botticelli's *Primavera* and *Venere*: Eighteen Literary Readings." *Forum Italicum* 13, no. 4 (1979): 439–53.

Conlon, John J. "Eliot and Pater: Criticism in Transition." *English Literature in Transition* 25, no. 3 (1982): 169–77.

Corso, Gregory. *Gasoline.* New York, 1973.

Court, Franklin E. "The Matter of Pater's Influence on Bernard Berenson: Setting the Record Straight." *English Literature in Transition* 26, no. 1 (1983): 16–22.

Curtius, Ernst Robert. *European Literature and the Latin Middle Ages,* trans. Willard R. Trask. New York and Evanston, Ill., 1963.

Dempsey, Charles. "*'Mercurius Ver'*: The Sources of Botticelli's *Primavera.*" *Journal of the Warburg and Courtauld Institutes* 23 (1960): 251–73.

Dickens, Charles. *Pictures from Italy, Sketches of Boz, and American Notes.* New York, 1877.

Doyle, Arthur Conan. *The Complete Works of Sherlock Holmes,* 2 vols. Garden City, N.Y., n.d.

Egan, Patricia. "*Poesia* and the *Fête Champêtre.*" *The Art Bulletin* 41 (1959): 303–13.

Eliot, George. *Romola.* Oxford and New York, 1975.

Eliot, T. S. *The Complete Poems and Plays: 1909–1950.* New York, 1962.

———. *The Sacred Wood: Essays on Poetry and Criticism.* New York, 1965.

Ellis, Havelock. *The New Spirit.* Washington, D.C., 1935.

Ferguson, Wallace K. *The Renaissance in Historical Thought.* Boston, 1948.

Field, Michael [Katherine Bradley and Edith Cooper]. *Sight and Song.* London, 1892.

Fischel, Oskar. *Raphael.* London, 1948.

Fletcher, Ian. *Walter Pater.* London, 1959.

Freedberg, Sydney J. *Circa 1600: A Revolution of Style in Italian Painting.* Cambridge, Mass., and London, 1983.

———. *Painting in Italy: 1500–1600.* Harmondsworth, 1971.

———. *Painting of the High Renaissance in Rome and Florence,* 2 vols. Cambridge, Mass., 1961.

———. *Parmigianino.* Cambridge, Mass., 1950.

Freud, Sigmund. *Leonardo da Vinci and a Memory of His Childhood,* ed. James Strachey; trans. Alan Tyson. New York, 1964.

Gaunt, William. *The Aesthetic Adventure.* New York, 1967.

Gautier, Théophile. *The Complete Works,* trans. F. C. De Sumichrast, vol. 5. New York, 1910.

———. *Poésies complètes,* 2 vols. Paris, 1882.

Gilbert, Creighton. "On Subject and Non-Subject in Italian Renaissance Pictures." *The Art Bulletin* 34 (1952): 202–16.

Ginzburg, Carlo. "Morelli, Freud, and Sherlock Holmes." In *The Sign of Three: Dupin, Holmes, Peirce,* eds. Umberto Eco and T. A. Sebeok. Bloomington, Ind., 1983. Pp. 81–118.

Gombrich, E. H. *Symbolic Images: Studies in the Art of the Renaissance.* London, 1975.

Haggard, Rider H. *She.* Garden City, N.Y., n.d.

Hall, Marcia. "Michelangelo's *Last Judgment*: Resurrection of the Body and Predestination." *The Art Bulletin* 58 (1976): 85–92.

Hartt, Frederick. *History of Italian Renaissance Art.* Englewood Cliffs, N.J., 1969.

Hazlitt, William. *Twenty-Two Essays,* ed. Arthur Beatty. Boston, New York, and Chicago, 1918.

Heinse, Wilhelm. *Ardinghello.* Stuttgart, 1975.

Horne, Herbert P. *Botticelli: Painter of Florence.* Princeton, 1980.

Howard, Richard. "The Giant on Giant-Killing." *October* 1 (1976): 47–49.

Hugo, Victor. *The Hunchback of Notre-Dame,* trans. Walter J. Cobb. New York, 1965.

Huizinga, Johan. *Homo Ludens: A Study of the Play-Element in Culture.* Boston, 1964.

Inman, Billie Andrew. *Walter Pater's Reading: A Bibliography of His Library Borrowings and Literary References, 1858–1873.* New York and London, 1981.

Jarrell, Randall. *The Complete Poems.* New York, 1969.

Johnson, Samuel. *Lives of the English Poets,* 3 vols. Oxford, 1905.

Joyce, James. *Collected Poems.* New York, 1973.

———. *Ulysses.* London, 1966.

Keats, John. *The Complete Poems.* Harmondsworth, 1980.

Kemp, Martin. *Leonardo da Vinci: The Marvellous Works of Nature and Man.* Cambridge, Mass., 1981.

Kermode, Frank. *The Romantic Image.* London, 1957.

Ladis, Andrew. *Taddeo Gaddi: A Catalogue Raisonné.* Columbia, Mo., and London, 1982.

Landor, Walter Savage. *Imaginary Conversations: A Selection.* London, 1915.

Lee, Vernon. *Fancies and Studies.* London, 1896.

Lightbown, R. W. *Sandro Botticelli,* 2 vols. London, 1978.

Literary Works of Leonardo, The, ed. Jean Paul Richter, vol. 1. London, 1970.

Longhi, Roberto. *Officina Ferrarese.* Florence, 1968.

Meisel, Perry. *The Absent Father: Virginia Woolf and Walter Pater.* New Haven and London, 1980.

Monsman, Gerald. *Pater's Portraits: Mythic Pattern in the Fiction of Walter Pater.* Baltimore, 1967.

———. *Walter Pater.* Boston, 1977.

———. *Walter Pater's Art of Autobiography.* New Haven and London, 1980.

Moore, T. Sturge. *The Poems,* vol. 1. London, 1931–33.

Nabokov, Vladimir. *The Annotated Lolita,* ed. Alfred Appel, Jr. New York, 1970.

———. *The Defense.* New York, 1970.

———. *The Gift.* New York, 1963.

———. *Glory.* New York, 1981.

———. *Invitation to a Beheading.* New York, 1959.

———. *Laughter in the Dark.* New York, 1960.

———. *Lectures on Literature.* New York, 1980.

———. *Pale Fire.* New York, 1974.

———. *The Real Life of Sebastian Knight.* New York, 1959.

———. *Speak Memory: An Autobiography Revisited.* New York, 1979.

———. *Strong Opinions.* New York, 1981.

———. *Transparent Things.* New York, 1972.

New American Poets, The: 1945–1960, ed. Donald M. Allen. New York, 1960.

Offner, Richard. *A Critical and Historical Corpus of Florentine Painting,* section 3, vol. 8. Glückstadt, 1958.

Orczy, Baroness Emmuska. *The Scarlet Pimpernel.* Philadelphia, n.d.

Ovid. *Metamorphoses,* trans. Rolfe Humphries. Bloomington, Ind., 1955.

Pascoli, Giovanni. *Poesie,* vol. 10. Bologna, 1928.

Pollitt, J. J. *Art and Experience in Classical Greece.* Cambridge, 1972.

Panofsky, Erwin. *Studies in Iconology: Humanistic Themes in the Art of the Renaissance.* New York and Evanston, Ill., 1962.

Pater, Walter. *Appreciations.* London, 1907.

————. *Marius the Epicurean: His Sensations and Ideas.* London and New York, 1893.

————. *Miscellaneous Studies.* London, 1907.

————. *Plato and Platonism.* New York and London, 1893.

————. *The Renaissance,* ed. Donald L. Hill. Berkeley and Los Angeles, 1980.

————. *The Renaissance,* ed. Kenneth Clark. Glasgow, 1975.

————. *The Renaissance,* ed. Arthur Symons. New York, 1919.

————. *Selected Writings,* ed. Harold Bloom. New York, 1974.

The Penguin Book of French Verse: The Nineteenth Century, ed. Anthony Hartley. Harmondsworth, 1965.

The Penguin Book of Italian Verse, ed. George Kay. Harmondsworth, 1960.

Pico della, Mirandola. *On the Dignity of Man, On Being and the One, Heptaplus,* trans. Charles Glenn Wallis, P. J. W. Miller, and Douglas Carmichael. Indianapolis, 1965.

Pope-Hennessy, John. *Luca della Robbia.* London, 1980.

Portable Oscar Wilde, The, ed. Richard Aldington. New York, 1948.

Riccò, Laura. *Vasari Scrittore: La prima edizione del libro delle "Vite."* Rome, 1979.

Rilke, Rainer Maria. *The Selected Poetry,* trans. Stephen Mitchell. New York, 1982.

Robb, Nesca. *Neoplatonism in the Italian Renaissance.* London, 1935.

Rossetti, Dante Gabriel. *The Complete Poetical Works,* ed. William Michael Rossetti. Boston, 1907.

————. *Dante and His Circle.* Boston, 1887.

Rousseau, Jean Jacques. *The Confessions,* ed. L. G. Crocker. New York, 1957.

Samuels, Ernest. *Bernard Berenson: The Making of a Connoisseur.* Cambridge, Mass., and London, 1979.

Schwartz, Delmore. *Selected Poems.* New York, 1967.

Secrest, Meryle. *Being Bernard Berenson: A Biography.* New York, 1979.

Settis, Salvatore. *"La Tempesta" interpretata: Giorgione, i committenti, il soggetto.* Turin, 1978.

Seznec, Jean. *The Survival of the Pagan Gods: The Mythological Tradition and Its Place in Renaissance Humanism,* trans. Barbara Sessions. New York, 1961.

Shattuck, Roger. *The Innocent Eye: Modern Literature and the Arts.* New York, 1984.

Shearman, John. *Mannerism.* Harmondsworth, 1967.

Spalding, Francis. *Roger Fry: Art and Life.* New York, 1980.

Stein, Richard L. *The Ritual of Interpretation: The Fine Arts as Literature in Ruskin, Rossetti, and Pater.* Cambridge, Mass., and London, 1975.

Stevens, Wallace. *The Necessary Angel: Essays on Reality and the Imagination.* New York, 1951.

————. *Poems.* New York, 1959.

Stevenson, Robert Louis. *The Strange Case of Dr. Jekyll and Mr. Hyde.* New York, 1968.

————. *Treasure Island.* New York, 1911.

Stokes, Adrian. *The Image in Form,* ed. Richard Wollheim. New York, 1972.

Swinburne Letters, The, ed. Cecil Y. Lang, vol. 3. New Haven, 1969.

Symonds, John Addington. *Renaissance in Italy,* 2 vols. New York, 1935.

Turner, A. Richard. "Who Invented Leonardo?" (unpublished lecture).

Van Dine, S. S. [Willard Huntington Wright]. *The Benson Murder Case*. New York, 1983.
————. *The Bishop Murder Case*. New York, 1929.
————. *The "Canary" Murder Case*. New York, 1983.
Vasari, Giorgio. *Le Opere*, ed. Gaetano Milanesi, 9 vols. Florence, 1981.
————. *Lives of the Artists*, ed. George Bull. Harmondsworth, 1980.
————. *Lives of the Most Eminent Painters, Sculptors, and Architects*, trans. G. Du C. de Vere, 3 vols. New York, 1979.
————. *Lives of Seventy of the Most Eminent Painters, Sculptors, and Architects*, eds. E. H. and E. W. Blashfield and A. A. Hopkins, 4 vols. New York, 1897.
Verne, Jules. *Around the World in Eighty Days*. New York, 1964.
————. *Twenty Thousand Leagues Under the Sea*. Cleveland and New York, 1946.
Walter Pater: An Imaginative Sense of Fact, ed. Philip Dodd. London, 1981.
Warburg, Aby. *Gesammelte Schriften*. Nendeln-Liechtenstein, 1969.
Wells, H. G. *The Invisible Man*. New York, 1964.
————. *The Time Machine and Other Stories*. New York, 1963.
————. *The War of the Worlds*. New York, 1964.
Wilbur, Richard. *The Beautiful Changes and Other Poems*. New York, 1947.
Wilde, Johannes. *Venetian Art from Bellini to Titian*. Oxford, 1974.
Winckelmann, Johann Joachim. *History of Ancient Art*, 4 vols. New York, 1968.
Wind, Edgar. *Pagan Mysteries in the Renaissance: An Exploration of Philosophical and Mystical Sources of Iconography in Renaissance Art*. New York, 1968.
————. "Platonic Justice designed by Raphael," *Journal of the Warburg Institute* 1 (1937): 69–70.
Woolf, Virginia. *Orlando*. New York and London, 1956.
Yashiro, Yukio. *Sandro Botticelli and the Florentine Renaissance*. Boston and London, 1925.
Yeats, William Butler. *The Collected Poems*. New York, 1979.
————. *The Oxford Book of Modern Verse: 1892–1935*. New York, 1936.
————. *A Vision*. New York, 1966.

Index